Stitched Journeys
with
BIRDS

Inspiration to Let Your Creativity Take Flight

MARTHA SIELMAN

SCHIFFER
CRAFT

4880 Lower Valley Road • Atglen, PA 19310

Other Schiffer Books by the Author:
Art Quilts International: Abstract & Geometric, ISBN 978-0-7643-5220-1
Art Quilts Unfolding: 50 Years of Innovation, ISBN 978-0-7643-5626-1
Museum Quality : Exploring Art Quilts with SAQA, ISBN 978-0-7643-6475-4

Cover and interior design by Ashley Millhouse
Type set in Mr Eaves Sans/Mrs Eaves
Front cover: Tamara Kostianovsky, *Fowl Decorations, Photo by J.C. Cancedda*
Back cover, top: Janine Heschl, *Bird 'n' Bones;* back cover, bottom: Ruth Powers,
Harrier Hunting

ISBN: 978-0-7643-6692-5
Printed in China

Published by Schiffer Publishing, Ltd.
4880 Lower Valley Road
Atglen, PA 19310
Phone: (610) 593-1777; Fax: (610) 593-2002
Email: Info@schifferbooks.com
Web: www.schifferbooks.com

For our complete selection of fine books on this and related subjects, please visit
our website at www.schifferbooks.com. You may also write for a free catalog.

Schiffer Publishing's titles are available at special discounts for bulk purchases
for sales promotions or premiums. Special editions, including personalized covers,
corporate imprints, and excerpts, can be created in large quantities for special
needs. For more information, contact the publisher.

Nancy G. Cook | *Ground Fire Brings Light and Life: Long Leaf Pine and
Red Cockaded Woodpecker*

CONTENTS

INTRODUCTION

Birds bring life to the landscape. They are found everywhere in the world and are always interesting to watch, study, and enjoy. Their movements and interactions remind us of ourselves, yet they are also able to fly up in the heavens. They bring joy and excitement into our lives.

We need to take care of our environment and to protect our birds. Birds are so full of life that seeing a dead bird depicted in art is shocking. When an artist shows a dead bird, they hope that their art will make us more aware.

Birds were an intrinsic part of the environment in which I grew up. My mother always fed the birds, and so did her father, my grandfather. It was part of the rhythm of our lives: feeding birds, watching birds, waking to birdsong. And then I got interested in learning more about them, so I joined Cornell Lab of Ornithology's FeederWatch program, which asks people who feed the birds to help build our understanding of bird behavior by monitoring the birds that come to our feeders. The lab aggregates the data from these "citizen scientists" to look for trends.

In the meantime, I also developed a career in the arts as the executive director of Studio Art Quilt Associates, Inc. (www.SAQA.com), a position that I've now held for nineteen years. SAQA is a membership organization of more than four thousand artists around the world, artists who create amazing art in fiber. SAQA organizes traveling exhibitions, convenes conferences, and publishes catalogs, books, and magazines filled with gorgeous art.

When I met collector Frank Klein and viewed his art collection, I suddenly saw how my two passions could overlap. In addition to being an avid art quilt collector, Frank is a professional photographer and citizen scientist with a particular interest in photographing and studying the birds around his West Texas home. Frank Klein wrote: "I set up and maintained a 135-nest box trail, and I used to see the bluebirds and other native cavity-nesting birds up close and record their growth from eggs to fledglings.

This led to the desire to better document this development with photography. A picture is worth a thousand words.

"The more you look, the more you see. I take their pictures because birds are absolutely stunning. We can learn so much from them. They are dinosaurs that turned into little angels."

Once I saw Frank's photographs, I started to notice other kinds of bird art everywhere. And I realized that there is stunning fiber art being created that is inspired by birds. I became obsessed with collecting this art and sharing it with others.

This book is the result. Because I believe that everyone is inherently creative and that making art is a major source of joy, I asked the artists whose work is showcased in this book to offer their best advice about how to get started as an artist. The common theme in their responses is "Just Do It!" The more that you create, the more that you will enjoy the process and the more that you will enjoy the results. Creativity is part of being human, so make art whenever possible.

I have grouped the art in several ways so that you can see connections between and among the artworks. Some artists are featured with just one magnificent piece. Look at how they've used such simple materials: a sheet of paper, a length of thread, a piece of fabric to create a powerful image and message.

There are a series of galleries that showcase how different artists approach the same type of bird from a variety of perspectives. Chickens and black birds were some of the most popular subjects. Why are some birds more popular than others? Does the medium affect how you react to the art?

This book only begins to explore all of the magnificent bird art that's been and is being created. I hope it inspires you to create and to look for birds and art everywhere!

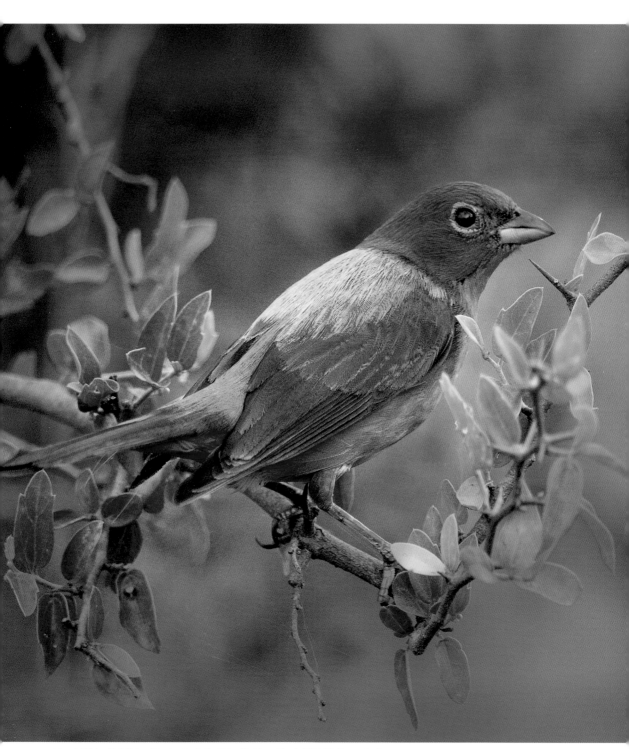

Frank Klein, *Male Painted Bunting Perched on Spiny Hackberry Shrub*, 2018. Photographed with Nikon D850 with 800 mm F5.6 Nikon Lens.

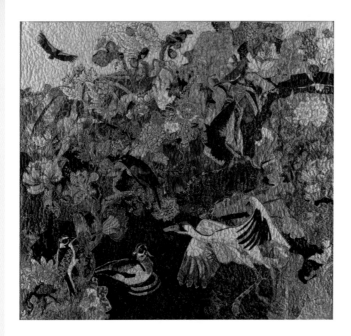

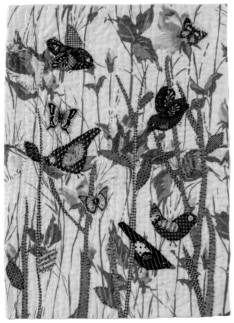

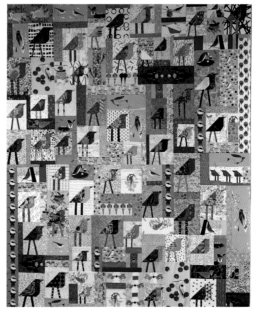

Top: Annie Helmericks-Louder | *Tender Bellies* | 72 × 70 inches; 2013 | Manipulated commercial and hand-dyed fabrics | Collaged, stitched

Bottom left: Beth Shibley | *Garden Friends* | 23 × 17 inches; 2016 | Vintage curtain, cotton | Hand appliquéd, hand quilted

Bottom right: Nancy Beth Blake | *Nestled in Your Wings* | 74 × 62 inches; 2022 | Cotton | Pieced, quilted

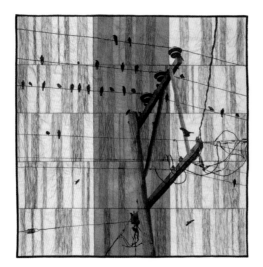

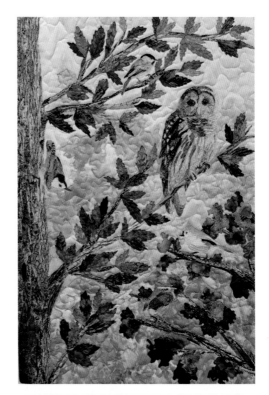

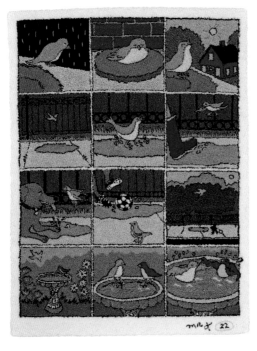

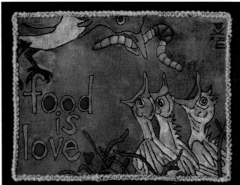

Top left: Susan Bianchi | *High Voltage Birds* | 45 × 45 inches; 2015 | Hand-dyed cottons, cotton/linen fabric, oil sticks, threads | Digitally printed, pieced, painted, machine quilted | *Photo by Curt Bianchi*

Top right: Carol A. Monti | *Woodland Sentries* | 30 × 20 inches; 2021 | Fabric, thread, fiber-reactive dyes | Raw-edge appliquéd, hand dyed, free-motion quilted

Bottom left: Liz Alpert Fay & Marisabina Russo | *A Bird Tale* | 24 × 18 × 0.5 inches; 2022 | Silk and cotton threads on cotton | Punch needle embroidered | *Photo by Brad Stanton*

Bottom right: Sara Mika | *Food Is Love* | 6 × 8 inches; 2012 | Muslin, fabric paint, thread | Hand painted, free-motion machine stitched and quilted, embellished

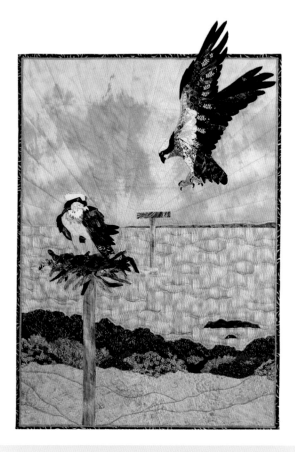

BETSY ABBOTT

North Andover, Massachusetts, USA

Listen to your own "art spirit." Forget what the market may be looking for. If you create from whatever feeds your passion, viewers will feel this and take notice.

Many of my earliest childhood memories are of exciting discoveries in the natural world of the New England coast and its surrounding fields and woodlands. After receiving my first pair of binoculars at age nine, I couldn't get enough of the outdoors. I devoured guidebooks and listened to birdsong recordings by the hour, and I even wrote to authors and illustrators of the bird books I received as a child. Birds quickly became the primary object of my wonder and the enduring source of my passion. They captivate me with their dazzling colorations and graceful flight patterns, remarkable variety and diversity, individual habits and behaviors, distinctive calls and inspiring migrations, adaptability and resilience, and, above all . . . their wildness and mystery.

Birds of prey have a special place in my heart, drawing me to their power and fearsome beauty. They occupy a dynamic place at the top of the food chain, signaling both the health and the fragility of whole ecosystems. Some—especially the osprey, snowy owl, screech owl, and northern harrier—have become almost mystical or archetypal spirits in my life.

Fidelity | 48.5 × 32.5 inches; 2008 | Cotton | Thread painted, raw-edge appliquéd, machine appliquéd | *Photo by Tom Grassi–Image Tec*

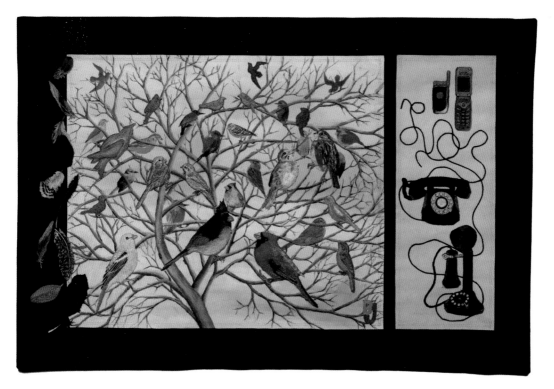

B. J. ADAMS

Washington, DC, USA

Spend time experimenting. Play with material in many colors, then repeat using many techniques. Try every size and weight of both the material and the technique. Keep trying. My only warning is to keep it simple: do not put everything you know or learn into every work. Simplicity is beautiful.

Washington, DC, has always been the capital of gossip, chatter, and rumors. The exchange of gossip is represented by the birds, while the passage of time is represented by the aging of the telephones. All the birds are in pairs except for the yellow one (*lower left*). To be gossip, there needs to be something to be talked about, and the yellow bird is the one.

Birds are great subjects because of their variety of forms, shapes, and sizes. I love to watch them. If I could choose, I would probably focus on tropical birds, just because of their unusual shapes and colors. Since I do not live near these colorful birds, I love to see a bright-red cardinal as it flies through the greens of nature.

Gossip: Political and Social | 25.5 × 38.5 inches; 2006 | Cotton, cotton canvas, thread, acrylic paint | Free-motion machine embroidered, heat-transferred images, painted, appliquéd | *Photo by PRS Associates Inc.; Collection: DC Arts and Humanities*

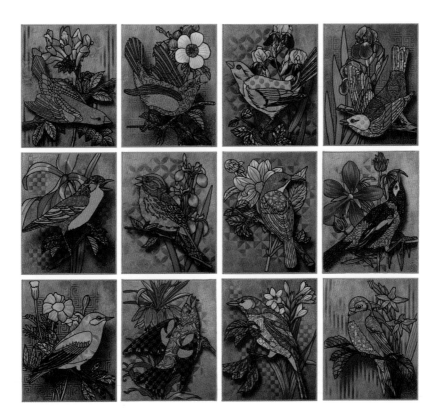

JUDITH AHLBORN

Littleton, Colorado, USA

Try lots of different techniques and styles to see what interests you most or is the most fun to do. Let each piece tell you what you learned from it, and let that knowledge help you with the next one. Just have fun and enjoy the process!

I have been drawn to birds as inspiration for my art for as long as I can remember. They cause me to stop, take a moment out of my busy day, and just watch them in fascination. The motion of a bird flying past my window catches my attention and encourages me to spend some time appreciating the beauty of the world around me.

I often spend time browsing through bird books, bird calendars, or images online. Sometimes I will see a painting of a bird and there may be one thing about it that I particularly like. That one thing may inspire me to create a whole new series of bird pieces.

Calendar Birds | 31 × 34 inches; 2016 | Cotton | Digitally designed, free-motion and straight stitched

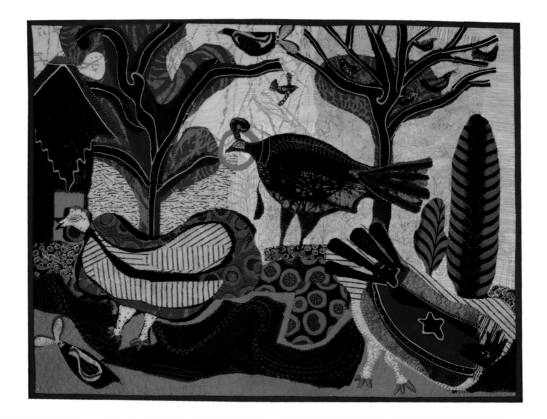

PAMELA ALLEN

Kingston, Ontario, Canada

Go with what your eye sees as the composition unfolds. I am NOT a believer in preliminary drawing to which one must adhere, but rather enjoy doing what the composition is telling me to do as it develops. I spend a lot of time online looking at other artists' work and have a collection of those that appeal to me on my studio walls, not to copy but to see how other artists have tackled the same theme.

I rarely start with a plan except maybe for subject matter. I have a very small stash of fabrics compared to other art quilters, so I make do with every sort of combination. I routinely cover the batting with three large shapes. Then I start to arrange smaller elements into a composition that may intimate an environment for my subject.

I have favorite birds, which I believe is based on their personalities. Chickens are brash, yet domestic. Songbirds can be gregarious, but some are loners. Turkeys (alas for them) are delicious! I always stop to watch a bird of prey soaring high. They are so aerodynamic, whether effortlessly gliding or suddenly streaking down to the ground. No matter what category, birds are beautiful to look at.

3 BIG and 8 SMALL birds | 34 × 44 inches; 2017 | Cottons, recycled clothing, embroidery threads | Hand-stitched, raw-edge appliquéd, free-motion machine quilted

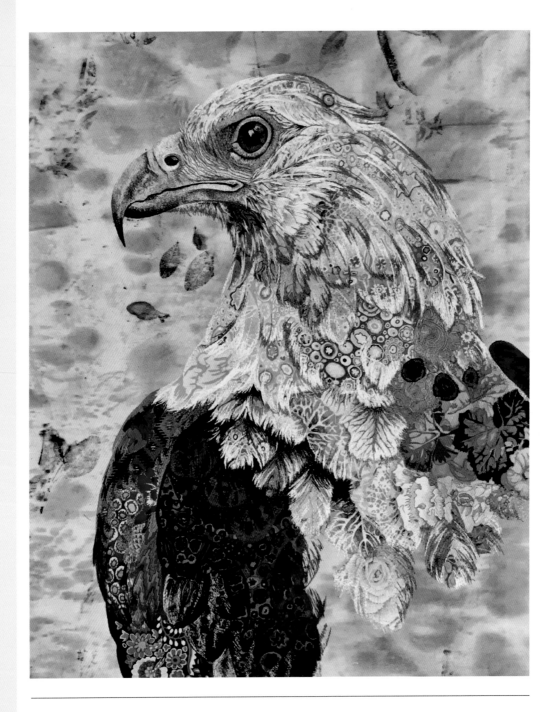

Sophie Jane Standing | *African fish eagle* | 33 × 22 inches; 2021 | Liberty tana lawn fabrics, paint | Appliquéd

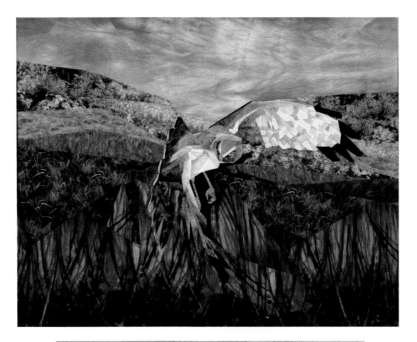

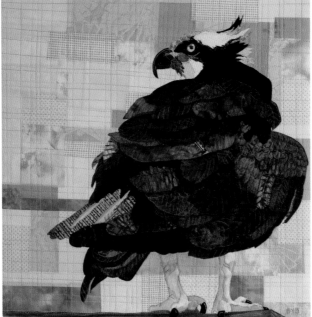

Top: Ruth Powers | *Harrier Hunting* | 42 × 51 inches; 2012 | Hand dyed and commercial cottons | Machine pieced, machine quilted

Bottom: Barbara Yates Beasley | *Clara* | 20 × 20 inches; 2015 | Commercial hand-dyed cotton, silk, acrylic paint, art markers | Raw-edge fused appliqué, free-motion stitched

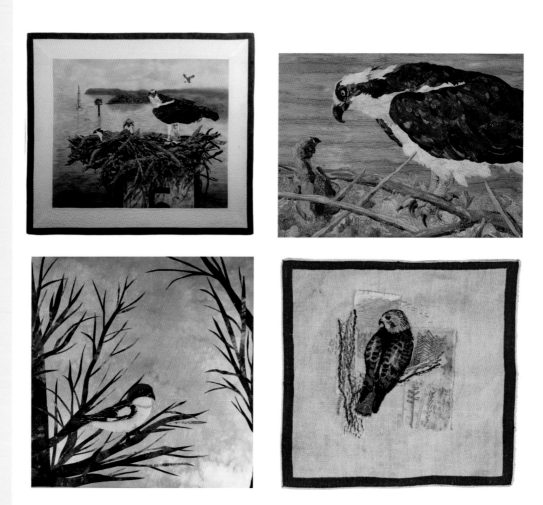

Top left: Suzette Coppage | *Sailing under Watchful Eyes* | 30 × 36 inches; 2017 | Hand-painted and commercial cottons | Painted, raw-edge appliquéd, thread painted | *Photo by Roger Miller*

Top right: Jerri A. Stroud | *Before You Leave This Nest* | 27 × 37 inches; 2020 | Cotton, batik | Collage, free-motion quilted

Bottom left: Sarah Lykins Entsminger | *Woodcut Shrike* | 24 × 24 inches; 2018 | Hand-dyed cotton, felted wool, ultra suede, beads, glass button, acrylic paint, threads | Machine appliquéd, hand appliquéd, hand embroidered, beaded, machine quilted

Bottom right: Carla I. Corbin | *I Can See You* | 10 × 11 inches; 2021 | Discarded linen napkin, commercial and dyed cloth, thread | Hand appliquéd and stitched

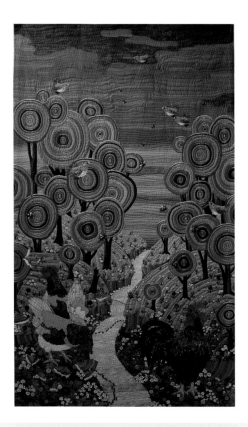

THOM ATKINS

Santa Cruz, California, USA

Love fabrics and don't be afraid to choose ones that work for you. Remember the old adage "Color gets the credit, but value does the work!" Value is the key to making a design work, the placement of lights and darks. If I'm in doubt, I pin the fabrics up on the design wall and stand back and see which ones come to the fore.

When I start a new piece, if I'm really stuck, I'll look through my stash to see what speaks to me, and then select other fabrics that go with it. I also keep a file of pictures cut from magazines that appeal for some reason, be it color, form, texture, or subject material.

Birds come in so many beautiful colors and shapes. My parents were birders. I learned a great deal about birds from them, and I have always enjoyed watching birds. I like the added potential of movement they bring to the design.

The Birds and the Beads | 74 × 42 inches; 2013 | Printed cottons, seed and bugle beads | Machine appliquéd, hand beaded

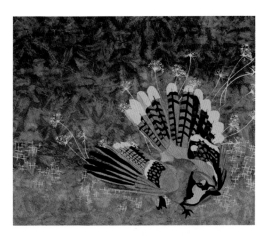

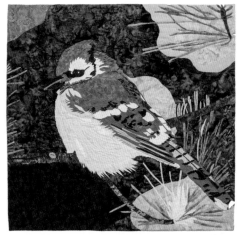

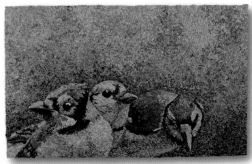

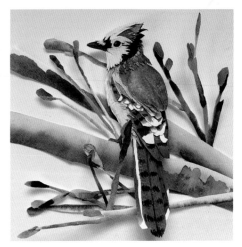

Top left: Deon Lewis | *Blue J* | 30 × 30 inches; 2014 | Cotton, thread, screen printing ink | Raw-edge appliquéd, machine quilted, screen printed | *Photo by Eric Frazer*

Top right: Judy A. Makinson | *Jay's Nest* | 40 × 40 inches; 2012 | Cotton | Machine pieced, raw-edge fused machine appliqué, machine quilted

Bottom left: Mita Giacomini | *Trio* | 18 × 30 inches, 2017 | Wood, silk, cotton, and other natural and synthetic fibers | Surface woven

Bottom right: Sarah H. Suplina | *Bluejay* | 8 × 8 × 1.25 inches; 2021 | Painted watercolor paper | Painted, cut, assembled

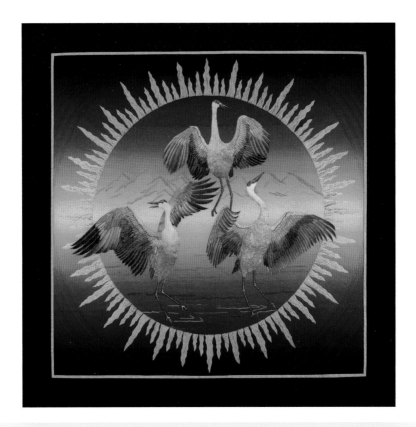

JOANNE BAETH

Bonanza, Oregon, USA

If you have a vision, experiment with all kinds of techniques to achieve your goal. I am constantly inspired by other artists and their creative works. Each artist has a different interpretation of birds in nature, and that is exciting. There are no rules; just have fun.

I take a lot of photographs of birds, but I am not a professional photographer. I set my point-and-shoot camera on Burst, which takes several pictures in a few seconds, especially important for when birds are in flight. The pictures that I like are loaded onto my computer and printed out. I make sketches using these references, and I will often trace the bird's main features, using a light box. A pattern is made from my sketch, and then I can really get creative making feathers.

I am fortunate to live in a rural area in southeastern Oregon with wetlands, refuges, forests, and lakes nearby. This amazing area is on the Pacific Northwest migration route for over three hundred species of birds. I have been a birdwatcher for most of my life, and I am outdoors often. I am inspired by all birds, especially when they are in flight, taking off, landing, or perching. I love the challenge of creating realistic feathers for different birds, and I spend hours observing birds in their natural settings.

A Time to Dance | 47 × 47 inches; 2020 | Discharge paste, fabric paints, salt, metallic paints, beads, inks, hand-painted cottons, dyed silk organza | Discharged, painted, beaded, machine quilted | *Photo by Rob Jaffe*

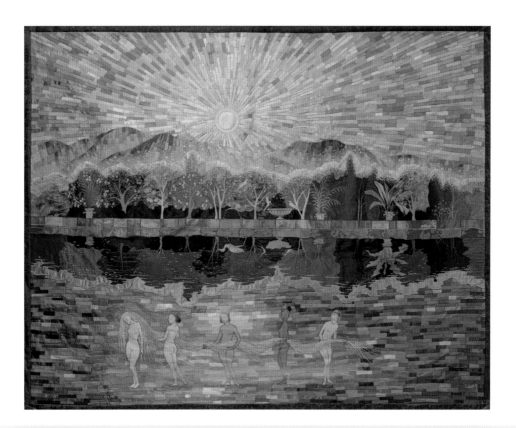

IZABELLA BAYKOVA

St. Petersburg, Russia

It's best to go your own way. Do art all the time. Try to find a meditative state while doing your art, so that you can free yourself from unnecessary superficial notions and find your innermost truth.

I carry a work diary with me and write down and sketch out all my ideas. This diary lies beside my bed, and if I have a dream that might become a work, I write it down in detail and then sketch it out. *Golden Hair* began as a recurring dream: I was diving down into transparent water. I felt weightless, like I was floating in the water like a fish, and I felt so happy. I saw a woman standing in the water nearby, a woman with long golden hair. Her hair was so long that other women were holding it over the water in heavy golden cascades. An unearthly glow filled the air. When I awoke, I felt reborn. The dream stayed with me for years, until I made this piece, *Golden Hair*.

What inspires me about birds is their beauty and symbolic meaning, especially owls and swans. When I was four years old, my nickname was Owl. Since then, the owl has been my friend and mascot. The owl is the symbol of wisdom, clairvoyance, and knowledge. A small detail of a girl with an owl in *Mysteries of Christmas* is my self-portrait at the age of four. It is a Splyushka owl (*Otus scops*), or "cute sleeping one," because of the soft whistling sound it makes.

Golden Hair | 51 × 63 inches; 2021 | Silks, synthetics, tulle | Appliquéd, hand and machine embroidered

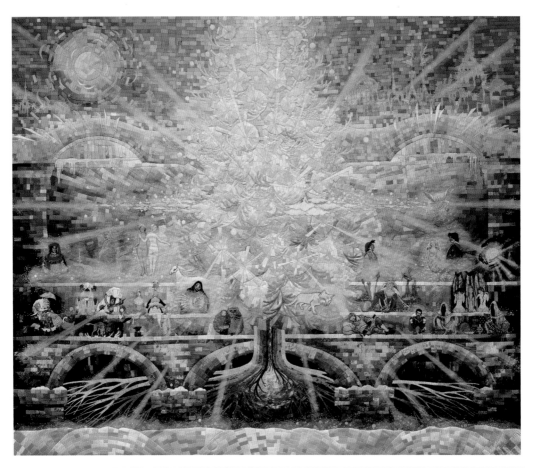

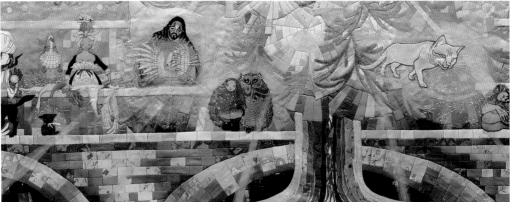

Detail

Mysteries of Christmas | 91 × 79 inches; 2011 | Silks, synthetics, tulle | Appliquéd, hand and machine embroidered

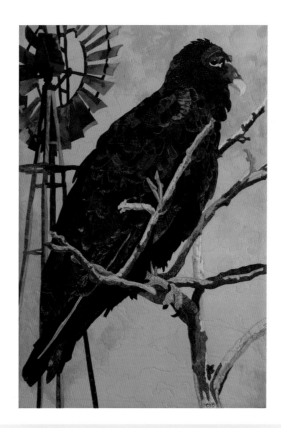

BARBARA YATES BEASLEY

Boulder, Colorado, USA

Find a subject or technique that excites you. That will make it easier to work in a series by tweaking each new artwork. It is in this repetition that you start asking, "What if?" As you answer that question, you will grow as an artist.

My work always starts with a personal encounter with a bird or animal, or perhaps an exciting photo that catches my eye. When I don't know what to do next, I start scrolling through fifteen years of photographs.

I like to create portraits of all kinds of animals, but when it comes to birds, I gravitate to the larger birds that know their place in the pecking order. I'm usually attracted by the attitude of the bird first and then their unique features. I think turkey vultures are so ugly that they cross over to being sweet, with a face only Mom could love. You can find numerous nest cams to watch vultures, ospreys, eagles, and other birds in their natural habitat.

Street Cleaner | 30 × 20 inches; 2015 | Commercial, hand-dyed, rusted, tea-dyed cotton fabric, silk, acrylic paint, art marker | Raw-edge fused appliqué, free-motion stitched

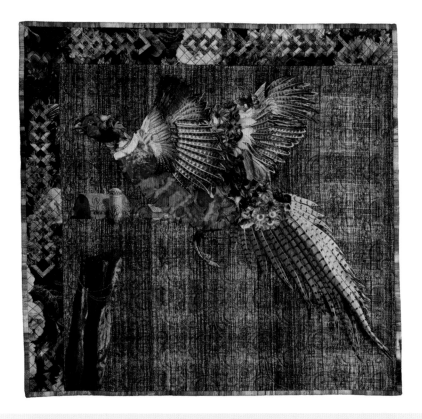

PAULA BERGAN

Arlington, South Dakota, USA

Just do it. If it works, great; if not, try something else. If you make a mistake figure out what you did wrong, tear it apart, and do it again.

I love birds, their peaceful sounds, gorgeous colors, and beauty in flight. I am particularly excited when I see wild game birds and eagles.

Pheasant in Flight | 24 × 24 inches; 2018 | Fabric, feathers are cut from flower petals | 3-D appliquéd

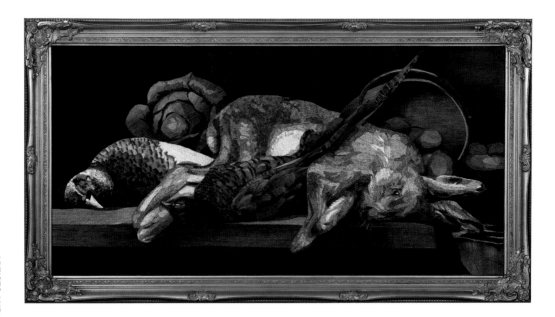

IAN BERRY

London, UK

An artist should do what you really want to do and say. Judge yourself on the quality of work and on yourself as a human being, not on the likes and followers on apps for muggles.

This series came about when I was asked to be a part of a show with Kate Jenkins, for the Illustrated Recipe during the Brighton Festival in 2013, based on food of the Regency period. I became interested in the game side and the behind-the-scenes of their kitchens. Gastro pubs and game dishes were all the rage in London at that time. Given my background, if I was around during the Regency period, I would have much more likely been behind the scenes in the kitchen and not at the banquet!

My mum and dad can name all the birds that fly, but I have not yet picked that up. So, sadly here, I portray them dead, inspired by Dutch Renaissance still-life painting. The thing that I really wanted to focus on was how to depict them in denim, without showing that it is denim, like shiny feathers using denim and nothing else. It must have worked: *Vogue* called it the highlight of the Brighton Festival!

Game Pie | 61 × 122 inches; 2013 | Denim | Fused

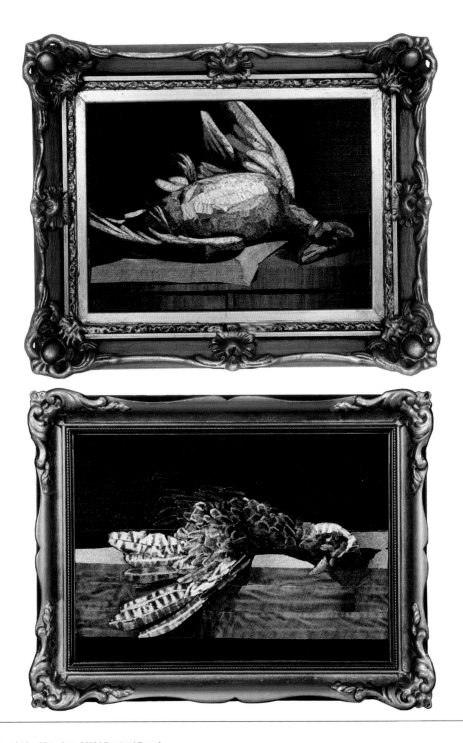

Top: *Duck* | 40 × 65 inches; 2013 | Denim | Fused
Bottom: *Pheasant* | 40 × 65 inches; 2013 / Denim | Fused

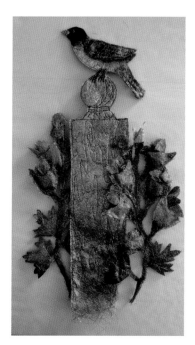
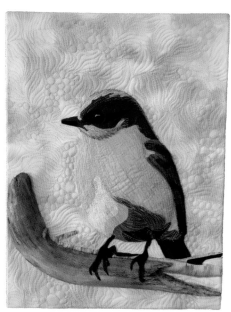
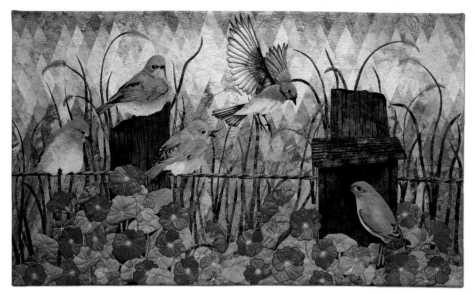

Top left: Eileen Doughty | *Diane's Backyard* | 14 × 7.5 × 0.5 inches; 2021 | Blended and self-fused Angelina fibers, metallic threads | Machine stitched, layered monkshood flowers

Top right: Krista Zeghers | *Eastern Bluebird on Branch* | 16 × 12 × 1 inches; 2019 | Cotton, inks, driftwood stick | Raw-edge appliquéd, trapuntoed, inked, free-motion quilted | *Photo by Joe Ofria*

Bottom: Laura E. Ruiz | *Bluebirds* | 33 × 56 inches; 2013 | Hand-dyed and commercial cottons, inks | Pieced, appliquéd, inked, quilted

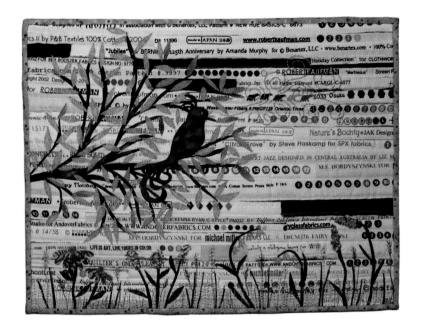

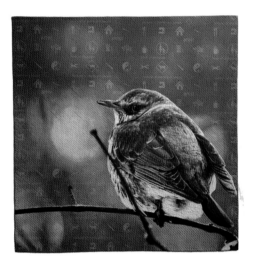

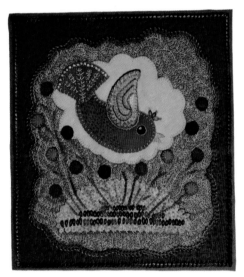

Top: Iina Alho | *The Blue Bird of Hope* | 12 × 15.5 inches; 2021 | Selvages, commercial fabrics, embroidery thread | Free-motion appliquéd, fused, hand stitched

Bottom left: Suzan Engler | *Icons in Blue* | 40 × 40 inches; 2017 | Cotton | Digitally designed image printed on cotton, machine quilted

Bottom right: Laura Wasilowski | *Blue Bird with Happiness* | 10 × 9 inches; 2021 | Felt, wool, hand-dyed pearl cotton threads | Free-form hand embroidered

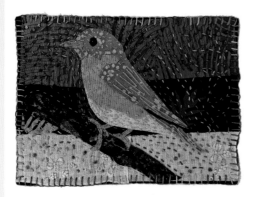

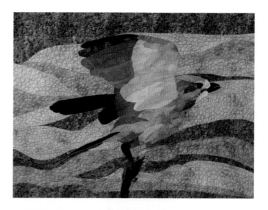

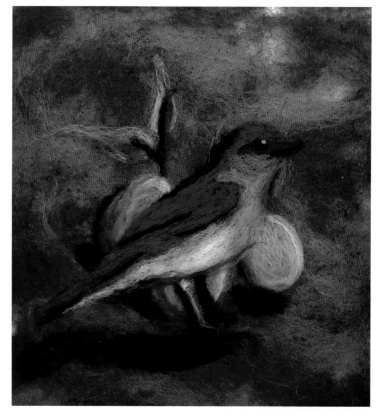

Top left: Martha E. Ressler | *Bluebird 2* | 5 × 7 inches; 2019 | Vintage linen, batiks, embroidery thread | Raw-edge appliquéd, hand embroidered

Top right: Janet Lorraine Rhind | *En Route* | 33 × 41 inches; 2017 | Cotton, cotton embroidery thread | Hand appliquéd, machine quilted, hand embroidered

Bottom: Mirta Ester Ormazabal | *Bluebird* | 7 × 7 inches; 2018 | Wool | Wet and needle felted

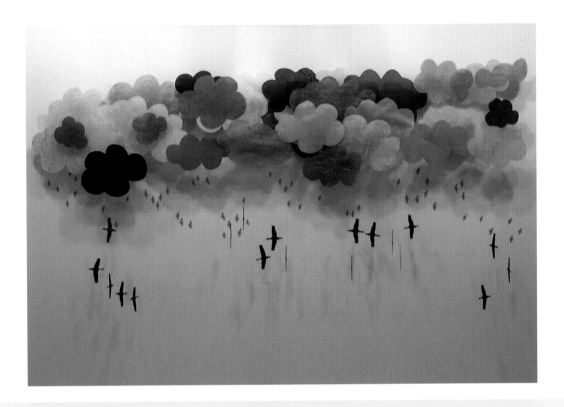

CHARLOTTE BIRD

San Diego, California, USA

Think about what you like to do and what interests you. Write it down in a notebook and date your entries, so you can review where you were, where you are now, and where you want to go. Try anything at least once. Then, practice, practice, practice.

Birds represent elegance, freedom, and wildness. I live on an urban canyon in San Diego, California. We watch for the winter migrants in the fall and the summer migrants in the late spring. That annual cycle—nesting, raising and fledging chicks, and migration—is an affirmation of life. Sandhill cranes are among my favorite birds. Their ethereal song represents the land I love: the Far North of Alaska and northwestern Canada. They nest on the tundra and

taiga, usually raising one colt. When it is time to fly south, the adult pair takes the juvenile with them to establish the flight and route memory.

Migratory birds are the "canary in the coal mine" with respect to the natural world and human impact of climate change. As the climate changes, its impact on the survival of the various species provides both fascinating scientific study and alarming foreboding of the future.

Migration—an Installation | 9 feet × 46 inches; 2021 | Polyester organza, hand-dyed and commercial cottons, oil stick, fish line | Hand-cut and fused appliqué, machine stitched, machine quilted, hand sewn, hung on fish line | *Photo by Gary Connaughton*

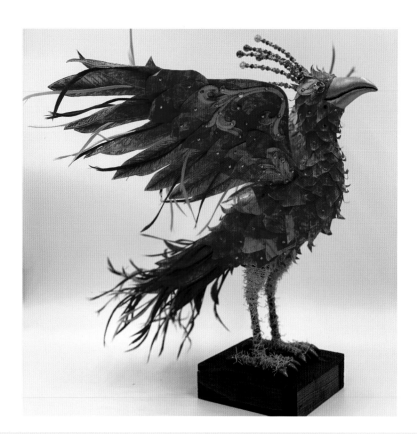

LINDA BLUST

Reno, Nevada, USA

Be an original. Follow your own muse rather than copying somebody else's style. And don't be afraid to make mistakes. Not every effort will be a masterpiece, but it's guaranteed to be a teaching moment that will help you in the future.

I have a passion for all wildlife, but I'm particularly drawn to birds. Perhaps it's because of their accessibility. After all, birds are everywhere. All we need to do is look out our windows to observe them going about their lives. I'm also intrigued by their sheer alienness. They look nothing like us or any other earthly creature.

While I love all birds, I prefer to sculpt large pieces at least 2 feet tall. This is partly because I believe that large textile sculptures get more respect as "real art" than small pieces, which are often dismissed as crafts or toys. But it's also because bigger sculptures provide more surface space that I can embellish with stitching, paint, and mixed media.

The greatest challenge with large bird sculptures is figuring out how to balance a big irregular shape atop a pair of skinny legs. Each piece requires a good deal of trial and error before it's upright and sturdy. You'd be surprised how much wire is hidden under the fabric feathers to keep the bird from tipping over.

Sun Dancer | 20 × 18 × 28 inches; 2020 | Hand-painted cotton, lace, embroidery floss, wire, paint, polymer clay, beads, buttons | Hand and machine quilted, hand and machine embroidered, needle sculpted

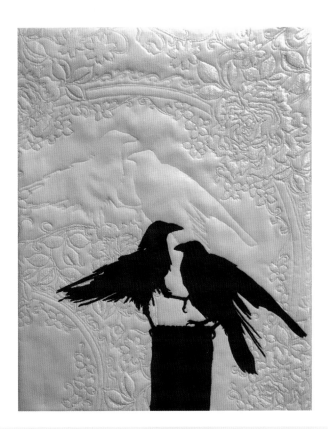

DONNA BRENNAN

El Dorado Hills, California, USA

One of the most elusive aspects of creating art is originality. Artists look to other artists for ideas and inspiration and then use that to trigger our own ideas. Looking back at my own most original stuff, even from years and years ago, might be the right spot to launch the next piece.

My husband's photographs often help spark my quilts, and we like the collaboration. We love birdsongs and all the bird activity in the garden. We watch them and learn their habits: the towhees kick the ground and hop back to scratch for food, the titmice fly in scalloped swoops from the tall oak next door, the mourning dove sits in the feeder like he's at the beach. We're ecstatic when someone moves into a birdhouse we've put up. Birds add life to the garden.

Our favorite birds are the common grackles with their variety of whistles, and I really love mockingbirds, which are the Rich Littles of the bird world: "Listen, this is my quail imitation." "Oh, very good!" The flocks of cedar waxwings are a treat, especially when thirty or more try to take a bath in the birdbath at the same time. We have respect for the crows and are still studying them, but they really clean out the feeders fast.

Damask Pas de Deux | 21 x 16 inches, 2016 | Vintage tablecloth, cotton | Raw-edge fused appliqué, free motion quilted | *Photo by: Bill Brennan*

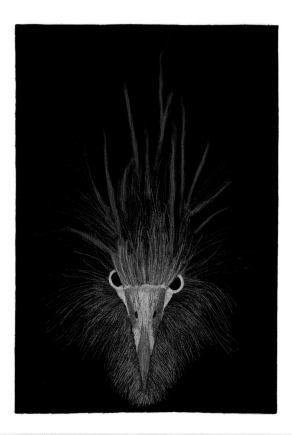

MELANI BREWER

Cooper City, Florida, USA

Find something you love and are passionate about. Touch it, study it, research it. Draw it, paint it, stitch it, and you will know it intuitively. Soon you will be creating artwork about what you love. A walk in my yard or in a forest inspires me. Birds, butterflies, flowers, or water: there is always something for me to stitch.

I'm amazed by the evolution of birds: their many colors, feathers, and beaks. Songs, courtship dances, and nest building are unique to each species. Sizes vary from the bee hummingbird to the flightless ostrich and every size in between. On my lake, egrets, herons, and storks in particular provide inspiration. Storks lifting a wing to shade the water from the sun reveal the fish they hunt. The elegant strut of the giant egrets, as if on a fashion runway, displaying their beautiful feathers.

Nature and art hold the clues to life.

Tricolor Egret | 21 × 15 inches; 2020 | Cotton, wool roving, threads | Drawn, thread painted | *Photo by Matt Horton*

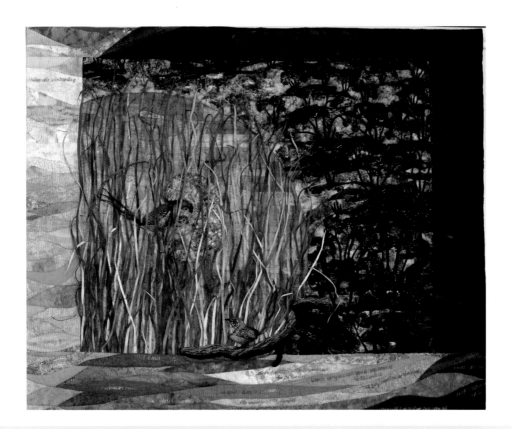

KATHY BROWN

Adelaide, South Australia, Australia

Find your passion and research it. Representing your art the same way each time can be confining, so try new processes—experimentation brings new learning and growth.

I research extensively: the bird, their environment, and why they are now endangered or threatened. During this process, a story begins and a scene that may best represent this story becomes evident.

Because I live in the driest state of the driest continent on Earth, over time I have seen the destruction of our mallee vegetation both by man and fire, and the impact of this on our native birds. We have such a high rate of vulnerable, endangered, and extinct birds in Australia. My passion has been to tell their stories before a possible catastrophe. One such quilt was about the mallee emu-wren; two years after completing the quilt, a fire destroyed both the birds and the habitat. They are now extinct in South Australia and endangered in other states.

I have loved watching and listening to birds for years. I've been noticing changes: small birds disappearing, larger birds moving in. As I grew up in and love the Mallee regions of South Australia, my quilts aim to show the environment, beauty, and plight of the threatened and endangered birds in South Australia.

Are we too late? Mallee Threatened Bird Series #3, The Mallee Emu-Wren | 28 × 34 × 1.5 inches; 2011 | Cottons, synthetics, furnishing fabrics, organza, tulle, hand-painted visofix, silk, paint, feathers | Hand and machine pieced, reverse appliquéd, hand and machine appliquéd, hand embroidered, stump work, transferred manipulated photo, hand-painted, printed, machine lace, woven, hand quilted | *Photo by Peter Hurt*

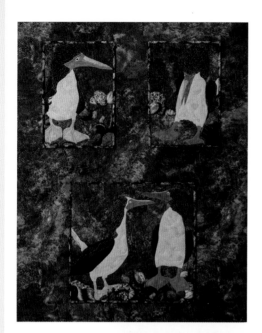
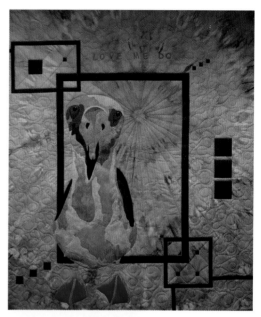
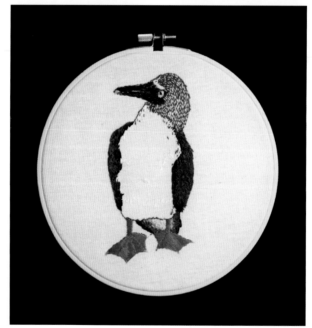

Top left: Tina Sommer Paaske | *Looking for Love* | 40 × 31.5 inches; 2017 | Cotton | Raw-edge fused appliqué, machine quilted

Top right: Tina Sommer Paaske | *Love Me Do* | 41 × 35 inches, 2016 | Hand-dyed and commercial cottons | Raw-edge fused appliqué, machine quilted

Bottom: Amy Green | *My Eyes Are Up Here!* | 9 × 9 inches; 2020 | Linen, cotton embroidery floss | Free-hand embroidered

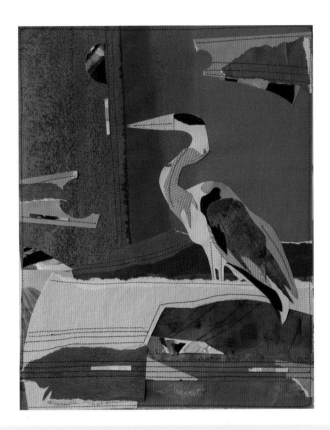

HANNAH BURNWORTH

North Manchester, Indiana, USA

Make time to create often. Seek out the constructive criticism of artists you respect. Ask questions. Take photos often and keep them organized. Celebrate your growth: the art journey is an incredible one.

Watching birds invites a connection with nature and offers a chance to unplug from our chaotic schedules. They remind us that nothing works independently or in isolation. Birds are connected to our weather, our plant life, our agriculture, and the way we live. My favorite birds live where I live. They breathe the same air. They are some of the most common birds in northern Indiana: cardinals, nuthatches, belted kingfishers, and great blue herons.

Just like birds, collaged pieces do not work in isolation but join a flock of other unique papers to create something beautiful. Sometimes I'll dump out a bag of beautiful paper scraps on the table and watch them scatter. I take close-up photographs, examining color and pattern combinations that happen by chance. This gives me ideas for a variety of color palettes and compositions. It also doesn't hurt if I have a cup of tea and a little dark chocolate nearby to get me in the mood to create.

Great Blue Heron | 14 × 11 inches; 2020 | Handmade and found papers, thread | Collaged, machine stitched

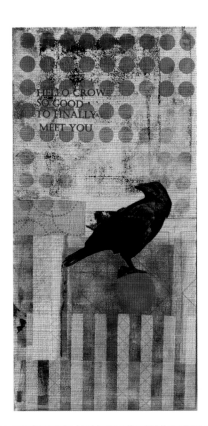

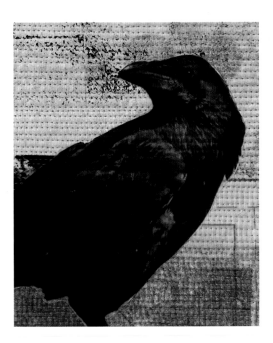

ANA BUZZALINO

Calgary, Alberta, Canada

Find your inspiration and concentrate on one technique at a time. Work with it and explore it until you are comfortable with it before you move on to something else. Even if you decide it was not what you were looking for, it will be another tool for the future. Start small and try to find the time and space to practice your art every day, even if it is for fifteen minutes. Creating a practice takes discipline.

I sometimes work in a sketchbook as a way to jot down ideas and create quick drawings. I have notebooks around me full of ideas and pieces of paper with lists: to-do lists and lists of techniques I want to try. I also paint, monoprint, and write on papers so that I have them handy for new work. I find that they are small enough and easy enough to work with, even if I have only a few minutes.

For as long as I can remember, I've loved ravens, crows, and seagulls. I have many books about them and make art honoring them. I grew up in a small seaside resort in the Buenos Aires province, and I would observe all manner of birds in the trees and at the beach. People disliked the seagulls because they would try to steal your food and beg for crumbs, but I found them fascinating and would pick up their feathers and take them home with me.

Hello Crow | 24 × 12 inches; 2021 | Fabric, paint, tissue paper, photo transfer, thread, wooden board | Collaged with monoprinted fabrics, stitched, painted, photo transferred

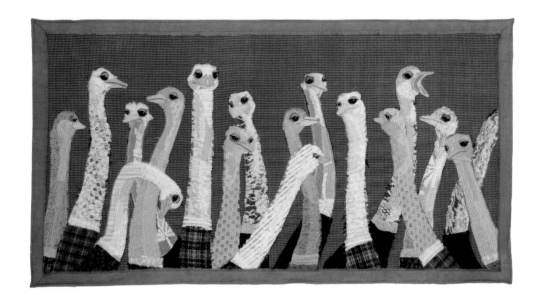

TRACEY CAMERON

Calgary, Alberta, Canada

Play, experiment, and don't be afraid to make bad art! Try a new technique, work with a new material, or explore a new subject matter. These shake-ups help us connect to our instincts and get us out of a judgmental state of mind.

I like to get out into the world and go thrifting. Because I use recycled textiles in my work, a trip to the thrift store expands my color palette and often inspires a new combination or idea.

I choose to celebrate the beauty in birds because I am endlessly fascinated by them. For a time, I focused mostly on large tropical birds such as flamingos and peacocks, but I've realized the beauty and mystery of common urban birds such as pigeons (see Pigeons and Doves gallery) and magpies. It's the curve of their necks, the graphic shape of their form, their strange movements, their ability to take flight, and their wildness.

Birds are simultaneously free and tame, beautiful and a pest, known and mysterious. It's this dualistic nature that I find so interesting. It allows me to explore the limitations and celebrations that we impose on wild creatures doing their best to flourish amid our chaos.

Ostriches | 27 × 35 inches; 2016 | Recycled fabrics, thread, leather, ribbon, paint | Raw-edge appliquéd, collaged, quilted, painted

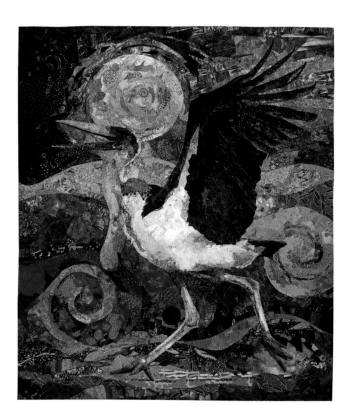

SUSAN CARLSON

Harpswell, Maine, USA

If you have an idea, pursue it and see where it takes you. The way I work in fabric collage began over thirty years ago with the desire to "paint" with fabric, and glue became the way I could apply my fabric to my "canvas." If I hadn't given it a try then, I wouldn't be where I am now in my artwork.

My subjects are frequently generated from pursuing interesting stories about animals. In January 2016, I read a story in *National Geographic* titled "Vultures—More Vital Than Vile," by Elizabeth Royte. She reminded me of the vital importance of scavengers and the threats they face in many of their habitats. The thought of a scavenger portrait coincided with a desire to create a quilt using only leftover (scavenged) material scraps from previous fabric collages—I had a new subject.

As I looked for a vulture photo to use as a reference, a running marabou stork caught my eye. I soon learned that marabou storks (*kaloli* is the Ugandan name) are also scavengers, the world's only carrion-eating stork. They're considered one of the world's ugliest animals and have a horrible disposition that can keep both vultures and hyenas at bay from a food source—all details that for me added to the story about scavenger birds.

Kaloli Moondance | 72 × 63 inches; 2016 | Fabric | Collaged, free-motion machine quilted | *Photo by Tom Allen*

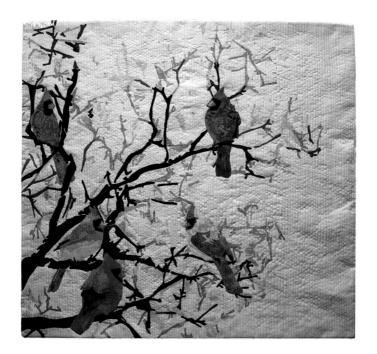

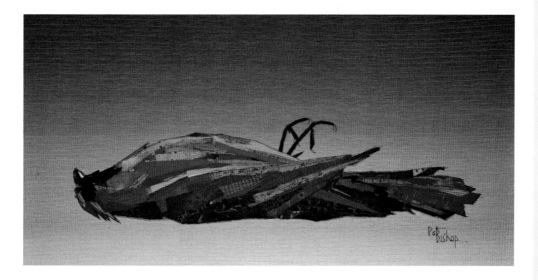

Top: Martha Wolfe | *Wild Life: Cardinals* | 34 × 41 inches; 2015 | Commercial prints, batiks, hand-dyed cottons, silk organza, hand-painted silk habotai | Fused, raw-edge appliquéd, machine quilted

Bottom: Pat Bishop | *Cardinal Down* | 15 × 30 inches; 2019 | Recycled, hand-dyed, and commercial fabrics | Fused, machine stitched

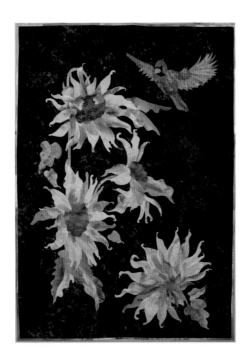

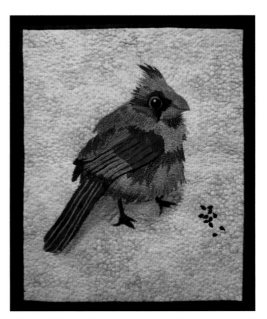

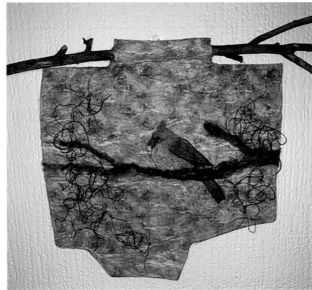

Top left: Jackie Berry | *Tempting Sunflower Seeds* | 60 × 43 inches; 2014 | Batik, paint, threads | Raw-edge appliquéd, painted, free-motion quilted

Top right: Dale Catherine McMillan | *Guest of Honour* | 18.5 × 26 inches; 2018 | Cotton, rayon, and polyester threads | Free-motion appliquéd, thread painted, free-motion quilted

Bottom: Susan Marie Ronchka | *Ms. Cardinal* | 10 × 12 × 0.5 inches, 2020 | Cotton, floss, threads, raffia, woods, wood branch | Thread painted, free motion machine quilted, embellished | *Photo: Ed Hoffman*

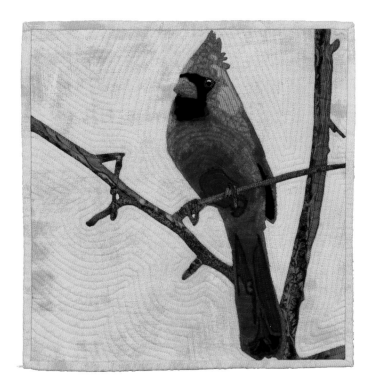

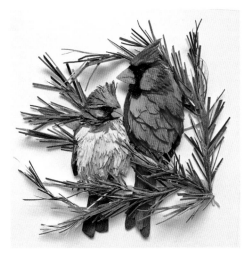

Top: Virginia Greaves | *The Cardinal* | 12 × 12 inches; 2014 | Cotton, fabric paint | Machine appliquéd, machine quilted, painted

Bottom left: Mita Giacomini | *She Sings* | 12 × 12 inches; 2020 | Wool, silk, cotton, and other natural and synthetic fibers | Surface woven

Bottom right: Sarah H. Suplina | *Cardinal Love* | 8 × 8 × 1.25 inches, 2020 | Painted watercolor paper | Painted, cut, assembled

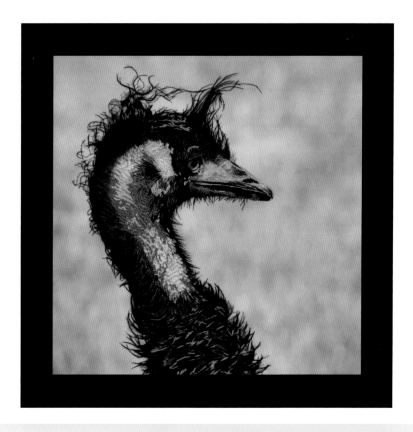

LISA CHARLES

Ranchester, Wyoming, USA

Enjoy learning new things. When you see something that interests you or that you like or dislike, think to yourself about how you could use it in a different way that will fit into what you are trying to achieve. Have fun doing what you feel like doing, and see what will develop by chance.

Birds are especially intriguing to me because they seem to have a superior attitude. They are colorful and humorous. *American Wood Duck* (in the Ducks gallery) caught my attention because of his beautiful colors. Then I noticed how curious and calm he was. It was as if he was asking me to take his picture. It brought back memories of my summers as a child at a lake in the north woods of Wisconsin. I love watching the wildlife.

When I saw my friend's photograph of an emu, I laughed out loud. Something about the look in her eye said that she really didn't care what anybody else thought about the way she looked. I wish I had that kind of confidence!

Bad Hair Day | 12 × 12 inches; 2015 | Cotton, threads | Thread painted using free-motion embroidery | *Photo by Teresa Garrett-Martin*

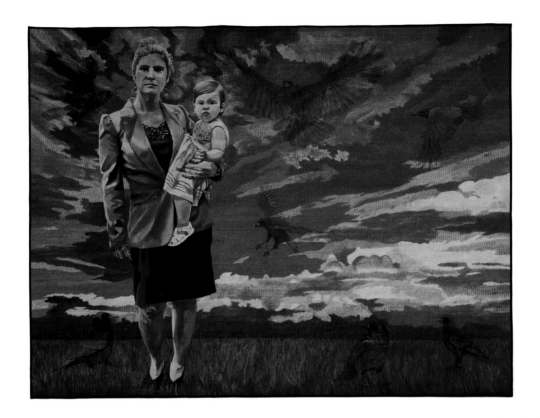

HOLLIS CHATELAIN

Hillsborough, North Carolina, USA

If you really want to grow as an artist, find a way to create every day. Find people who inspire you to make your own art. Risk making art that shows your voice. Find teachers that challenge you and encourage you to step out of your comfort zone.

My ideas come through dreams, visions, or just what happens in my life. Birds inspire me because they are smart, observant, and beautiful to watch. They teach us to notice things, and if we pay attention, they send us messages. I love all birds but seem to have regular encounters with crows, hawks, and owls.

Equality | 59 × 79 inches; 2019 | Cotton, dye, threads | Hand dye-painted, machine quilted | *Photo by Jason Dowdle—Blue Sky Digital Photography*

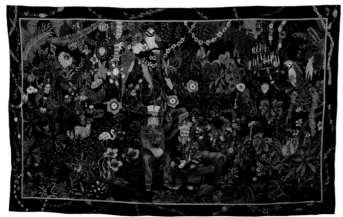

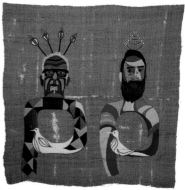

LEO CHIACHIO & DANIEL GIANNONE

Buenos Aires, Argentina

Observe nature. Look carefully. See the balance of color that exists in nature. We love birds because they represent freedom, and their fragile silhouettes are very beautiful. We are especially interested in representing the native birds that inhabit the jungles and mountains of Latin America.

Birds living in the wild are a critical part of *Familia en el alegre verdor* ("the family in the joyful greenery"). Green is synonymous with life, constant change, and renewal. Nature is "the great green," the most precious treasure that humans have in this world. We are its heirs, and we must work to create awareness of the importance of caring for it.

In Native American cultures, birds are seen as divine messengers of hope, transformation, and miracles. "Peace" is a tribute to the Chilean artist Violeta Parra and her work "Against the war" (1962). Embroidering on worn burlap references the tradition of Chilean burlap and the importance of the figure of the artist in the Latin American context. We portrayed ourselves with two doves in our hands. The doves symbolize peace. The flowers on our heads represent the soul.

Left: *Familia en el alegre verdor* | 46 × 78 inches, 2019 | Canvas, cotton, rayon, and wool threads | Hand embroidered | *Photo by: Nacho Iasparra*

Right: *Paz (Homenaje a Violeta Parra)* | 25 × 25 inches; 2016 | Burlap, cotton threads | Hand embroidered | *Photo by: Nacho Iasparra*

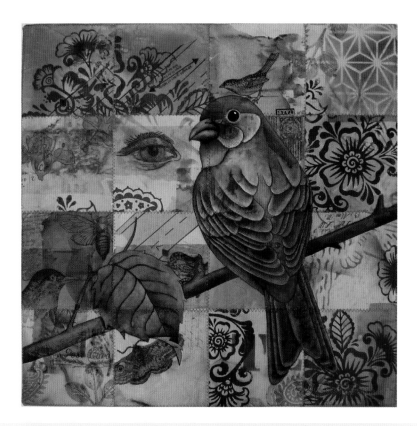

JUDY COATES PEREZ

Sacramento, California, USA

I think it's important to have perseverance and not to be afraid to take risks or make mistakes, because that's where you learn the most. If you enjoy the process, you'll keep doing it and your skills will improve with every additional hour you put in.

I often get my inspiration walking in nature and photographing things. I am completely fascinated with birds in all their shapes, sizes, colors, songs, and behaviors. While I often use photos of birds as references to get their pose and proportions correct, I don't always paint them in a realistic manner. I tend to simplify details and alter colors and patterns to create uniquely stylized birds.

Red Finch | 16 × 16 inches; 2014 | Cotton, tea bags, paper ephemera, paint sticks, acrylic inks | Stained, collaged, drawn, stamped, thermofax screen printed, painted, quilted

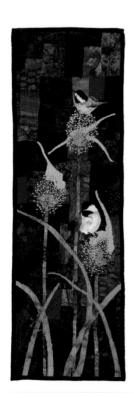
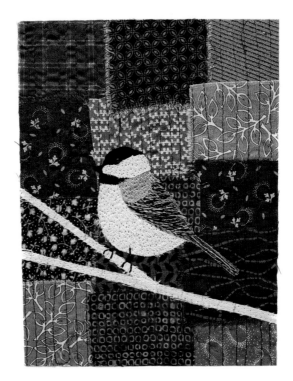
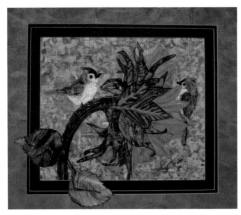
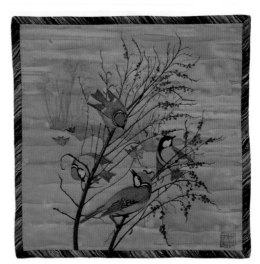

Top left: Doreen Prakshot | *Chickadees in Garlic* | 26 × 8.5 inches; 2019 | Batik, cotton, crochet thread, acrylic paint | Free-cut raw-edge appliquéd, machine stitched, painted, hand embroidered

Top right: Darcy Lynn Hunter | *Chickadee* | 10 × 8 inches; 2019 | Cotton, bead | Collaged, free-motion quilted, thread painted

Bottom left: Dolores Fegan | *Titmice on Sunflower* | 22 × 21 inches; 2019 | Hand-dyed and commercial fabric, confetti fabric, tulle, glue | Hand-cut confetti fabric sprinkled and captured under tulle, raw-edge appliquéd, thread painted, free-motion straight-line stitched | *Photo by Robert Catlin*

Bottom right: Aileyn Renli Ecob | *Titmice in Winter* | 12 × 12 inches; 2018 | Cotton, paints | Painted, machine appliquéd

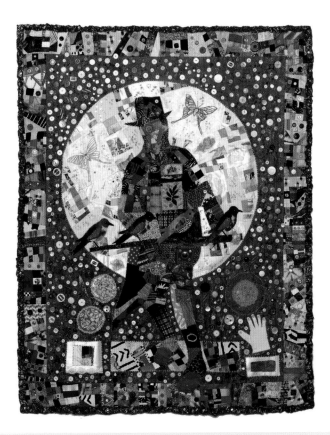

JANE BURCH COCHRAN

Rabbit Hash, Kentucky, USA

Don't be too critical of yourself. I always finish a piece, even if I don't like it, because a new idea will come to me as I'm working.

Write down all your ideas. People send me so many things, such as gloves, aprons, crochet potholders, and even baby dresses. I put them away but will use them at some point. I love to sew random patchwork together and may just do that to jump-start my creativity.

I live in the country on a hill, so I see lots of birds both flying and at our bird feeder. When I was young, I was frightened by birds, but now I love to see the turkey buzzards soaring with the wind. I used my first bird when I decided a quilt was getting "too soft and fluffy," so I added some flying blackbirds for contrast. I have used flying blackbirds several times because of their strong contrast in the design. I also have used perching birds for accent, detail, and mystery.

Moonlight | 77 × 61 inches; 2007 | Fabrics, recycled fabric items, beads, buttons, paint | Machine pieced, machine appliquéd, hand appliquéd using beads, hand embellished with beads and buttons, hand quilted and tied with embroidery thread

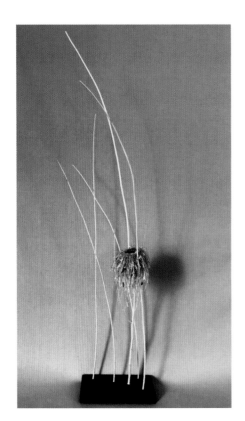

Detail

JUDITH CONTENT

Palo Alto, California, USA

Follow your instincts and enjoy the journey. Slowing down and letting my imagination fly is my way of jump-starting my creativity. This can happen when hiking, gardening, painting walls, and doing handwork such as embroidery or hemming.

I am inspired by the ability of birds to fly. Just imagine that! I am also inspired by their beauty, their songs, their nests, their eggs. I am amazed at their ability to migrate, to adapt to their environment, and to care for their young. Western bluebirds have feathers that are an out-of-this-world blue. I see these birds while hiking in the foothills of Northern California, and they never fail to amaze. I also love chickadees. These are the birds of my youth, growing up in New England. I loved their cheerful call, and the fact that they came to our bird feeder and sat on our fingers. I think that's a real memory. I certainly hope so.

Blush | 28 × 5 × 7 inches; 1996 | Various threads, fibers, yarn, wood, willow, painted acrylic leaves, polymer clay | Crocheted, knotted, painted, constructed

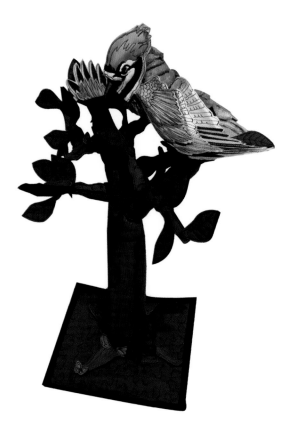

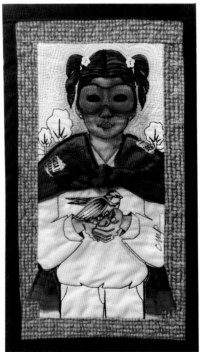

CAROLYN CRUMP

Houston, Texas, USA

Practice and try to learn something new every day. Never be discouraged if something doesn't turn out perfectly.

Nature always jump-starts my creativity. I love studying the graphic design of animals and plant life. When I was about three years old, we lived on the third floor of a triplex. Birds would build their nests so close to our balcony. I was always fascinated by them. I found peace and joy from watching them fly and feed their babies, and from studying the colors of their feathers.

Left: *Mr. Blue Jay* | 13.5 × 16 × 12 inches; 2020 | Cotton, string, felt, dye | Machine quilted
Right: *Super Hero* | 12 × 7 inches; 2018 | Cotton, felt, dye, watercolor paint | Machine quilted

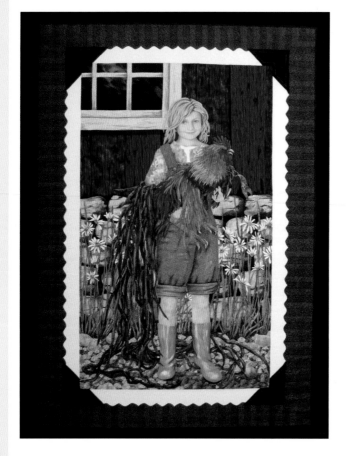
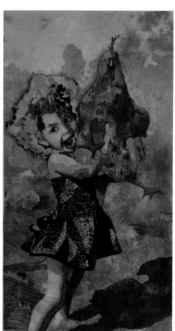

Left: Denise Havlan | *Shannon's Bantam* | 70 × 50 inches; 2009 | Cotton, denim, embellishments | Hand and machine appliquéd, machine embroidered, photo transferred, painted, machine quilted

Right: Marilyn Muirhead | *Barnyard Friends* | 45 × 25 inches; 2020 | Hand-dyed and commercial fabrics | Printed, quilted

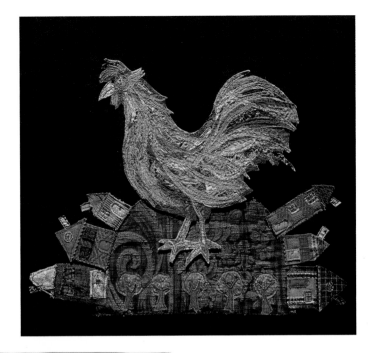

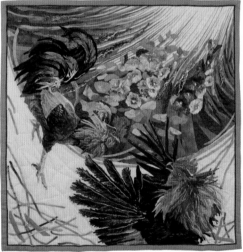

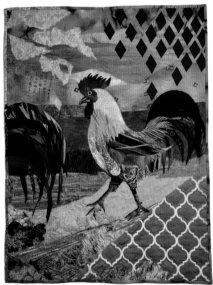

Top: Frances Palgrave | *Hen—Source of Life* | 16 × 20 inches; 2019 | Cotton, linen | Collaged, free-motion embroidered

Bottom left: Natalia Lashko | *Roosters* | 30 × 30 inches; 2021 | Cotton | Hand appliquéd

Bottom right: Tamar Drucker | *I Think I Know Where I'm Going* | 23 × 29.5 inches; 2019 | Cotton, ultra-suede, silk, yarn | Collaged, free-motion quilted

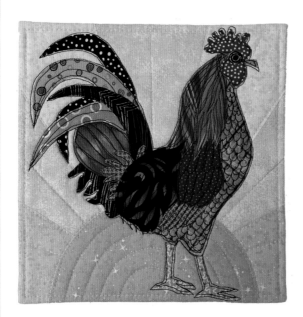

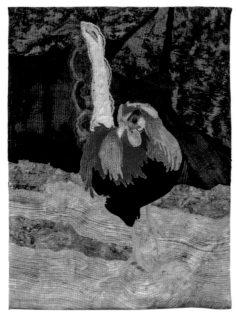

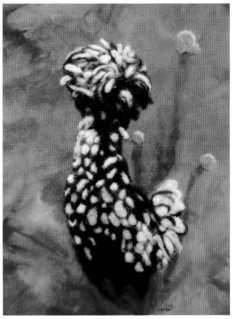

Top: Terry Aske | *Good Morning, Sunshine!* | 9 × 9 inches; 2017 | Commercial cottons | Fused raw-edge appliqué, machine quilted

Bottom left: Laurie Mutalipassi | *Kauai Rooster* | 16 × 12 inches; 2021 | Cotton, lace | Raw-edge appliquéd, machine quilted, painted, drawn | *Photo by Johanna Love*

Bottom right: Anna Marie Peterson | *Polish Chicken* | 14 × 11 × 0.5 inches; 2017 | Wool, wool roving | Hand needle-felted on a piece of hand-dyed wool

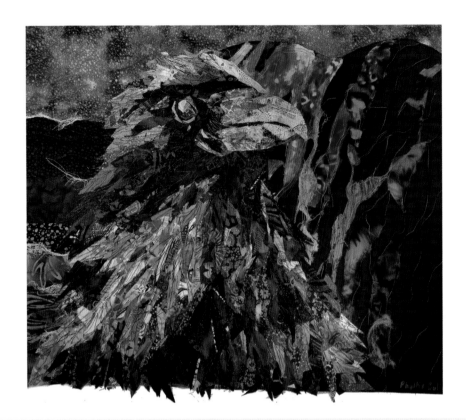

PHYLLIS CULLEN

Ninole, Hawaii, USA

Look at your surroundings and think about what inspires you. See what artwork captivates you. Learn techniques from as many teachers as you can, especially those dealing with your favorite subject matter, or whose work you admire.

Then, just start. Play with fabric, doodle, arrange, and rearrange. After a few acres of art creations, accept that it is a process, and when you start to create what's in your head, it will grab you, and you will join our ranks of addicted fabric artists.

Birds are a riot of sound, color, movement, and positive energy. Birdsong is so wonderfully assertive, with amazingly loud and happy sounds coming from such tiny creatures. Bird colors vary from softly blending to stridently defiant

of the colors in their surroundings. And those tiny bodies can fly, thousands of miles in some cases. Birds symbolize total freedom, curiosity, cheer, and hope.

I love them all, but local birds capture my heart. Some birds are revered by native Hawaiian culture, and I love to see them as aumakua, or ancestral guardians. The alala, or Hawaiian raven/crow, is extremely intelligent, can use tools, and is an aumakua I have chosen to depict in my work.

Alala at the Lava | 22 × 25 inches; 2020 | Commercial and hand-dyed cottons, cheesecloth, wool roving, perle cotton, poly threads | Dyed, collaged, free-motion quilted

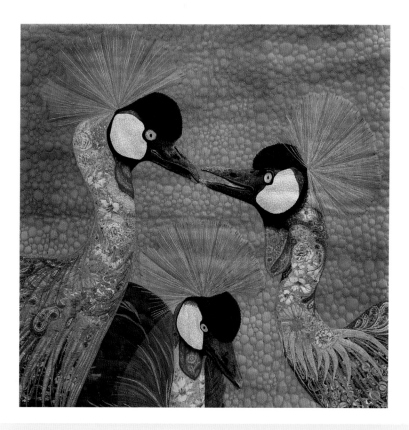

TILLY DE HARDE

Johannesburg, South Africa

We take our surroundings for granted because we see them every day, but look a bit closer and there is a whole world of life that we do not notice.

Play, try new materials and new techniques, and experiment all the time. Do not be too critical of yourself and do not compare your work to others.

I look at nature for inspiration in most of my work. Since I live in South Africa, it is easy to find this everywhere. The cranes of Africa are particularly inspiring to me, since so much of their habitation is being taken over by developing countries.

If I can make people aware of these beautiful creatures by taking part in exhibitions and by allowing my work to speak to the viewers, I hope that more people will become aware of the plight of birds and that it will awaken a carefulness about our fragile environment.

The beautiful texture of birds' feathers and wings lends itself to the techniques that I use to create my bird artworks. There is such a wide variety of textiles and threads that I have at my fingertips that are absolutely perfect to embroider the direction and texture of birds. Once I have decided what I want to create, I usually have to sketch the bird and enlarge it to the size that I want to work in. All I need to do then is to walk into my studio, audition some textiles and threads, and start working.

Grey Crowned Cranes | 27 × 27 inches; 2018 | Artist canvas, cotton, paint | Collaged, thread painted, free-motion machine embroidered and quilted | *Photo by Johann Harmse*

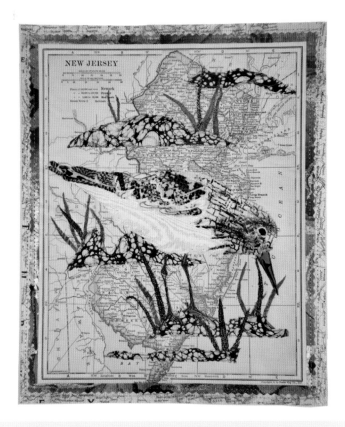

VIVIKA DENEGRE

Guilford, Connecticut, USA

Find joy in what you do. As Teddy Roosevelt said, "Comparison is the thief of joy," and perfectionism is not your friend. Pursue art for art's sake and take joy in every aspect of your work.

I find creativity by looking at photos, illustrations, and Audubon books about birds. When I pull all the information together, I compose the background of the bird collage. This often includes paper maps, painted fabric, and raw-edge appliqué.

I grew up in rural Maine, and although the chirping and singing of birds was a constant soundtrack of my childhood, I never paid much attention to them until I was an adult. It was my father's joy in watching the chickadees visit the bird feeder during his last few months that

got my attention. He set up a video camera and recorded several hours of this very docile scene through the living-room window. After he died, we found the recording. At first, I thought it was a mistake—he must have pushed "record" accidentally, because who would record hours of birds flying back and forth in their backyard? But soon I realized it was his way of sending me a message: notice the little things. Be aware of the beauty that surrounds you. And never forget that your father loves you and is with you always.

New Jersey Shore Bird | 12 × 10 inches (framed); 2018 | Vintage map, artist paper, fabric | Collaged, raw-edge appliquéd | *Photo by David Wright*

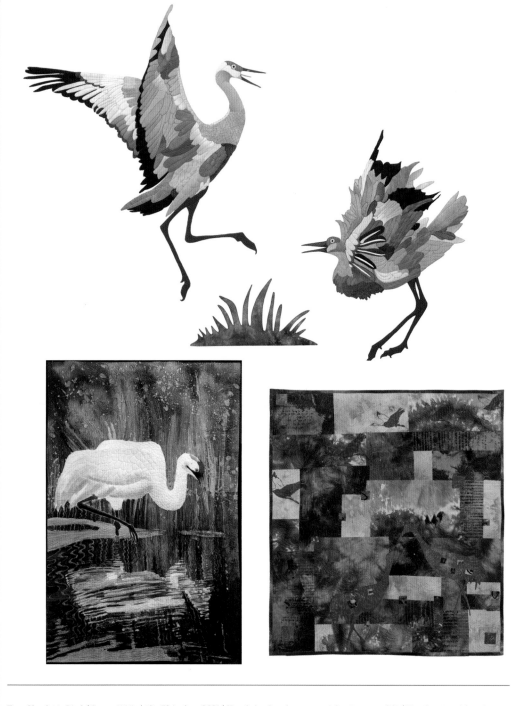

Top: Charlotte Bird | *Roy and Millie* | 43 × 72 inches; 2021 | Hand-dyed and commercial cotton, eco felt | Hand-cut and fused appliqué, machine stitched, machine quilted | Birds drawn from photos by Christy Yunker Happ with permission | *Photo by Gary Conaughton*

Bottom left: Judith Roderick | *Whooper Reflection* | 53 × 36 inches; 2014 | Silk | Painted, machine quilted

Bottom right: Bella Kaplan | *Courtship* | 34 × 31 inches; 2018 | Hand-dyed cotton | Dyed, screen printed, machine quilted, collaged, fused

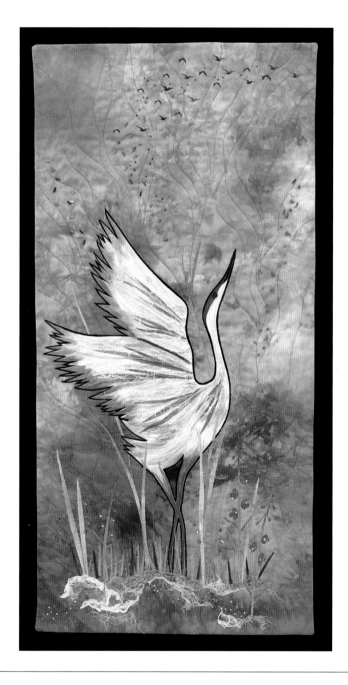

Nancy Dobson | *Ellen's Crane* | 33 × 16 inches; 2019 | Hand dyed and painted fabrics, cheesecloth, beads, thread | Dyed, painted, thermofax screen printed, appliquéd, beaded, stitched

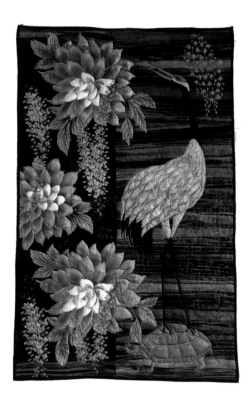

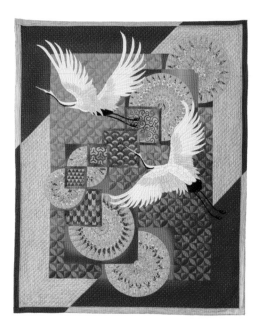

Left: Allison Avery Wilbur | *Lifelong Friends* | 51 × 29 inches; 2018 | Kimono, commercial cotton, paint | Drawn, painted, stamped, longarm quilted

Right: Misako Sano | *Together* | 59 × 47 inches; 2020 | Cotton | Hand pieced, quilted, appliquéd, and embroidered | *Photo by Nobuo Honma*

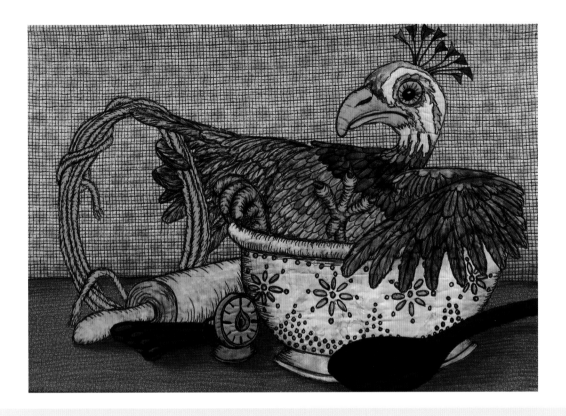

RHONDA DENNEY

Emporia, Kansas, USA

Experiment with tools and techniques until you find something that resonates with you. Dare to be yourself. We each have a creative voice, one that is unique. Do not compare yourself with others; look only at your own journey of discovery.

Have fun and explore! Take your time and be patient and forgiving of lessons learned. I learn something from every piece I create.

I am always inspired by photographs, a moment caught in time. I love the challenge of re-creating subjects in my fiber art. I want to create a piece that invites tactile confirmation of the textures and form, as well as their spirit.

Birds are one of my favorite subjects because there is so much character in their movement and expressions. Each type of bird provides a different set of motivators. I love birds with distinctive attributes that I can accentuate.

CLUE—Mrs Peacock in the Kitchen with a Rope | 21 × 30 inches; 2019 | Cotton | Pigments on fabric, raw-edge appliquéd, free-motion stitched | *Photo by Michael Arterburn*

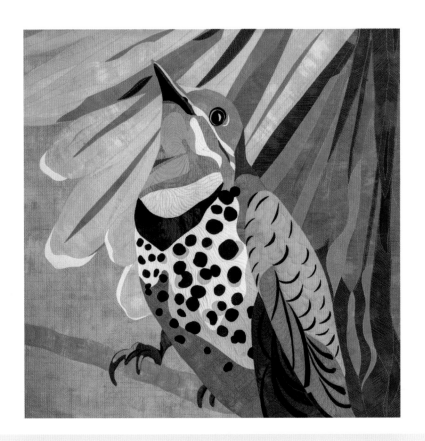

LINDA DIAK

Chester, Vermont, USA

I'm just starting to make art myself! My advice is to listen to what causes your heart to flutter, notice what makes your spirit soar, and ignore the noise of those who say what one must or cannot do. I read the books and watched the videos, but I found most of the means of construction were too rigid, too detailed for me. I took a bit of knowledge from each, gathered supplies, and just started.

Bird feathers, the gleam in their eyes, and their personalities all spark my imagination. I love them all. Capturing wild plumage is certainly fun, but I especially enjoy their demeanors and the challenge of finding ways to portray that.

Edgar (in the Tropical Birds gallery) came to me while I was working on another piece. I stopped what I was doing and worked up a sketch. But like all my pieces, he evolved into a very different bird than the one I had drawn. *Yellow Shafted Northern Flicker* was made by request. I was given the option of the flicker or a tree, so of course I went with the bird. There were size restrictions, so to keep the bird large enough for expression but also to show his tail feathers, I placed those feathers behind him, as if from another bird.

Yellow Shafted Northern Flicker | 34 × 34 inches; 2021 | Cotton | Raw-edge appliquéd, free-motion quilted

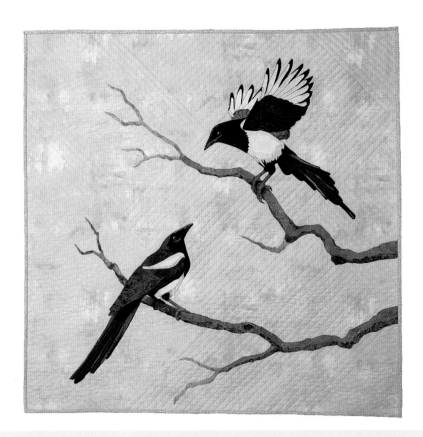

MARIAN EASON

Moab, Utah, USA

Go with what you feel is right for you, and don't be afraid to experiment. I started out making traditional quilts. I have an art background, and I finally followed my instinct to do something different, to be more original with my designs. I always have ideas floating around in my head, but I find that being issued a challenge gives me the push I need to get started.

I am amazed at the variety of species in the bird kingdom, from the smallest hummingbird to the largest raptor. I am a longtime birder and have come to appreciate the colorful feathers that span the color spectrum, behaviors that show adaptation to specific environments, and vocalizations that can be raucous or soft as a whisper.

I live in the American Southwest. Black-billed magpies are common here, and I enjoy watching their antics and their cautious investigation of something unfamiliar. Raptors are common here also, and they are majestic in their behavior. One of my most memorable and enjoyable experiences was when I was asked to release a golden eagle back into the wild.

Mischief's Afoot | 33 × 33 inches; 2019 | Cotton | Fused raw-edge appliqué, machine quilted | *Photo by Nick Eason*

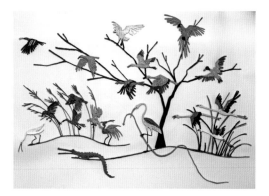

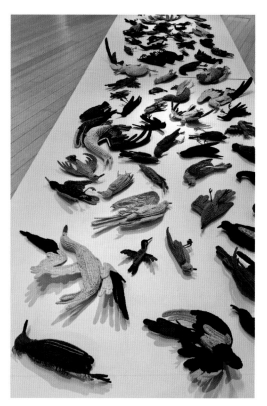

CAROL ECKERT

Tempe, Arizona, USA

Coiling is a time-intensive process, and I spend long days in the studio. I've always tried to work every day. In the beginning, when I had consuming family and work responsibilities, that time was sometimes just thirty minutes before everyone else woke up, but it kept me focused. My "studio" was often a corner chair, but I just kept going, finding time and space wherever I could.

Today my studio is a refuge filled with books—art history books, volumes of mythology and poetry, antique editions of Aesop's Fables—manuscripts filled with the stories humans have recounted since ancient times as they tried to make sense of their world. These are the stories that find their way into my work, not as specific narratives, but as references to the connections between people across continents and centuries, and to the natural worlds they inhabit.

These ancient and mysterious tales have more recently given way to influences from seventeenth-century paintings of dead game, eighteenth-century cabinets of curiosity, and nineteenth-century natural-history museums, tracing a history of humankind's dominion over nature that has implications for our current times.

Left: *Valley of the Quest* | 43 × 62 × 3.5 inches, 2015 | Cotton, linen, wire | Coiled | *Collection of the Mesa Contemporary Arts Museum*
Right: *Memento Mori: The 100 Dead Birds Project* | Dimensions variable | Cotton, linen, wire | Coiled

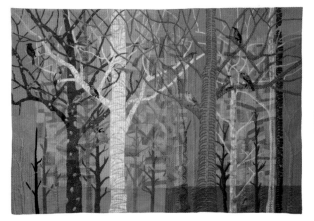

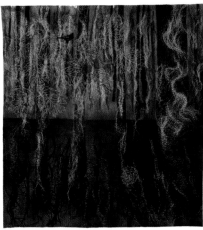

NORIKO ENDO

Setagaya-ku, Tokyo, Japan

Enjoy! Keep working on making the art you want. If you like a certain color, such as purple, then keep using that color. Or if you like a certain pattern, then use it, modifying it in your own way.

I love to walk in the woods, looking at the birds singing, listening to the fallen leaves whispering, seeing the dappled light, and enjoying the changing color of the seasons.

The landscape serves as my inspiration, and it comes alive when I add birds. I love paintings that include birds. Their feathers come in so many amazing colors.

I had been making landscapes for many years, and I wanted to make those landscapes more romantic, more idyllic. Adding birds to the trees gave me the emotional, symbolic, beautiful elements that my art needed. When I paint the birds, I imagine them flying through the woods or resting on the branches of the trees.

Left: *Birds* | 53 × 77.5 inches; 2015 | Silk, cotton, wool yarn, silk flakes, polyester threads, paints | Machine pieced and quilted, painted, machine embroidered, hand embroidered, machine couched | *Photo by Yuji Nomura*

Right: *Birds Play with Silver Threads* | 50 × 48 inches; 2021 | Hand-dyed cotton, sheep leather, metallic threads, polyester yarn, tulle, acrylic paints | Layered fabrics and spread silver threads covered with tulle, machine quilted, painted | *Photo by Yuji Nomura*

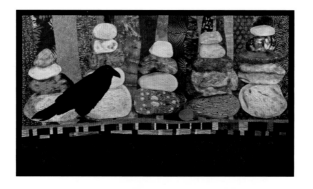

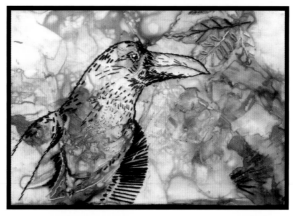

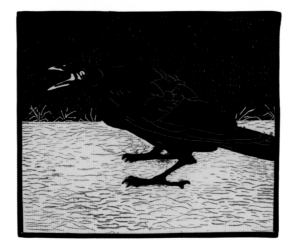

Top: Mary Arnold | *Rockin' Raven* | 24 × 42 inches; 2015 | Hand-dyed and commercial fabric, batiks | Painted with ink, appliquéd | *Photo by Mark Fry*

Center: Rickie Seifried | *Raven Eco Dye* | 8 × 10 inches; 2011 | Eco-dyed paper, cotton thread | Hand stitched

Bottom: Hanneke Reinalda-Poot | *Screaming Bird* | 14 × 18 inches; 2020 | Cotton, silk, paint | Drawn, painted, machine stitched | *Photo by Donald Reinalda*

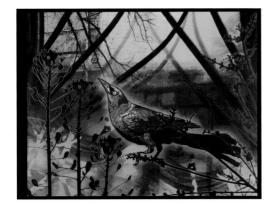

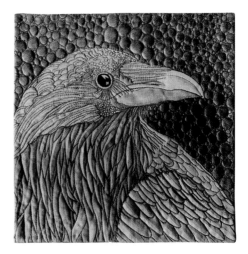

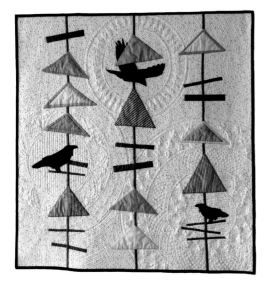

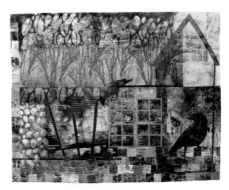

Top left: Diane Rusin Doran | *Return of the Grackle* | 39.5 × 51 inches; 2010 | Silk, rayon threads | Digital collage printed on silk, free-motion machine quilted

Top right: Susan Brubaker Knapp | *Raven in Green* | 11 × 11 inches; 2021 | Cotton, paint | Printed, whole-cloth painted, free-motion quilted

Bottom left: Joanne Marie Allen | *Birds on the Wire* | 40 × 39 inches; 2019 | Riley Blake fabrics | Machine and raw-edge appliquéd, machine quilted

Bottom right: Bobbi Baugh | *Entering Untold Stories* | 37 × 47 inches; 2021 | Hand-painted and hand-printed fabrics, acrylic paints | Painted, collaged, machine stitched

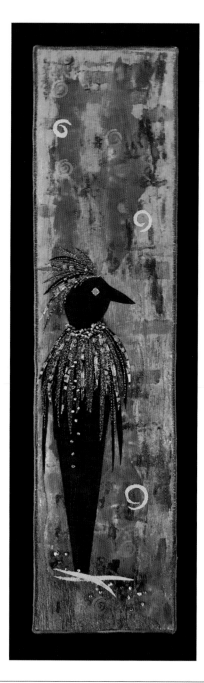

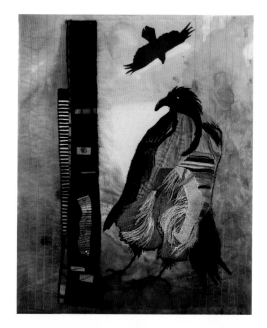

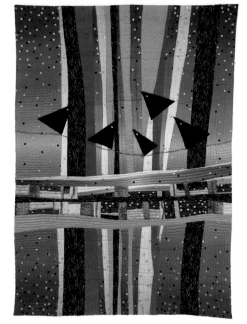

Left: Nancy Dobson | *Raven Dance* | 19.75 × 5 × 2 inches; 2019 | Painted canvas, commercial cottons, thread, beads | Painted, appliquéd, stitched, beaded

Top right: Susan Strickland | *Shape Shifter* | 20 × 16 inches; 2020 | Hand-dyed silk, copper, beads, cotton | Metalworked, hand dyed, beaded, thread painted | *Photo by Darrell Strickland*

Bottom right: Albert Cote | *Singing Choir* | 36.5 × 26.5 inches; 2020 | Commercial fabric, metal beads | Curved piecing, raw-edge appliquéd, machine quilted

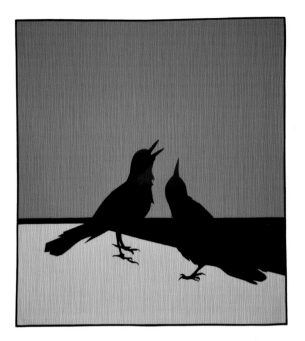

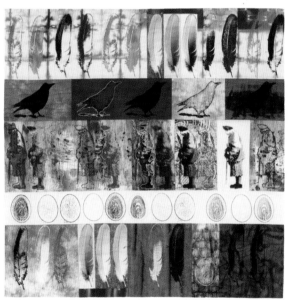

Top: Joanne Alberda | *Winter Birds at Water's Edge* | 43 × 39 inches; 2020 | Commercial and hand-dyed cotton | Pieced, collaged, machine stitched

Bottom: Linda Colsh | *Amazing Grace* | 40 × 40 inches; 2008 | Cotton, silk | Dyed, painted, printed, machine pieced and quilted

Photo by Pol Leemans

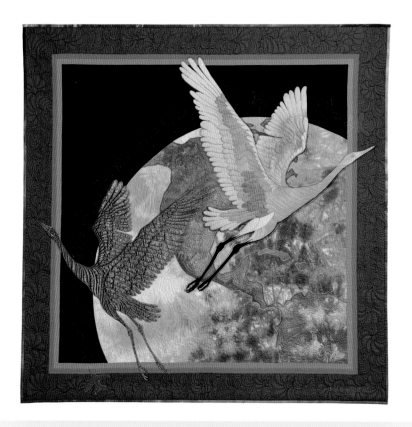

CARYL BRYER FALLERT-GENTRY

Port Townsend, Washington, USA

If you have too many ideas and don't know where to start, pick the one that looks like the most fun to make. Try at least three variations before you settle on a final design.

In most of my bird quilts, I start with a simple sketch or even just an outline of the birds, usually in pencil, then scan them into my computer and play with various arrangements and backgrounds. Once I have several variations, I start having preferences, and the design develops from there.

Because I spent so much of my life in the sky, first as a flight attendant and then as a traveling quilt teacher, sky and flight have often found their way into my visual vocabulary. To me, flying without the aid of an airplane seemed like it would be the ultimate feeling of freedom. I have also found that birds find their way into my work at times of major life changes.

I'm especially attracted to egrets and cranes because of their grace and beauty, so I have used them in my work more than other species. In most of my quilts, the birds are abstract, with the species intentionally ambiguous, because the birds represent life events.

Farewell to the Silver Bird | 48 × 48 inches; 1997 | Cotton | Hand dyed and painted, machine pieced, appliquéd, and quilted

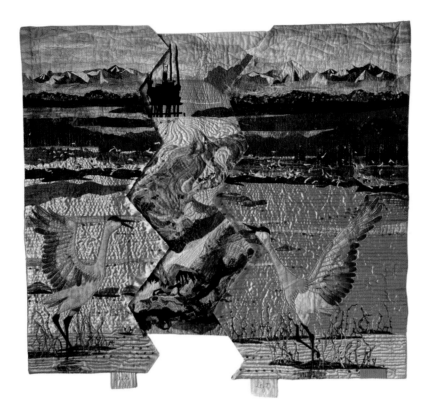

LAURA FOGG

Ukiah, California, USA

Just do it! Have fun. Dive in and play with your materials and see what happens, and let go of the outcome—remember that even the most-famous artists create an awful lot of pieces that never make it to galleries.

My hardest challenge is to focus on one clear image, theme, or message at a time instead of going crazy with too many started projects. My head is swimming with ideas that I want to express through my art, but there is never enough time or energy to do it all. That's okay.

I use birds in my art because they are free in a way that humans can never be. Birds have wings that give them the power to escape predators and travel enormous distances to worlds, real and imagined, that humans can rarely visit. We see birds as messengers: their presence, absence, or condition gives us insight into the health of our surroundings, and they function as a harbinger of things to come.

Precarious Balance | 43 × 51 inches; 2019 | Commercial and hand-dyed cottons, satin, cheesecloth, novelty trims | Raw-edge appliquéd, freehand machine quilted

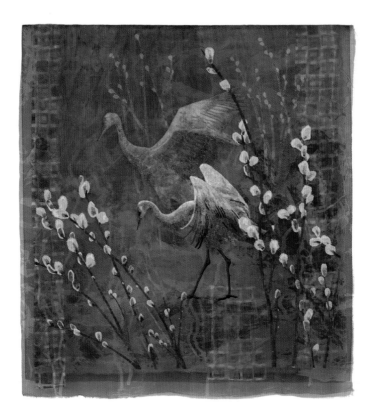

KARIN FRANZEN

Fulton, Missouri, USA

Experiment. Have fun. Take risks. Be curious. But also master your techniques so that your "craft" is the best quality that it can be.

I enjoy all of nature, but I am particularly tuned into birds. When getting a degree in biology, I took an ornithology course during which I spent many, many hours studying birds, including spending just about every one of my Saturdays out in the field. In the wee hours of the morning, I would head out to the lakes, fields, and sloughs; come back for lunch in the cafeteria; then go back out for an entire afternoon in the city parks and cemetery. It's that very intimate knowledge of birds and their behavior and habitat preferences that informs my artwork.

This series was inspired by the spirited dance of sandhill cranes and features their graceful acrobatic movements. When all nine pieces are viewed as a series, they depict the sequential movements of a single adult male crane jumping and whirling through an ever-changing seasonal context. The use of multiple layers of loosely draped sheer fabrics produces the ethereal environments as shapes, patterns, and colors interact.

A Time to Dance—April 28th | 47 × 44 × 2 inches; 2008 | Silk organza, fabric dye | Dyed, silkscreened | Photo by Eric Nancarrow

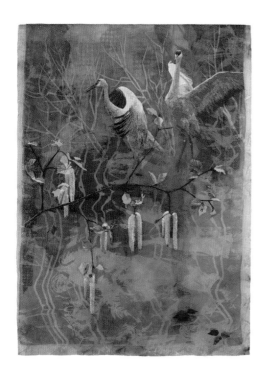

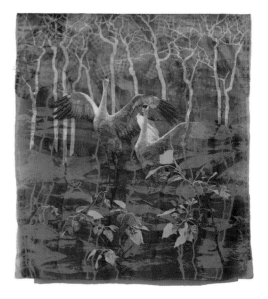

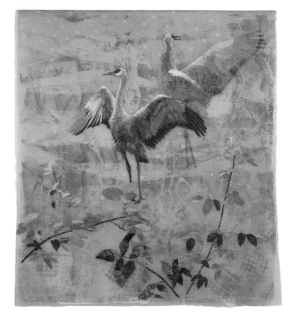

Top left: *A Time to Dance—May 17th* | 60 × 43 × 2 inches; 2008 | Synthetic sheer fabrics | Machine appliquéd | *Photo by Eric Nancarrow*

Top right: *A Time to Dance—June 6th* | 53 × 49 × 2 inches; 2008 | Cottons | Free-form quilted and stitched | *Photo by Eric Nancarrow*

Bottom: *A Time to Dance—June 21st* | 49 × 45 × 2 inches; 2008 | Used clothing | Hand embroidered | *Photo by Eric Nancarrow*

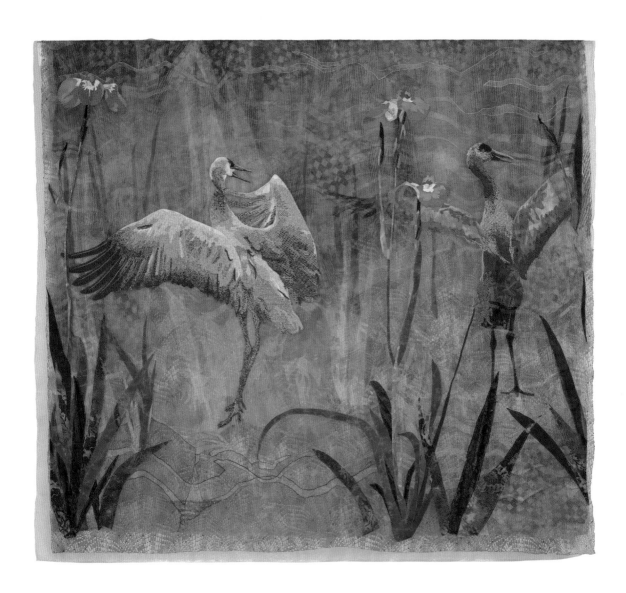

A Time to Dance—July 2nd | 42 × 48 × 2 inches; 2008 | Hand-dyed cotton, embroidery yarns and threads | Stenciled | *Photo by Eric Nancarrow*

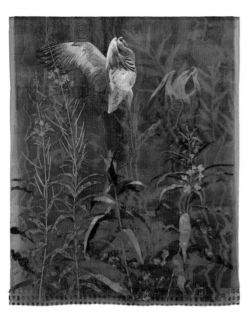
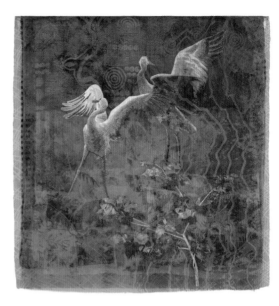
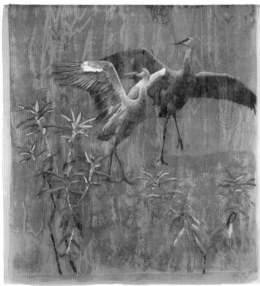
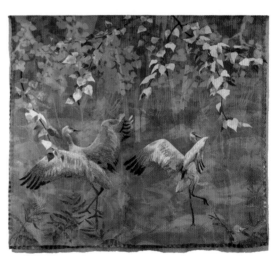

Top left: *A Time to Dance—July 19th* | 52 × 43 × 2 inches; 2008 | Synthetics | *Photo by Eric Nancarrow*

Top right: *A Time to Dance—August 4th* | 46 × 43 × 2 inches; 2008 | Fabric paints | *Photo by Eric Nancarrow*

Bottom left: *A Time to Dance—August 16th* | 46 × 43 × 2 inches; 2008 | *Photo by Eric Nancarrow*

Bottom right: *A Time to Dance—September 9th* | 48 × 55 × 2 inches; 2008 | *Photo by Eric Nancarrow*

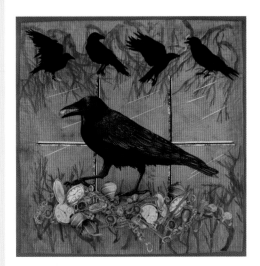

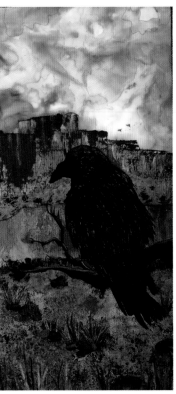

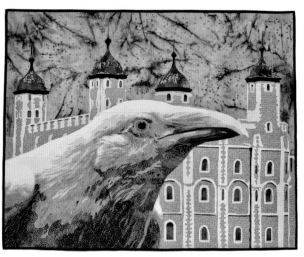

Top left: Susan Fletcher King | *Jacob's Treasures* | 40 × 40 inches; 2015 | Cotton, inks, paint, threads | Painted, raw-edge appliquéd, machine stitched and quilted | *Photo by Rick Wells*

Top right: Mary Pal | *Something to Crow About* | 12 × 12 inches; 2019 | Cheesecloth, paint | Sculpted cheesecloth mounted on painted, stretched canvas

Bottom left: Kathleen Malvern | *Raven's Watch* | 24 × 12 inches; 2019 | Fabric, dye, acrylic paint, thread, sponges, sand medium | Dyed, painted, stamped, thread painted, machine quilted

Bottom right: Virginia Greaves | *The White Raven* | 32 × 40 inches; 2013 | Cotton | Machine appliquéd and quilted | *Photo by Mike Yip*

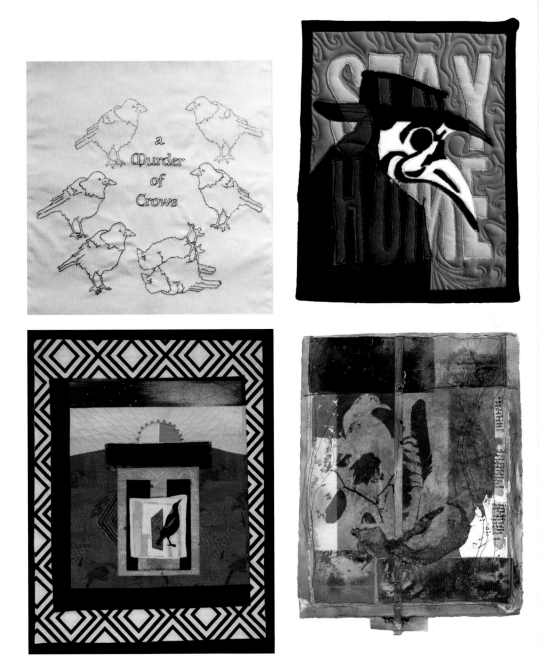

Top left: C. Jacqueline Venus | *A Murder of Crows* | 21 × 21 inches; 2019 / Cotton | Stitched

Top right: Audrey Hyvonen | *Stay at Home* | 12.5 × 10 inches; 2020 | Cotton. | Collaged, machine stitched

Bottom left: Joyce Paterson | *She Sings Her Song* | 24.5 × 19.5 inches; 2017 | Cotton | Fused, pieced, appliquéd, free-motion quilted

Bottom right: Wen Redmond | *Whispers of the Positive* | 30 × 23 inches; 2010 | Inkjet prints, cyanotype, silk organza, cheesecloth, watercolor paper, ink drawings, mediums | Hand-pulled print, monoprinted, collaged, sewn, painted, layered

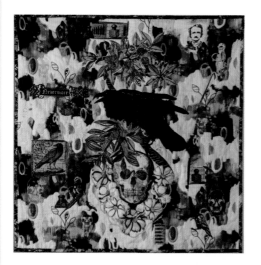

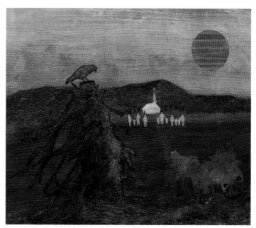

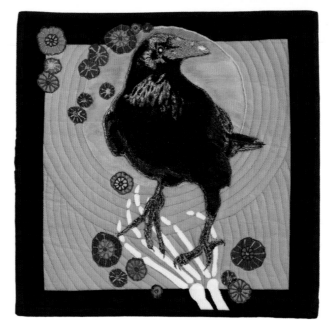

Top left: Sheryl LeBlanc | *Edgar, Audubon & Me: A Tribute to the Mischief Maker* | 36 × 36 inches; 2015 | Commercial fabric, silk ribbon, pleather, metallic-wrapped fibers, plastic eye | Silk-ribbon embroidered, appliquéd, screen printed | *Photo by Jon Meyers Photography*

Top right: Valerie Cecilia White | *First Sunday* | 25 × 30 inches; 2019 | Evolon, paint, markers | Monoprinted, painted, appliquéd, thread painted | *Photo by Wes Magyar*

Bottom: Sharon Mehl | *Soul Seeker* | 15 × 12 inches; 2020 | Cotton, organza, paint | Machine embroidered, appliquéd, painted, machine quilted

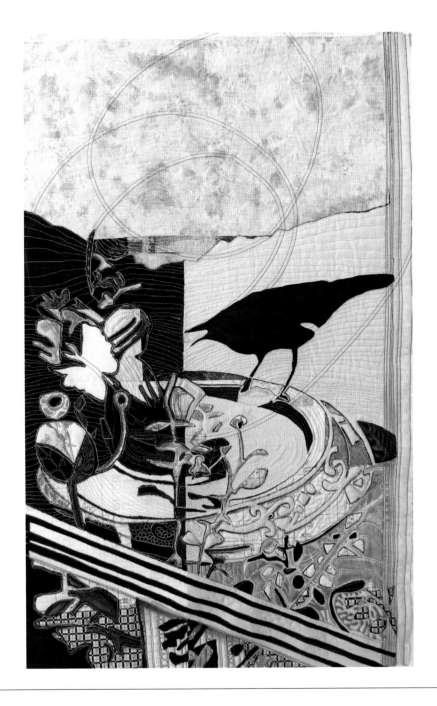

Debra Goley | *Truth or Consequences* | 40 × 25 inches; 2017 | Hand-dyed and commercial fabric, paint | Drawn, reverse appliquéd, painted, free-motion quilted

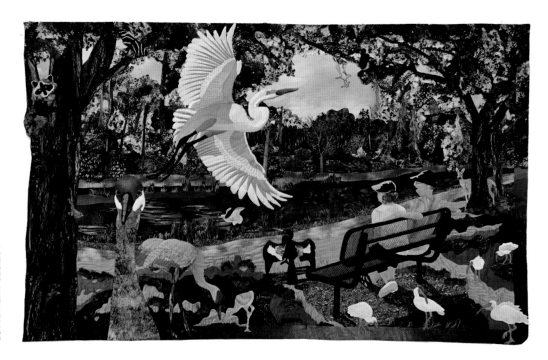

JEAN FREESTONE

Osprey, Florida, USA

Immerse yourself in information about art. Give yourself some TLC (Take Lots of Classes), attend quilt shows, read quilting books and online sites, join a guild and a cottage group. These are baby steps to building your "toolbox." You should find out if this interest is sustainable since you will spend time and money in your art. Is this your joy?

Two of my joys have been finding a community of quilting friends and discovering my favorite quilt topics. I create better alone, but friends encourage. The wildlife around me, particularly birds, gives me a focus and inspiration.

To me, birds are beautiful survivors. They span the globe and have been around since the days of the dinosaurs. They have learned to live with people in all our environments. Now that I am retired and living in Florida, I find that the birds that land on my quilts are the easily identifiable ones I often see from my window, while kayaking, or walking near waterways. One of my favorites, the sandhill crane, often finds its way onto my quilts.

My awareness of our feathered friends also extends to those endangered. I hope that my quilts inspire people to protect all these free spirits of the sky!

Timeshare at the Blue Bench | 37.5 × 61 inches; 2021 | Commercial cotton, silk, beads, speciality yarn, netting | Turned-edge hand appliquéd, raw-edge appliquéd, reverse appliquéd

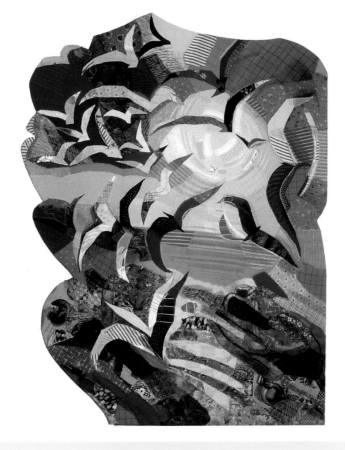

LESLIE GABRIËLSE

Rotterdam, Netherlands

Emerging fabric artists need to realize that even today, textiles are considered a craft and not accepted by most art galleries as high art. There are exceptions to this rule, but it has been slow to change.

My choice of fabric as my material, because of its tactile element, goes back to my training at the Art Academy in Rotterdam: fabric was used there as a visual material similar to the use of oil paint. Fabric has continued to be my preferred art medium throughout my seventy-year career as an artist, both in my work and also in commission assignments from individuals and companies.

I like to start with a small pencil sketch with indications of color in watercolor. For commissions, the presentation sketches are painted with more details. The total piece is sewn by hand, but acrylic paint sometimes helps me give parts of the details more volume.

When depicting birds, I generally have no preference for any particular species. The finches (shown in the Finches gallery) are the exception. I have admired them for quite some time when flying in and out of their food net. I took the time sitting on a chair with camera at hand and watched them up close. Then as a presketch, I made a photo collage of their different movements.

Birds in the Wind | 97 × 72 inches; 1994 | Fabric, thread | Collaged, hand stitched

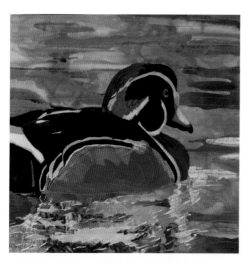

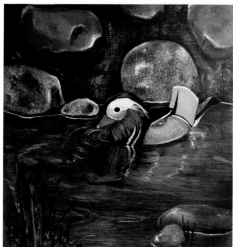

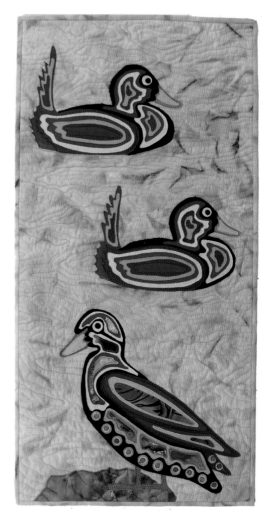

Top left: Barbara Yates Beasley | *Alix* | 12 × 12 inches; 2017 | Commercial and hand-dyed cotton, silk, acrylic paint, art markers | Raw-edge fused appliqué, free-motion stitched

Right: Irene MacWilliam | *3 Ducks* | 24 × 12 inches; 2016 | Cotton, paint | Painted, layered appliqué, free-motion stitched

Bottom left: Sue Holdaway Heys | *Peking Duck* | 35 × 35 inches; 2014 | Cottons, watercolor pencils, paint, thread | Fused, painted, quilted

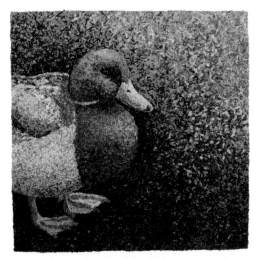

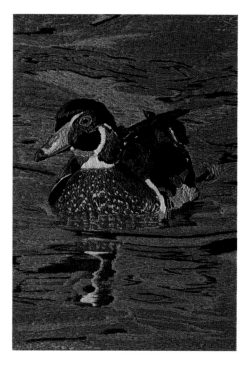

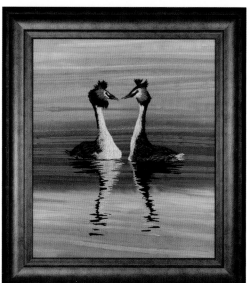

Top left: Mita Giacomini | *Hey* | 20 × 20 inches; 2020 | Wool, silk, cotton, and other natural and synthetic fibers | Surface woven

Top right: Lisa M. Charles | *American Wood Duck* | 10 × 7 inches; 2017 | Cotton, thread | Thread painted using free-motion embroidery | *Photo by Gregory Case Photography*

Bottom left: Angela Knapp | *Reflected Love* | 20 × 17 inches; 2020 | Fabric, paint, plain and variegated cotton threads | Layered, fused, painted, free-motion embroidered, stitched

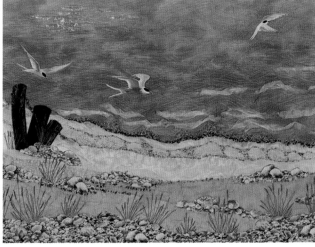

Detail

GINA GAHAGAN

Bozeman, Montana, USA

We're all creative beings. The talent within us just needs nurturing and feeding—with our time, thought-fulness, and work. Be creative every single day, even for short periods of time, to fan the flames.

I spend considerable time meditating on what inspires me. As I meditate, I turn over in my mind how to showcase that inspiration—a common occurrence often has un-common details. I coax a story out of those details, creating a narrative that becomes a jump-off point.

Birds are inspiring on many levels: from their hardiness in extreme, unimaginable environments to their amazing adaptations, they live, thrive, and rise to extreme challenges worldwide.

Humans have always revered birds, assigning attributes, special powers, and personalities to them. Birds are characters in our legends and in the sayings we have. Their personalities become our personalities. I find our stories about them fascinating. I'm intrigued that humans keep returning to birds as a channel for self-expression.

The Longest Journey | 55 × 24 × 0.5 inches; 2019 | Cotton, canvas, sheer polyester, beads, chain, grommets, paracord, acrylic paint, ink, water-soluble colored pencil | Appliquéd, fused, hand sewn, drawn, painted, hand embroidered, couched, thread wrapped, beaded, machine quilted | *Photo by Deidre Adams*

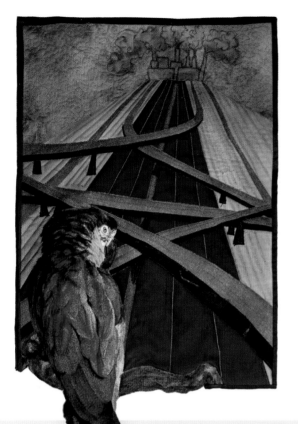

JAYNE GASKINS

Reston, Virginia, USA

Expose yourself to as much art as you can find. And read a wide variety of materials. I cruise the internet, libraries, galleries, and museums for interesting works by other artists. I find it impossible not to get excited by fresh new approaches in any art medium.

Most paleontologists believe that birds are living dinosaurs—or rather their much-smaller descendants. If this is true, you have to respect any species that survived an asteroid strike and massive volcano eruptions and then managed to evolve over sixty-six million years to thrive in a wide variety of habitats. But will they survive us? We've wiped out and paved over natural habitats, such as parts of the Amazon rainforest, leaving many species endangered. Can they adapt to belching factories and city life?

They Paved Paradise | 35.5 × 14.5 × 0.5 inches; 2021 | Cotton, sheers, paint | Thread painted, machine quilted, trapunto quilted, appliquéd, painted

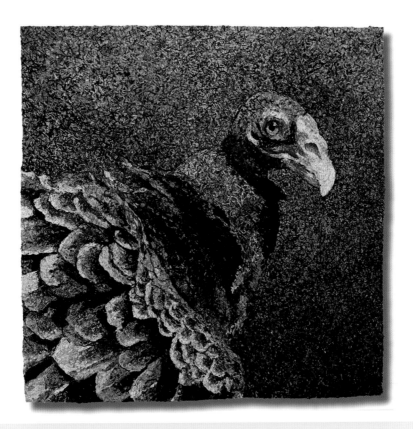

MITA GIACOMINI

Dundas, Ontario, Canada

Carve out daily time for your artwork, no matter how meager or fractured the time is. Show up in your studio, however you're able to define that space. You may start with only an hour a day at a card table and, in a few years, end up doing almost nothing else—like me—so be careful what you wish for.

I've learned over the arc of a lifetime to feel lucky in the presence of a bird, not just an unusual one but also—and sometimes especially—an ordinary one. From a design and artistic standpoint, vultures have it all: texture, color, rhythm, balance, contrast, and more. They carry visual and symbolic weight. I love the way they fold and unfold those great wings in strange, intriguing ways: a bit like origami, a bit like a dance.

At our local raptor center some years ago, I watched a presentation on turkey vultures, met one up close, and fell in love. The piece *Constant* is a portrait from that encounter. Beyond an artistic response, I hope that respectful depiction may encourage conservation of this important species. They transform rotting carrion into magnificent wings spanning 6 feet. They glide for hours with barely a flap, riding invisible currents in the sky.

Constant | 31 × 31 inches; 2019 | Wool, silk, cotton, and other natural and synthetic fibers | Surface woven

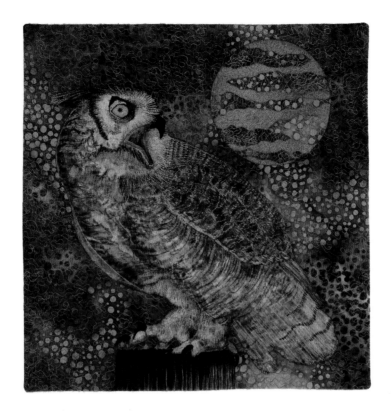

SUZANNE GILBRIDE

Cypress, Texas, USA

Jump in, make mistakes, try again, start over, sew over, rip out if needed. I've done it all. I'm teaching myself not to be perfect, and to let go of perfection, which can stifle your creativity.

I love birds, always have. I can spend days just watching and photographing birds. I'm newish to the world of quilting, and I have been thrilled to try different techniques on my bird quilts. All birds inspire me; I find them beautiful and interesting. I like to tell a story with their eyes, expression, and body movements.

My inspiration for *Whoo Goes There???* was from the idea that owls are hunters. They hunt at night, with powerful eyesight and strong talons and beaks, and they are rarely seen during the day. I tried to capture all of that in my quilt.

Whoo Goes There??? | 20 × 19 inches; 2018 | Fabric, cheesecloth, oil paint sticks, markers | Rough-edge appliquéd, thread painted, painted

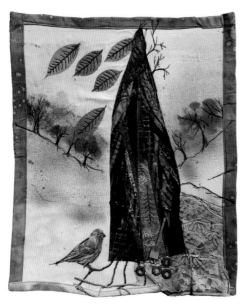
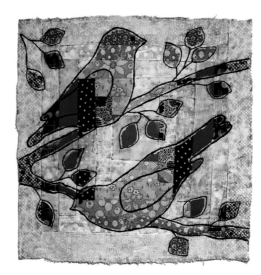
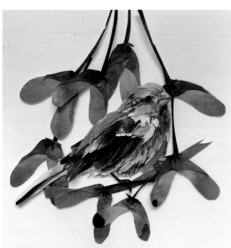
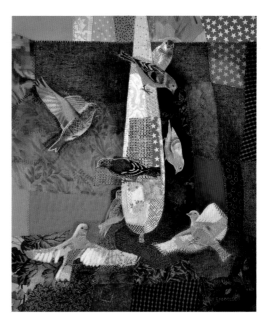

Top left: Darlene R. Bayley | *It's MY World* | 20 × 16.5 inches; 1997 | Cotton, peltex, organza, batiks, zipper, paper leaves, embellishments, twine, rayon thread, lace, candle-waxed batik | Dyed, batiked, stained, painted, couched, fused, stitched

Top right: Helene Kusnitz | *Happy Together* | 10 × 10 inches; 2020 | Vintage quilt block, gesso, cotton thread, beads | Painted, machine and hand stitched

Bottom left: Sarah Suplina | *Rosy Housefinch* | 8 × 8 × 1.25 inches; 2020 | Watercolor paper | Drawn, painted, cut, layered, assembled

Bottom right: Leslie Gabriëlse | *Finches* | 40 × 34 inches; 2011 | Fabric, thread, acrylic paint | Hand-stitched textile collage, painted

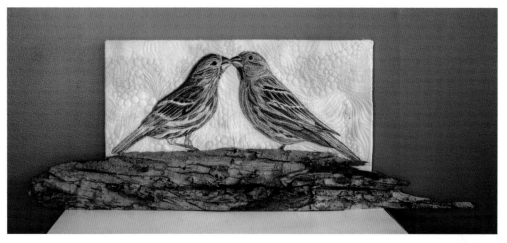

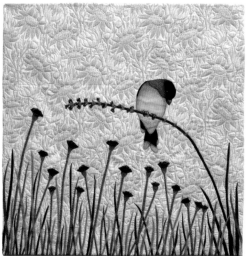

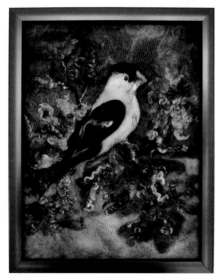

Top: Krista Zeghers | *Finch Kiss* | 10 × 24 inches (freestanding); 2019 | Commercial fabrics, inks, threads, tree bark | Hand painted, trapuntoed, machine stitched, mounted on tree bark

Botton left: Nanette Zeller | *Contemplation* | 36 × 36 inches; 2020 | Commercial cottons, watercolor pencils | Fused appliqué, free-motion quilted and stitched, colored

Bottom right: Karen Hull Sienk | *Goldfinch* | 14 × 11 × 1 inches; 2020 | Wool roving, curly-locks wool | Dry and wet needle felted

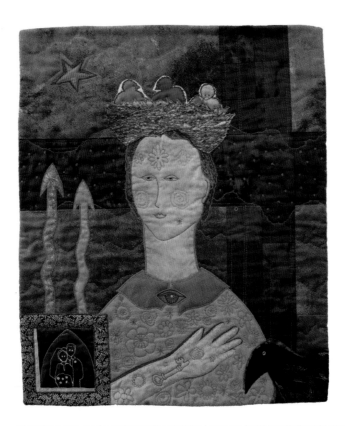

CLAIRE GIMBER

Scottsdale, Arizona, USA

Be a constant observer of nature and other artists' works. Always find time to devote to creating. Express what you see and what moves your passion. Completing your own work will teach you a lot, so keep busy making art.

I have a large collection of pictures from magazines, newspapers, and an online storage of images that I constantly add to and update. When I need a spark to get started on a new piece, I often refer to my pictures.

During our cold New England winters, my mother would always feed the birds that came to our yard. When I see birds, I'm reminded of my mother who died when I was thirteen. I remember her in my artwork through birds that I know she loved. Since birds and symbols are important to me in my artwork, I incorporated them into my self-portrait. Especially significant in the piece are the three stylized bluebirds of happiness pictured on the top of my head, which represent my three daughters, who are always on my mind.

Self Portrait | 20 × 17 inches; 2011 | Cotton, paint | Raw-edge appliquéd, free-motion stitched, painted

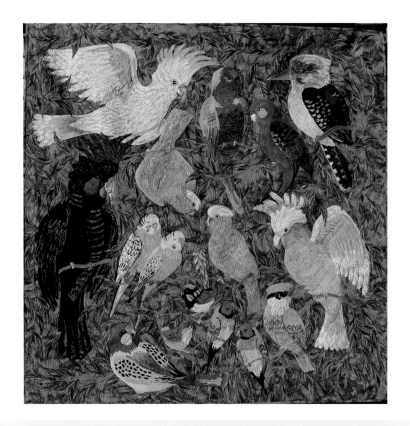

HELEN GODDEN

Canberra, Australian Capital Territory, Australia

Run with your passion.

I have been an artist all my life and began quilting at age thirty-eight. I am an extreme free-motion machine quilter (EFMMQ), and I am thrilled to have been awarded many times for my innovative quilts, both internationally and nationally. I am so lucky to travel and teach and share my love of quilting far and wide. My goal is to "Educate and Inspire" all quilters as they launch into the world of possibilities that is art quilting.

Australian birds are unique and the most diverse and colorful in the world. They are a part of our everyday life, even in the capital city of our country. We see the flashes of color as they dart through the trees and across the skies. We hear them every day as they herald in the morning or respond to the weather, as they fly home as the sun sets, or as they warn us if we are too close to their babies. They are colorful and free; they mean HOME to me.

Ornithology of Oz | 76 × 76 inches; 2015 | Cotton, paint | Hand painted, free-motion quilted

TAMI GRAEBER

Tucson, Arizona, USA

Just start! You need a beginning to change and work with. My finished project is never close to my first attempt.

The inspiration for *Hunter's Bounty* was trifold. I grew up with a Victorian still life that still hangs in my ninety-four-year-old father's house, and I wanted to do a replica of that frame. It was quarter-sawn oak, so I used wood grain fabric, turned it at an angle, and painted in highlights. Even the blackened patina designs on the frame are to the correct scale. I'm also a longtime collector of antique china. The platter is based on a nineteenth-century design of black transferware. And last, my husband owns a duck and goose refuge next to a pheasant club, so we see these

birds often. This actual pheasant was to be served for our meal, but a photo of his beauty was captured first.

I started *Tiles, Tapestry and a Teal Tail* as a response to a call for an entry for "New Traditions in Textiles," which asked for a wall hanging using unique materials and techniques. I used faux leather, textile-painted Talavera-style tiles, and a thread "painted" center peacock. Wool yarn was couched to accentuate the borders, and a heavily beaded edge sets it off.

Left: *Tiles, Tapestry and a Teal Tail* | 46 × 33 inches; 2020 | Cotton, leather, paint, yarn, embellishments | Thread painted, painted | *Photo by Vallejos Photography*

Right: *Hunter's Bounty* | 32 × 53 inches; 2017 | Cotton, muslin, paint, beads | Both raw- and turned-edge appliqué | *Photo by Vallejos Photography*

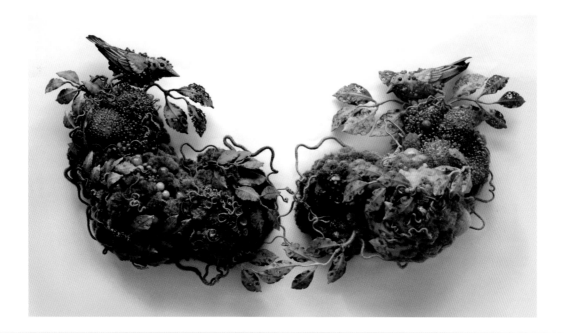

AMY GROSS

Delray Beach, Florida, USA

The closer your work gets to revealing what life is like for you, the more individualistic and interesting it becomes. You let other people see the world through your particular eyes, and that's a gift.

Ideas can come from a long walk, from something I read the night before, from drawings and notes I wrangled in my sketchbook, from some wonderful picture I've seen or place I visited. The best way to start is to bring your collections of experiences and inspirations into the studio with you and then just put in the time. It doesn't always translate, it doesn't always work, but it often works just enough, and that's what you build on.

As a very little girl I often woke up before sunrise, and I would lie there in my bed in the dark uncertainty, waiting for the sky to lighten. Just before the first suggestion of dawn, minutes before that earliest lavender light, the birds would begin to rustle and sing. It felt as if the sparrows were opening up the world for me, singing me into a new day of the ordinary and the surprising and the magical. Later on, they taught me about other aspects of life, including the end of it. I first witnessed loss from the passing of my pet, a bright-blue parakeet named Freddy, and I learned about the hard lessons of nature from the birds I found, folded and still, under backyard trees.

Blue Warbler, Yellow Warbler | 9.5 × 20 × 4 inches; 2018 | Embroidery thread, yarn, beads, paper, wire | Appliquéd, couched, quilted

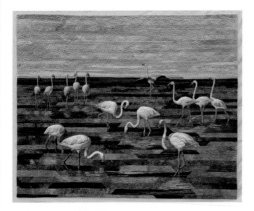

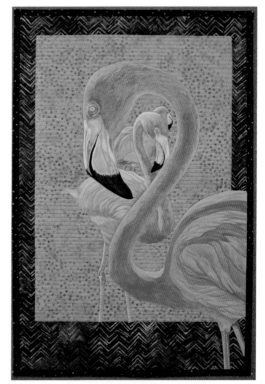

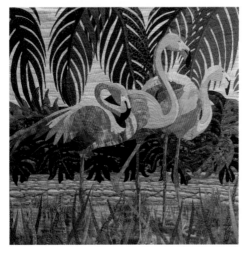

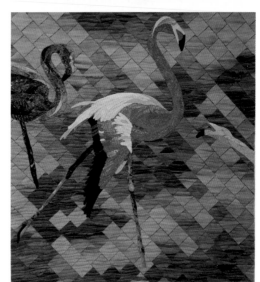

Top left: Ethelda Ellis | *Freestate Flamingos* | 31.5 × 39.5 inches; 2019 | Hand-painted, hand-dyed and commercial cottons | Pieced, raw-edge appliquéd, free-motion quilted and embroidered

Top right: Christine Holden | *Perspective in Pink* | 36 × 24 inches; 2019 | Cotton, batik, sueded polyester, paint, fabric pens | Painted, fused, free-motion stitched, quilted

Bottom left: Denise Oyama Miller | *Florida Flamingos* | 35.5 × 35.5 inches; 2010 | Fabric, thread | Raw-edge appliquéd, machine quilted

Bottom right: Madelyn Bell | *But I Raised Them All the Same* | 35.5 × 32 inches; 2018 | Batiks, netting, pigma pens | Raw-edge and turned appliquéd

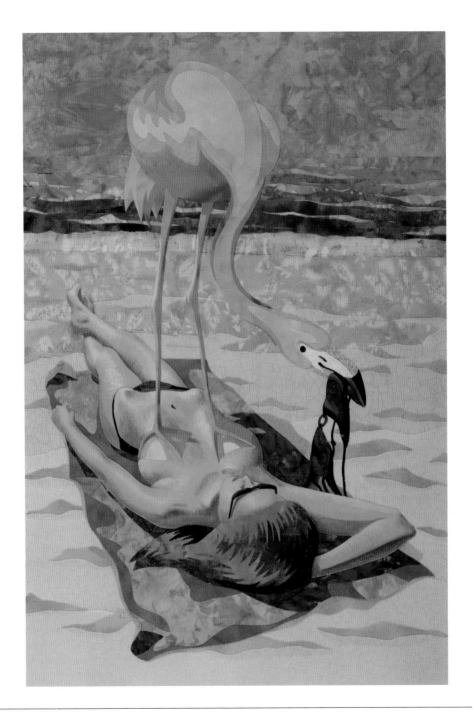

Kestrel Michaud | *Florida Beach Patrol* | 24 × 18 inches; 2009 | Cotton, paint | Fused raw-edge appliquéd, painted

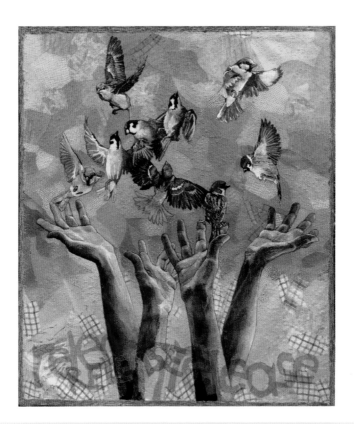

KATHRYN HARMER FOX

East London, Eastern Cape, South Africa

Learn to see by learning to draw. Embrace your mistakes, because they are your greatest lessons. Your successes will feed your ego (and often pay your rent). Your failures will teach you how to solve problems, paving your path to future success.

Imagine being able to lift your arms, take a little jump, and fly. You could flit through the tall grasses, soar over the ocean, or drop into the space between mountains. You would be able to build a house from mud and spit, sticks and twigs, or woven grass.

Everything inspires me about birds. I sit on my back stoop, drinking my early-morning coffee, and they arrive with the sun from all around. I have removed birds from the mouth of my smug, killing cat and soothed their racing hearts with the warmth of my cupped hands. I have raised these naked, pink, all-beak, food-demanding groundlings into feathered, chatty flying machines. Although each has its own uniqueness, I particularly like the mottled brown patterning and opportunism of the common mossie; I like the flash of acid yellow of the dexterous, argumentative finch, and I love the clumsy flap landings of the fruit-gorging mousebirds.

Release | 47.5 × 39.5 inches; 2019 | Dress and quilting scraps, snippets of netting, watercolor pencils, pens, markers, threads | Drawn, painted, free-motion machine embroidered, quilted

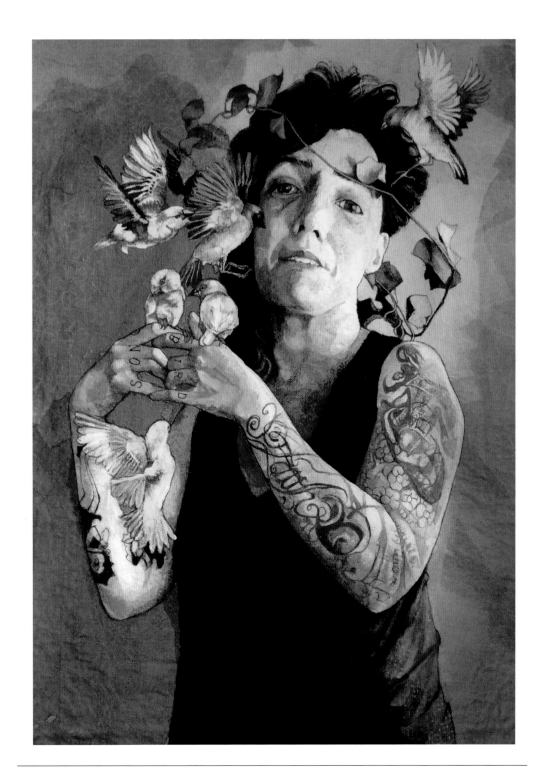

Song Bird | 51.25 × 39.5 inches; 2021 | Dress and quilting scraps, snippets of netting, watercolor pencils, pens, markers, threads | Drawn, painted, free-motion machine embroidered, quilted

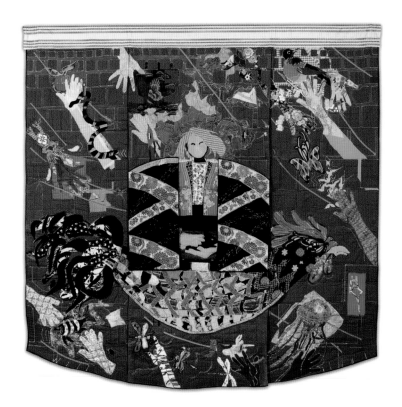

HENRY JAMES (JIM) HAY

Takasaki-shi, Gunma, Japan

Just start. Don't make a sketch. If you have all the ideas in your sketch, there is no reason to make it. It's done. That sketch becomes fifteen minutes of creativity followed by months of labor. I don't like labor. I want every minute to be creative.

Forget about techniques and craftsmanship. Too many art schools teach from technique lessons. Don't shape your "self" to techniques. Address ideas. Say what matters to you. Learn a technique when *you* need it to complete your idea.

There was no *High Sea* when I started, only that blue face. I liked it, added some green hair, a shirt, a vest. Let's make sleeves that can be raised to reveal tai chi traits. Find the ideas *as you make* the artwork. Hey, a rooster boat and hands that flutter like water.

High Sea | 85 × 85 inches; 2003 | Kimono, obi, recycled clothing | Drawn, machine sewn, appliquéd

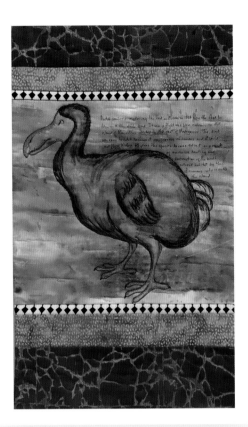

DOROTHY RAMSAY HEIDEMANN-NELSON

Lincoln, Nebraska, USA

Don't be afraid to fail. You can't create something unique if you feel that every endeavor must be successful.

Imagine what it must be like to have a body that can fly. As a young child, I remember learning about the whooping crane being on the brink of extinction, with only twenty-three birds remaining. Through conservation efforts, their number is now more than eight hundred. That is an amazing achievement.

The dodo bird was not so fortunate. In 1598, Dutch sailors documented the flightless bird endemic to the island of Mauritius, just east of Madagascar. However, excessive hunting and destruction of the bird's natural habitat resulted in it becoming extinct within sixty-five years. The dodo bird appeared in *Alice's Adventures in Wonderland* along with the drawings by John Tenniel two hundred years later and resulted in the dodo bird becoming an icon for extinction.

Dodo Bird | 20 × 12 inches; 2019 | Cotton, watercolor pencils, aloe gel, paint, ink | Painted, inked, thread painted, quilted

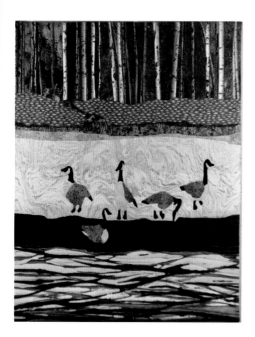

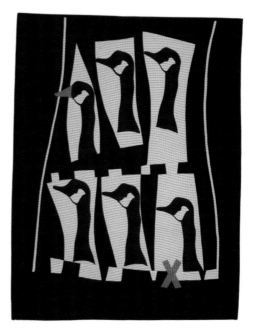

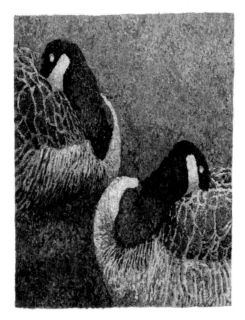

Top left: Alice Marie Magorian | *Frozen Lake* | 22.5 × 20.5 inches; 2019 | Cottons, hand-dyed fabrics | Collaged, machine appliquéd, machine quilted

Top right: Christine Seager | *No More* | 32 × 26 inches; 2015 | Hand-dyed and screen-printed fabric, felt | Screen printed, pieced, machine quilted | *Photo by Nick Seager*

Bottom: Mita Giacomini | *Repose* | 26 × 20 inches; 2020 | Wool, silk, cotton, and other natural and synthetic fibers | Surface woven

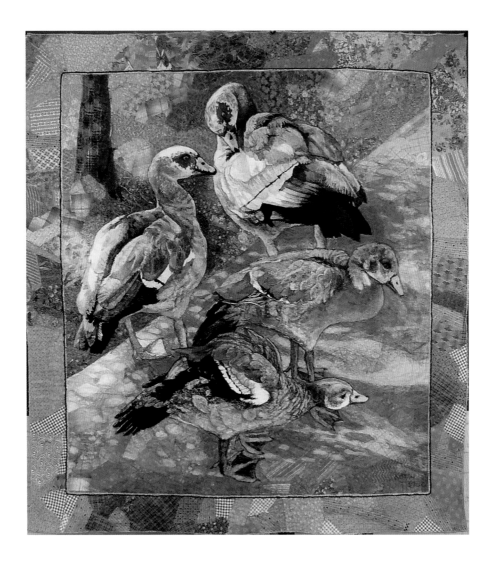

Kathryn Harmer Fox | *The Egyptian Goose Family* | 53.5 × 49 inches; 2017 | Dress and quilting scraps, snippets of netting, watercolor pencils, pens, markers, threads | Drawn, painted, free-motion machine embroidered, quilted

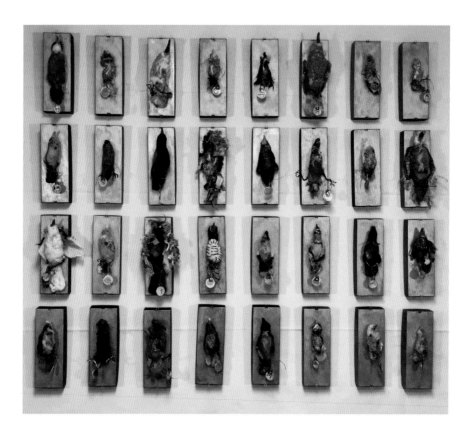

ANNIE HELMERICKS-LOUDER

Warrensburg, Missouri, USA

Trust yourself. Let your muse be the wonder of ordinary circumstances, dreams, memories, and all the variations between realism and abstraction.

I love all birds but am particularly interested in the ones living in my current environment. Birds are living records of days and nights spent under open skies. I am guided by my belief of Nature as a sacred presence that connects me with all other things. I seek awareness—my own and others—looking for ways to speak simply and sincerely. As such, birds are an important, recurring part of my imagery.

In a short time, perhaps twelve thousand years, the actions of our species have changed the trajectory of our planet. Our actions have been so profound that we are said to be entering the Anthropocene era, defined by global mass extinctions of species, deforestation, climate change, and acceleration of rising carbon dioxide levels and sea levels. More and more species, essential living links, have been severed from the chain of the land's diversity. For our sake as well as Nature's, we must make reconciliation.

Requiem for the Birds | Dimensions variable; 2020 | Sculpture

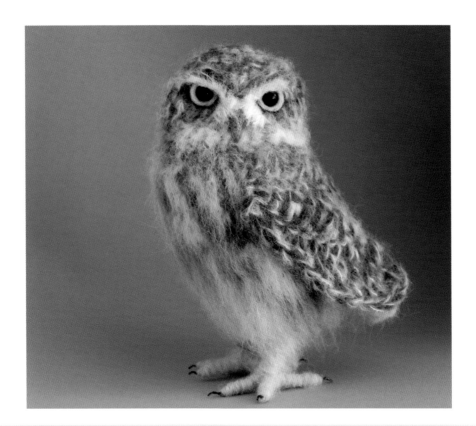

JOSE HEROYS

Haywards Heath, UK

Don't be afraid to try things out and to make mistakes; have a play and see where it takes you. Research your market to find out who will buy your products and where to sell them. Keep the faith by charging what you need to earn a living from your work. If you can, find someone with experience to give you advice and encouragement.

I have always loved birds and feel a special connection with them. I think they offer us an emotional link with nature that can help us slow down and reconnect with the natural world. As an enthusiastic birder, I spend a lot of time watching birds and try to use what I see to make my birds as lifelike as possible. For me, this means capturing their sense of aliveness, humor, and character.

Recently, I have started using my art to help raise awareness of endangered birds. In the UK, there is a list of vulnerable birds known as "Red List" species, whose populations have dramatically reduced in recent years. I have started making these birds and find that people are really interested in the story behind them and the reasons for their decline.

Little Owl | 6.75 × 4 × 5 inches; 2019 | Alpaca, merino, Shetland, mohair, and silk yarns; wire; semiprecious black agate beads for eyes | Crocheted, embroidered, needle felted

JANINE HESCHL

Vienna, Austria

"Fill in the Form." I read that in Julia Cameron's The Artist's Way, *and it has helped me so much during those unavoidable days of low inspiration and motivation. Just do one thing every day toward the goal you have set for yourself. Clean your desk, sort your threads, order new fabric, write that artist statement, apply to that call for art. It keeps the ball in the game, and no matter how small that action was, you filled out another part of that form to reach success.*

My greatest and only source of inspiration is nature! I get lost in the infinite beauty of animals. The closer I get and the more I zoom in, a world of its own unfolds right in front of my eyes. I am fascinated by the countless details that unveil themselves, trying to explore each and every one as meticulously as possible. My infatuation with the magic of the discovery of features helps me understand the nature of an animal and lets me connect to its being on a deeper level. You start with the rawness of what your eyes pick up at first—a silhouette, a pattern, a shape, and as you move in closer, the eyes adjust to absorb the softness in the details: texture, gradients, symmetry, reflections. I feel an overwhelming urge to translate what I see into thread.

Left: *Bird 'n' Bones* | 12 × 12 inches; 2016 | Poly-cotton fabric, batiks | Collaged, free-motion quilted, embroidered
Right: *Bob* | 8 × 8 inches; 2020 | Inktense pencils, poly-cotton fabric | Free-motion quilted, embroidered

Detail

MAGGY ROZYCKI HILTNER

Red Lodge, Montana, USA

Make art about what you care about. Use processes that feel good to you. Do at least a little art every day.

I respond to found materials, so sorting through my collected bits of embroidery can get me going. I do quick sketches of image ideas that pop into my head, then I research the ideas and symbolism that those images evoke.

I find embroidered bird motifs on old household linens from antique malls and thrift shops. Birds are fairly common, whether anthropomorphized and doing chores or idealized as part of a decorative scene. I collect images of birds to use in my work because certain birds have associations, and I use that to guide my viewer toward a feeling or memory.

A very common motif is the sparrow. Traditionally, sparrows symbolize luck and good fortune. For me, the image of them flying off depicts freedom or escape. I also use them as messengers to other characters in my scenes.

Little Birds | 32 × 14 inches; 2007 | Cotton, found embroidery, embroidery floss, cotton thread | Hand embroidered, machine stitched

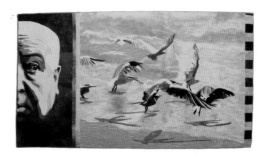

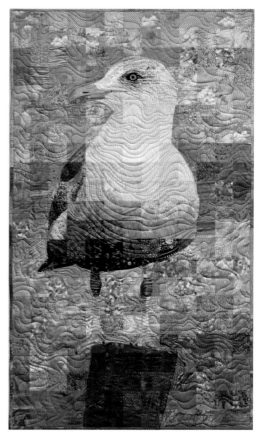

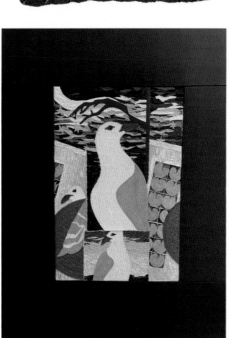

Top left: Sharon M. Crary | *Feathers in Flight* | 47 × 32 inches; 2016 | Yarns | Handwoven tapestry using eccentric wedge weave technique

Top right: Sandy Curran | *The Moment of Inspiration* | 39 × 70 inches; 2002 | Painted and hand-dyed cotton | Painted, hand appliquéd, machine quilted

Bottom left: Jennifer Allyn Cuthbert | *Seagulls at Dusk* | 23 × 19 inches; 2014 | Cotton, linen, silk, suede, thread | Fused cut-edge appliqué, free-motion quilted and embroidered

Bottom right: Sandra Bruce | *Seamus* | 43 × 26 inches; 2021 | Cotton, paint | Pieced, painted, free-motion quilted

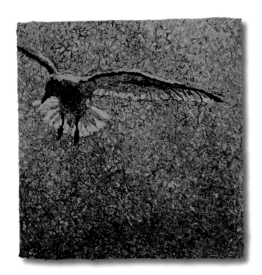

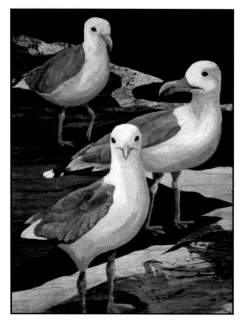

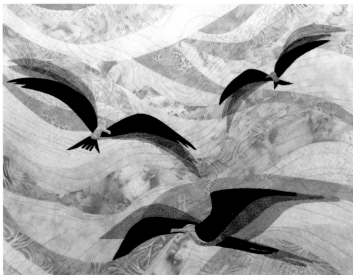

Top left: Mita Giacomini | *Aloft* | 18 × 18 inches; 2019 | Wool, silk, cotton, and other natural and synthetic fibers | Surface woven

Top right: Denise Oyama Miller | *California Gulls* | 26 × 19.5 × 1.5 inches; 2013 | Fabric, paint | Mixed media, machine quilted, painted

Bottom: Yemima Lavan | *Above the Clouds* | 20 × 24 inches; 2018 | Cotton, tulle | Fused appliqué, free-motion machine quilted

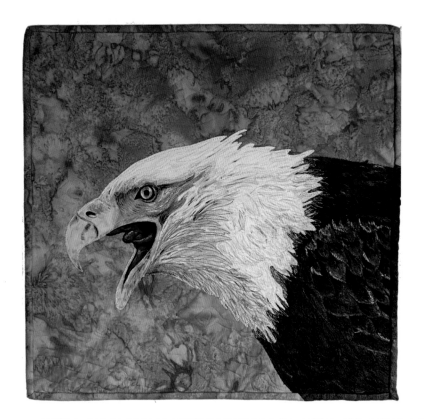

JOANNE HARRIS HOFFMAN

Englewood, Colorado, USA

Silence those negative voices in your head that say you are not an artist. Enjoy the process, since the journey of creating is as fulfilling as the end result!

Being out in nature always inspires me. I am fortunate to live in Colorado, and I get to be out in the wild a lot. Taking tons of photos helps; I am always looking at my surroundings with an artist's eye. There is line, shape, color, and texture everywhere.

The ability of birds to fly inspires me. They are not tethered to the earth as we humans are. They can dart, soar, ride the air currents; they are truly free. This is the stuff dreams are made of. Birds of prey inspire me the most. They personify daring, adventure, courage, fearlessness, and bravery.

Fierce | 17 × 17 inches; 2020 | Cotton, watercolor pencils, fabric paints | Collaged, raw-edge fused, drawn, painted

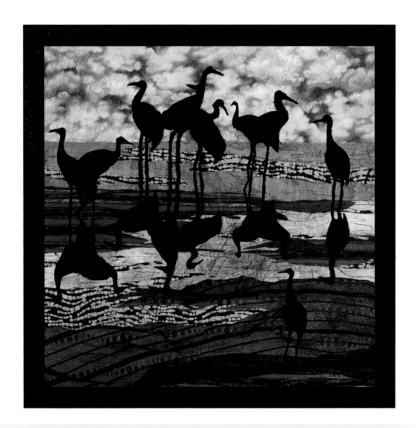

LINDA SHOCKEY HOFFMEISTER

New Smyrna Beach, Florida, USA

What makes your heart flutter and jump with excitement when you view another fiber artist's work? Study different styles and develop your own. Play.

Our feathered friends are a study of movement and color. Usually what inspires me is a photo I have taken, such as the one that inspired *Standing Tall*. I happened upon a beautiful flock of herons and was able to capture the moment.

As a former private pilot, watching the freedom that birds have soaring in the sky makes my heart sing. Often I will release bins of fabric and watch them float to the floor, landing in unusual color combinations, mimicking the movements of our feathered friends.

Standing Tall | 25 × 24 inches; 2014 | Silk, batiks, cottons | Fused, raw-edge appliquéd, painted, free-motion quilted

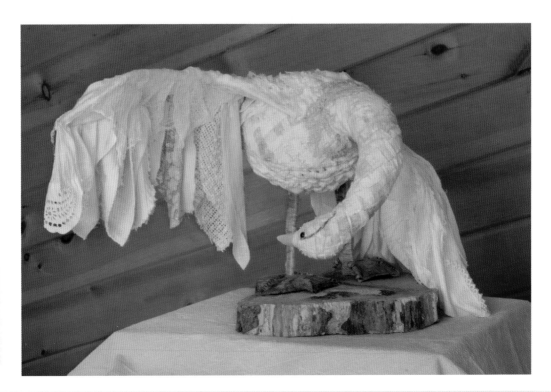

NANCY HULL

Halton Hills, Ontario, Canada

I advise artists to study what they are passionate about, then use various media and techniques to interpret what they feel. Above all, their day-to-day work and the final pieces that they create should bring them satisfaction and enjoyment.

For my entire life, I have been entranced by birds: their beauty, grace, behavior, songs, and comedy, and the magic of flight! Sometimes, I find a branch or root that looks like a bird's head and neck, and I'm inspired to create a bird sculpture using this found object.

The sculpture-building process begins by creating an armature with a specific size, shape, and posture of the bird that I have in mind. I often use fabrics and fibers in the final coat because they accept paint, dyes, inks, rusting, bleaching, stiffening, distressing, cutting, and sewing, and for the pleasure of their hand feel while creating the sculptures. My bird's legs and feet, usually metal, are often covered in fabric or wrapped in thread or other fibers. The feet are commonly wired into a wooden base for stability.

Gwendolyn | 14.5 × 24 × 21 inches; 2019 | Metal shelf rails and coat hangers, newspaper, cardboard, found wood, linen thread, recycled sweaters, shirts, canvas, vintage hankies, lace, christening gown, paint, commercial eyes | Built, carved, sewn

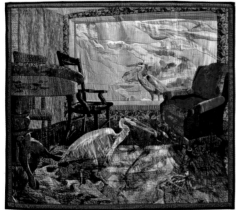

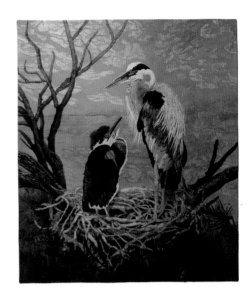

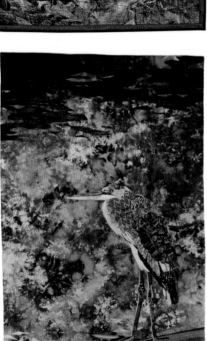

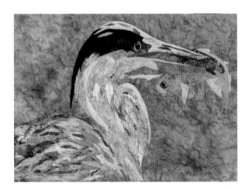

Top left: Annie Helmericks-Louder | *Side by Side: Blue Heron* | 95 × 81 inches; 1999 | Silk, manipulated commercial cottons | Hand dyed and painted, discharged, embroidered, hand stitched, hand quilted

Top right: Suzette Coppage | *The Rookery* | 45 × 39 inches; 2021 | Cotton, paint, colored pencils | Raw-edge appliquéd, thread painted, painted, machine quilted | *Based on photo by Roger Miller; used with permission*

Bottom left: Karol Kusmaul | *Riverside* | 67.5 × 36 inches; 2019 | Ice-dyed, commercial, and upcycled fabrics | Raw-edge collaged, hand appliquéd, hand quilted

Bottom right: Agnes Minnebach | *Dinner Is Ready* | | 8.5 × 26 inches; 2020 | Cotton, batik fabrics | Collaged, machine quilted

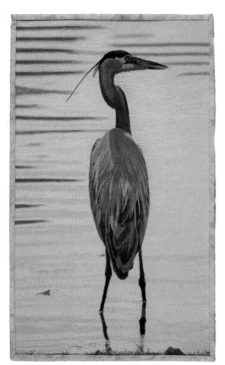

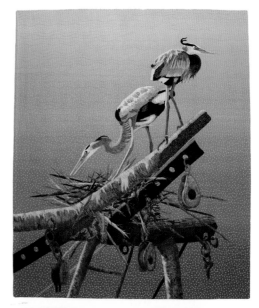

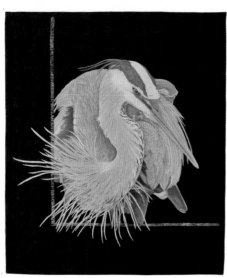

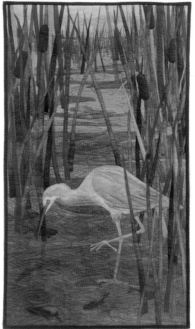

Top left: Hope Wilmarth | *Wading* | 20 × 12 inches; 2016 | Digitally prepared photograph on cloth | Machine stitched | *Photo by Rick Wells*

Top right: Sara Sharp | *Heron Loft* | 40 × 34 inches; 2019 | Cotton | Raw-edge fused appliqué collage, free-motion machine quilted, thread painted, pastel shaded

Bottom left: Christine Holden | *Big Blue* | 38 × 33 inches; 2020 | Cotton batik, sueded polyester, paint, fabric pens | Painted, fused, free-motion embellished and stitched

Bottom right: Charlotte Scott | *Early Morning Fishing* | 35 × 20.5 inches; 2017 | Hand-dyed silk organza and cotton, paint | Printed, raw-edge machine appliquéd, hand dyed, machine quilted

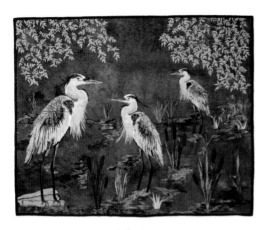
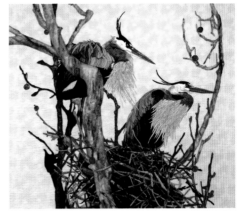
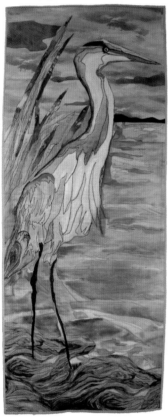
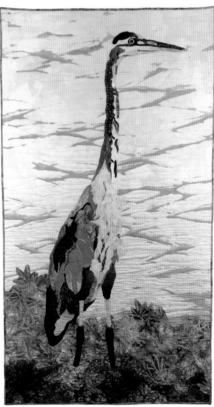

Top left: Susan W. Smith | *Heron's Garden* | 33 × 43 inches; 2017 | Hand-dyed and commercial cottons, Minkey, ribbons, yarns | Fused raw-edge machine appliqué, couched, decorative stitched, embellished, free-motion machine quilted | *Based on pattern by Toni Whitney Designs; used and modified with permission*

Top right: Shirely Tchou | *The Courtship Begins* | 51 × 54 inches; 2021 | Fabric, ink | Raw-edge appliquéd, inked | *Photo by Joseph Dick*

Bottom left: Emily Mae Stevens | *Wetland Blues* | 60 × 24 inches; 2016 / Duck cloth, cotton, paint | Hand drawn, stitched, painted, appliquéd

Bottom right: Alice Marie Margorian | *Genus Loci* | 64 × 36 inches; 2021 | Cotton, sheers, hand-dyed fabrics | Collaged, machine appliquéd, machine quilted

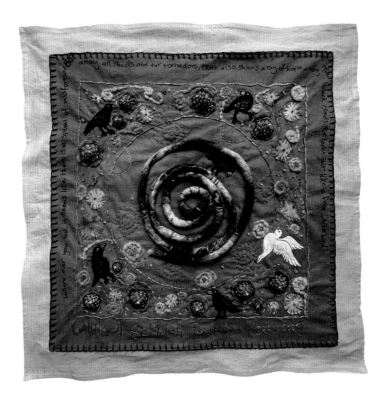

SEPIDEH INANLOU

Mehrshahr, Karaj, Iran

This piece was made for the Covid Chronicle Collective Project. The use of the birds in the piece symbolizes both death and disaster (the crows) and hope and uplifting (the dove). These symbols are used in both Iranian literature and poetry. The verse on the border of the poem was written by Soheil Inanlou, the artist's brother.

Where ever you look

it seems like there is a spiral of misfortune

BUT among all the ills and tar tornadoes,

there also shines a ray of hope

among the black clouds

that looks just like a free white bird..

Ray of Hope | 19.5 × 19.5 inches; 2021 | Hand dyed cotton, felt, animal fibers, wool embellishments | Dyed, sewn, embroidered

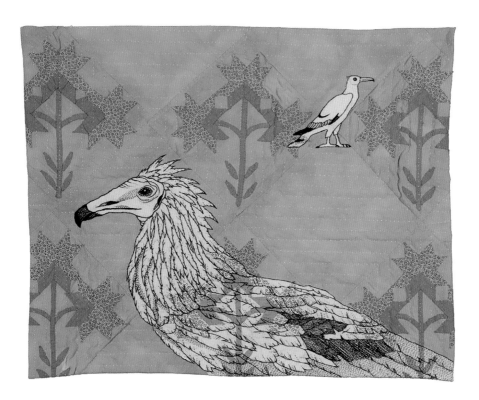

LAUREL IZARD

Michigan City, Indiana, USA

Keep on creating, no matter what. Rejections and creative blocks can bring an artist down, but that is why it's so important to make the art that comes from within. Your unique voice is important and needs to be sent out into the world.

I make some kind of art every day. I keep this going by having several projects at once: if I don't feel like embroidering, I can get on my sewing machine. If I'm not in the mood to sew, I draw or paint. Having a consistent sketchbook practice has been a very important creative source over the years, and I often refer to sketches and drawings done years ago for renewed inspiration.

I find birds inspiring because of their incredible diversity in body type, color, and movements. I can't think of an ugly bird, since each has its own unique beauty. Birds' ability to fly and the fabulous form of their feathers are things that I strive to capture in my work. Birds also have such interesting and vibrant personalities and are quite bright and resourceful. The fact that birds are descended from dinosaurs makes me love them even more.

Egyptian Vulture | 24 × 30 inches; 2020 | Cotton vintage quilt top, cotton embroidery floss, pearl cotton, paint | Hand embroidered, painted, hand quilted | *Photo by John Spomer*

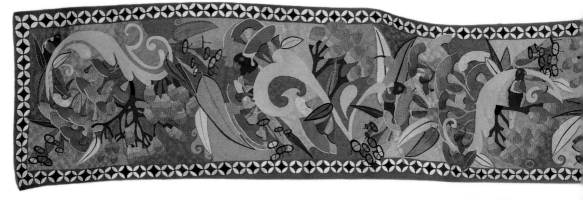

CATHY JACK-COUPLAND

Sydney, New South Wales, Australia

Inspired by a passion to create, I draw, draw, and draw some more. This process takes patience and practice but gives back tenfold. Design is a never-ending journey.

Scale is important when designing a large work, so the design is laid on the floor, where I walk by it regularly, and it stays there until the design is working and communicating my intention.

We live in an apartment overlooking a busy, working river in Sydney with a small garden featuring a birdbath, which attracts myriad birdlife. It becomes a playground for lorikeets, magpies, and honeyeaters, who come in small groups at certain times throughout the day. They dive-bomb or gently glide into the water or sometimes just sit there enjoying a cooldown. They play hide-and-seek in the frangipani and love to dry on long bamboo sticks we have placed around the garden. There's a pecking order though; the lorikeets rule.

I'm drawn to the highly intelligent magpie and based my narrative work *And Then There Were Three* on one magpie who started visiting us to be fed. He pretty soon brought his partner, and we learnt they were nesting in a nearby tree. Shortly after, we began to hear a squawking baby bird making up the threesome. They all still visit.

Top: *Pleasure, Beauty, Freedom* | 16.5 × 79.5 inches; 2021 | Rayon and polester threads on a felt substrate | Free machine embroidery | *Photographer: Julie G. Photography*

Bottom: *And Then There Were Three* | 15.7 × 81.5 × variable inches; 2021 | Felt, polyester and rayon threads | Free machine embroidered | This work was designed as a freestanding artwork, displayed in a serpentine shape so viewers can walk around and see both sides of the work. *Photo: Julie G. Photography*

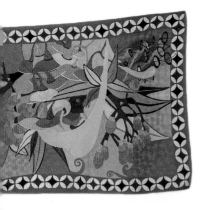

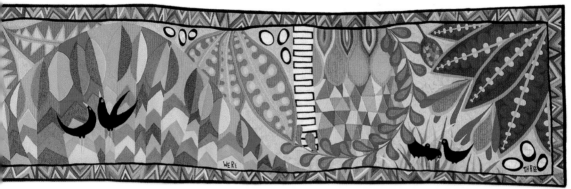

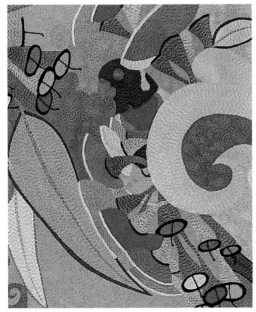

Detail 1

Detail 2

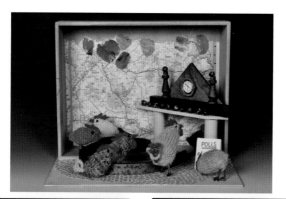

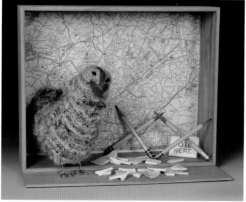

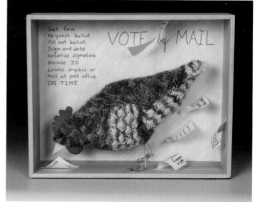

EVE JACOBS-CARNAHAN

Montpelier, Vermont, USA

See art in person! Visit museums, galleries, and local art centers. As you explore, study what attracts you to the work and what you dislike. Examine how the work is created and what materials are used. This will build your art muscle. Take workshops on techniques you know little about. When I began making artwork, I did not know how to construct armatures for sculpture, so I took workshops on wire and paper structure, mixed-media sculpture, and basketry.

I draw on current events for ideas and reflect on how to explain them visually. Birds are great subjects for artwork because they are so relatable. Since they live in proximity to people, they are familiar. We see them in every setting: city, farm, forest, desert, ocean, mountain. Because of their migratory and fragile nature, birds make great characters in stories of climate change and habitat destruction.

Birds also make great allegorical figures in stories about human society. The best bird for a particular artwork depends on the story I'm telling. I consider the bird's behavior, habitat, and even its name. I placed chickens in a drama about voter suppression, because "being chicken" means being frightened.

Top: *Making Voters Chicken: Line Time* | 9 × 11.5 × 9 inches; 2022 | Wool yarns, felt, wire, wood, paper, found objects | Knitted, sewn, assembled

Bottom left: *Making Voters Chicken: Obstacles* | 9 × 11.5 × 6.5 inches; 2022 | Wool yarns, silk, pottery shards, pencils, map, found objects | Knitted, assembled

Bottom right: *Making Voters Chicken: Follow the Instructions* | 9 × 11.5 × 3.5 inches; 2022 | Wool yarns, felt, wire, paper, paint | Knitted, sewn, assembled | *All Photos by: Paul Carnahan*

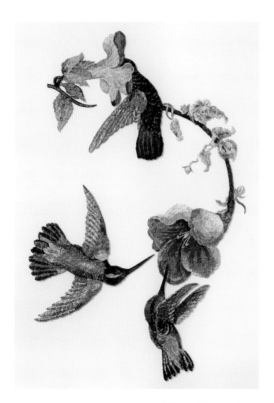

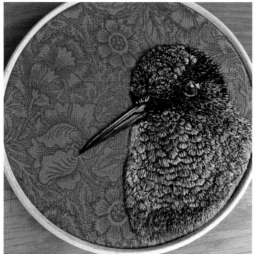

Top left: Louise Saxton | *Sky Jewels (after John James Audubon, 1833)* | 55.5 × 37.5 inches; 2016 | Reclaimed vintage and antique needlework, lace pins, nylon tulle, silk, beading pins on museum board | Assemblage | *Photo by Gavin Hansford, Australia*

Top right: Nari Haig | *Broadbilled Hummingbird* | 49.5 × 40 inches; 2021 | Cotton | Raw-edge appliquéd, free-motion quilted | *Photo by Dr. Susan Haig*

Bottom: Collette Kinley | *Hummingbird* | 6 × 6 inches; 2020 | Cotton, embroidery threads | Thread painted

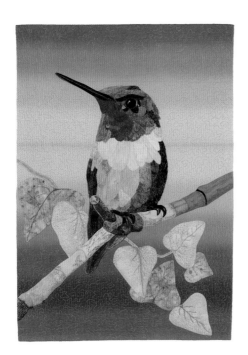

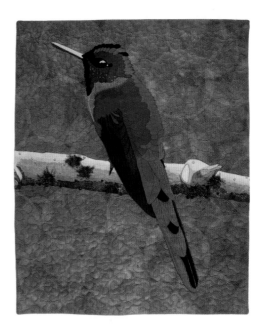

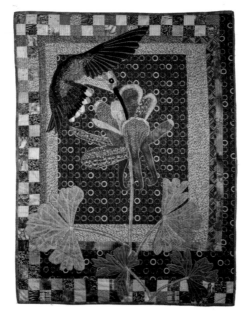

Top left: JoAnn Gonzalez Camp | *Top Gun* | 35 × 24 inches; 2010 | Cotton | Needle turned, hand appliquéd, machine quilted | *Photo by Kenny Gray*

Top right: Carla White | *Long Tailed Sylph Hummingbird* | 36 × 29 inches; 2019 | Silks, batiks, felt, tulle, perle cotton, watercolor pencils, Swarovski crystals | Raw-edge appliquéd, thread painted, layered, colored | *Photo by Howard Romero*

Bottom: Denise Fay Konicek | *Tiny Visitor* | 36 × 27 inches; 2018 | Cotton, heavyweight home-decorating fabric, paint, ink | Pieced, raw-edge appliquéd, machine quilted, hand embroidered, painted, inked | *Photo by Mark Flannery*

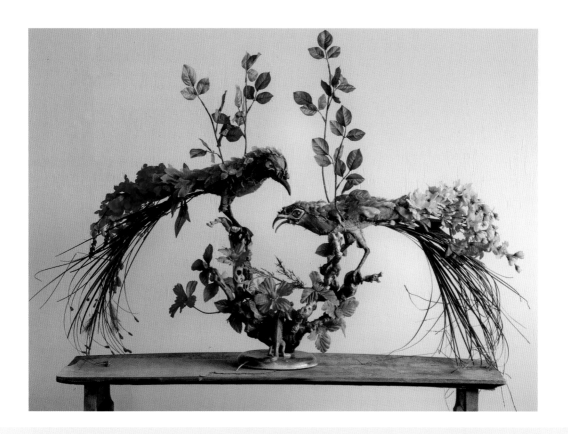

EMILY JAN

Alberta, Canada

Keep your eyes on your own path and just keep going, one step after another. Don't compare yourself to others around you, and don't worry about anyone else's opinion when you're first starting out. Also, unless you truly, truly love it, leave the art theory at the door. It took me years to untangle my brain from all the theory I had to absorb in undergrad and graduate school.

The improbability of birds is what most inspires me: the vast array of colors and forms that they have evolved and their elegant design as flying creatures on a mostly earthbound world. They are pretty miraculous, and they are our living link back to the world of the dinosaurs.

For diversity of form, the birds of paradise never fail to amaze me, not just in terms of their plumage but also their elaborate and outlandish courtship displays. I'll always have a soft spot for weaver birds, after having lived in South Africa for some years. One of the most common birds where I live now is the magpie, and they are endlessly amusing with their antics and their swagger. Their raucous calls are my alarm clock.

Apologue IV: Birds of Paradise | 30 × 40 × 14 inches; 2016 | Found objects, recycled textiles, resin | Sewn, sculpted

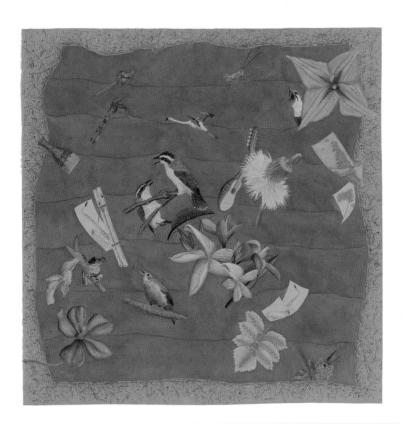

DONNA JUNE KATZ

Chicago, Illinois, USA

Learn from everyone and everything—teachers, peers, museums, books, nature—but don't be afraid to follow your own path. The more you create, the more ideas you generate.

I initiate ideas by doodling and creating thumbnail sketches and refining them in stages, as well as playing with color swatches and paint. Walking and sketching outdoors, visiting art and science museums, and bird-watching provide inspiration. Often going into my studio, where I have a collection of fossils, insects, dried leaves, seeds, and tree bark (and even a whole 8-foot dried cup plant stalk!), is enough to get me started.

I am inspired by birds that I've seen and birds that I would like to see. Especially wood warblers! The rose-breasted grosbeak has been a favorite ever since writing a report on it in elementary school. I'm also inspired by birds that appear in poetry and song ("The Blackbird," "The Baltimore Oriole," and the tropical birds whose sounds are heard in Gato Barbieri's recordings).

Birds symbolize freedom, liveliness, and song. They are beautiful, colorful, delicate, intelligent, and elusive. Their navigational ability inspires awe. And, sadly, their numbers are declining!

Gato Barbieri: Then AND Now | 26 × 25 inches; 2010 | Unbleached muslin, paint | Hand painted, hand quilted | *Photo by Tom Van Eynde*

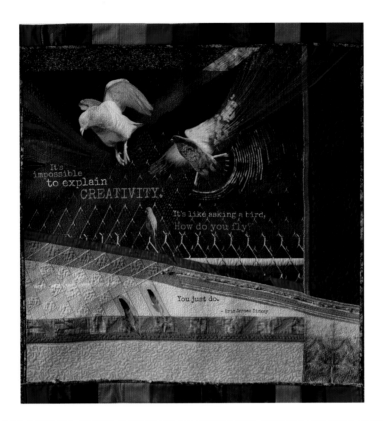

JILL KERTTULA

Charlottesville, Virginia, USA

"Inspiration is for amateurs; the rest of us just get busy and go to work" (Chuck Close). Don't worry about doing it "right"; you are probably not going to make the next Mona Lisa anyway. Just start, continue, and do what makes you feel satisfied, expanded, grateful, and interested. If you are none of those things at the start of a project, you will be in the middle . . . so just keep going. Do it for yourself, not for the audience or for posterity.

Photography is my sketchbook and my constant eye exercise. There is so much to see, react to, interpret, and try. I am living in a very urban setting, versus the rural area where we used to live. There is a parking structure across the street, and it is the home for a flock of pigeons. Their iridescent colors, their bright-red eyes, and their gentle cooing—all bring me joy and inspiration.

How birds move is especially inspiring—both their individual movements and their synchronized movements when flying as a flock. The dive-bombing maneuvers of crows; the murmurations of a flock of starlings, the rhythmic rise and fall of finches, or the instantaneous liftoff of a flock of pigeons. Dancing at its best!

Just Fly | 48 × 48 inches; 2015 | Custom and commercial fabrics, yarns, threads | Photo transferred, hand stitched, beaded, machine free-motion stitched, couched

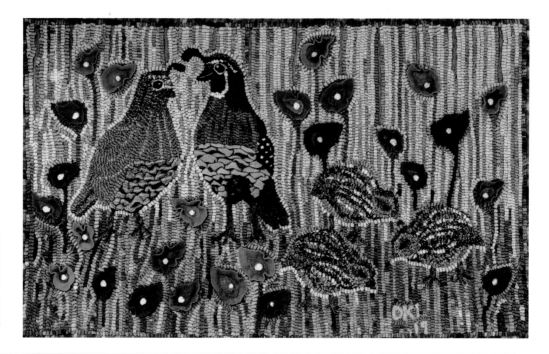

DENISE E. KILLINGSWORTH

Walnut Creek, California, USA

Try to learn from every experience and feel free to modify a method if it doesn't work for you.

I like to travel and take photos. I usually work from photos of birds that I have seen. I'm fascinated by the way they move. And I especially enjoy the colorful ones and the unusual ones.

My rug-hooking group has been doing California-themed rugs the last few years as a group display. We all decided that our state bird, the quail, was a fun choice for the 2019 Association of Traditional Hooking Artists biennial Denver show. Miner's lettuce grows in the foothills and was eaten during the gold rush.

Quail among the Miners Lettuce | 18 × 30 × 0.25 inches; 2019 | Linen, cut wool strips, wool roving, sari ribbon | Hooked, embroidered, needle felted, couched

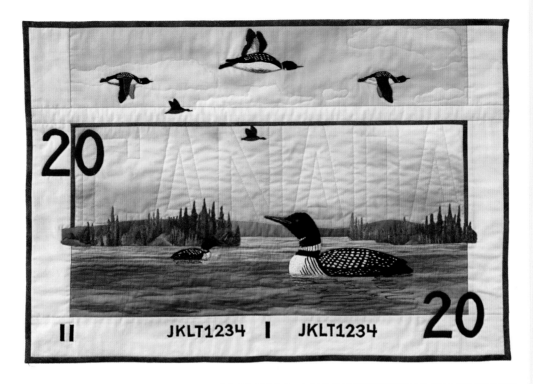

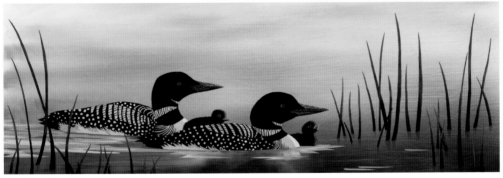

Top: Kathy Tidswell | *Bank Machine Blues* | 20 × 29 inches; 2005 | Cotton, paint | Painted, free-motion embroidered, blind-stitch appliquéd, free-motion quilted | *Photo by Roger Smith*

Bottom: Kestrel Michaud | *Family of Loons* | 15 × 36 inches; 2010 | Cotton, dye | Fused raw-edge appliqué, hand dyed

SUSAN FLETCHER KING

Houston, Texas, USA

Try everything! Build up that toolbox of processes and then experiment. Try not to fall into the trap that everything you do has to be beautiful or perfect. Look at your work critically and seek out like-minded artists for honest critiques. Observe young children making art and, like them, let art become play. That is how you find your authentic self as an artist.

Birds are a gift for gravity-bound humans. They never stop inspiring me with their flight, their colors, and their interactions with each other. While a bird can appear to be the most delicate and fragile of things, they may also fly for thousands of miles, traversing migratory paths year after year.

Birds are one of the most primal archetypal symbols. *My Divorce Quilt: Shredded* was an emotional response to having my husband start an affair after twenty-five years of marriage, which ultimately shredded our lives and family. The blackbird seemed like the best way to visualize and externalize my emotions.

My Divorce Quilt: Shredded | 48 × 36 inches; 2018 | Cotton, paint, inks, dyed and burned cheese cloth, various threads | Painted, raw-edge appliquéd, machine stitched and quilted | *Photo by Rick Wells*

COLLETTE KINLEY

Mount Pleasant, Western Australia, Australia

Allow yourself time to grow and evolve at your individual pace. It's your journey, not anyone else's. Patience is a difficult but important part of any journey. When I began my textile art, my work looked so very different to what it is now. As my confidence developed, so did my repertoire of artwork.

When there is a mental or creative block, take a simple walk outside in nature. Getting out of the space you are in physically and mentally can really help clear your head.

Birds have always fascinated me. Who doesn't remember the wonder and imagination as a small child dreaming of what it would be like to fly! I am passionate about the natural world, and birds are such an important part of those ecosystems. Birds are really accessible to study.

Just watching them in my garden, I can observe their individual behaviors, and they come in such an array of sizes and colors.

If I have my artist hat on, then my favorite bird would have to be a hummingbird. Stunning form, amazing jewellike colors, just such a privilege to re-create in thread. If I have my nonartist hat on, then my favorite would have to be owls. They are just such beautiful, enigmatic birds.

Kingfisher | 4 × 4 inches; 2019 | Cotton, embroidery threads | Thread painted

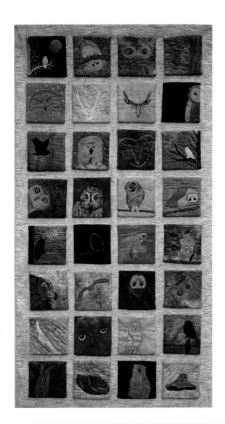

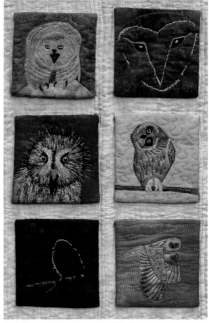

Detail

MONIKA KIRK

Hamburg, Germany

Look closely at the birds. Observe them in nature and take photographs. Become familiar with their way of life and the way they move. As a nature photographer, I have an extensive archive of owl photographs. My intention is not the photorealistic detailed illustration of the plumage in lifelike colors. As a textile artist, what fascinates me is to show the essence and individuality of each owl.

Owls are distinguished from all other bird species by their large, round head with forward-facing eyes and downward curved beak and their voluminous, cryptically colored plumage. Owls live in the dark of the night and are rarely seen during the day. They appear obscure and mysterious, but because of their humanlike face, they also seem familiar to us. I am especially mesmerized by their wonderful eyes.

Owls are endangered because of loss of habitat. I have loved them for more than forty years, and I am involved in owl conservation. A very special experience for me was meeting a great horned owl. I met her unexpectedly in the garden of an abandoned house. At a distance of only 10 yards, we looked into each other's eyes for several minutes without moving. It was like a magical glimpse into the soul, an extraordinary encounter that touched me deeply.

Owlery 1 | 45.5 × 24 inches; 2019 | Hand-dyed cotton, cork | Raw-edge appliquéd, painted, thread painted, hand and machine stitched

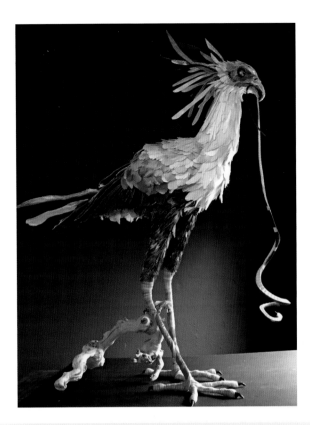

SANDRA KLINK

Bethel Park, Pennsylvania, USA

Persistence and practice will allow you to succeed. Try different things and fail, until you discover what works for you.

Look at the work of other artists. When I wanted to begin working in a more neutral color range, I found inspiration in the works of Walton Ford: the movement in his painting spoke to me.

I am especially inspired by large waterfowl, by the bird's form, positioning, and movement. Birds can soar and fly, while I am tethered to the earth.

I begin each sculpture by first creating anatomically correct line drawings. Then I build a wire frame onto which padding is placed. My freestanding sculptures are covered with multilayered feathers created out of hand-painted canvas. I have found this to be a very meditative process.

Secretary Bird | 34 × 38 × 12 inches; 2020 | Mixed media with painted canvas, copper wire, styrofoam, glue | Carved, painted

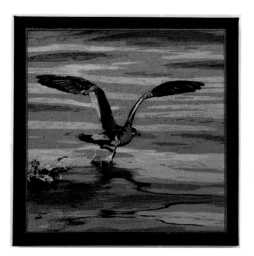

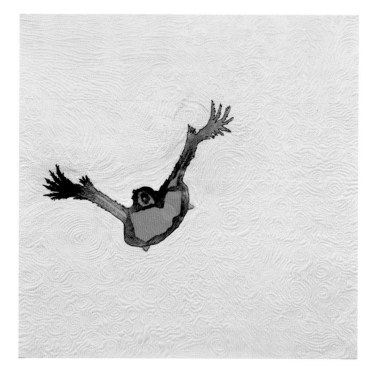

Top left: Mary Jane Sneyd | *Buller's Shearwater* | 12 × 12 inches; 2020 | Cotton, threads | Manipulated photo commercially printed, free-motion quilted, thread painted

Top right: Vali Groening | *Floating and Trusting* | 12 × 12 × 3 inches; 2003 | Cottons, metallic threads and foils | Machine raw-edge appliquéd, trapuntoed, machine quilted

Bottom: Rosanna Lynne Welter | *Landing* | 25 × 24 inches; 2020 | Satin, dye, threads | Disperse dyed photo transfer of original drawing, machine quilted

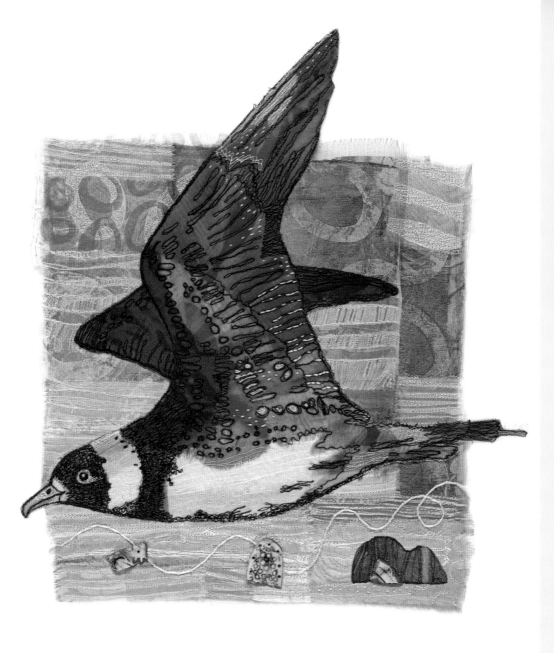

Deborah Campbell | *Arctic Skua* | 16 × 14 inches; 2021 | Silk organza, newsprint, recycled fabrics, paint, porcelain |
Handprinted, free-motion machine and hand embroidered

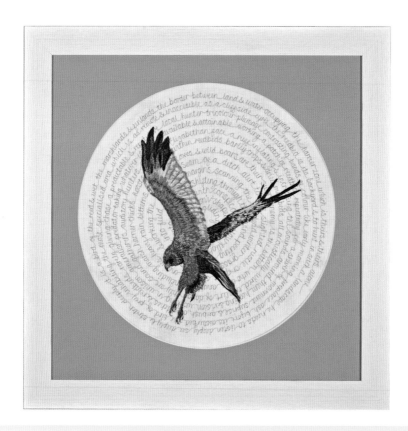

ANGELA KNAPP

Castle Cary, Somerset, UK

Give yourself time. It's initially difficult to find your voice and style. You can become overwhelmed and intimidated by the work of other artists. Make art for you; enjoy the process, experiment, and, most importantly, pick subjects that you connect with and feel passionate about.

My work aims to engage the viewer with the beauty and fragility of birds. I like to capture elements of their life, sometimes stitching text into the background to add to the story. Other pieces celebrate the sheer beauty within the bird world. My work is currently inspired by the birds thriving and declining on the local marshland and nature reserves in the southwest of England.

The planet is changing in so many ways, and many of the birds once common when I was a child are now facing declines in the UK of 70–90 percent. It is these stories and struggles that inspire me to create and, I hope, raise awareness.

Above the Reed Bed: Marsh Harrier | 16 × 16 inches; 2021 | Cotton | Raw-edge appliquéd, free-motion embroidered | *Photo by Dominic Hewitt*

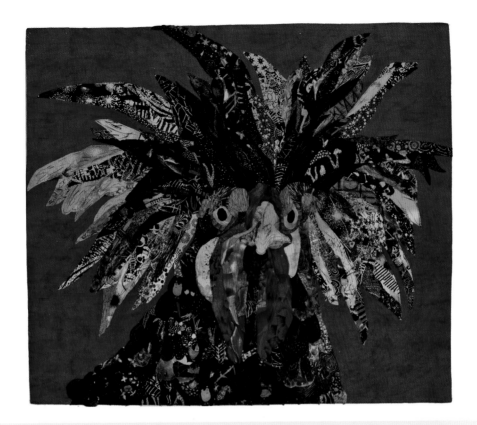

MARGARET KNEPPER

Melbourne, Florida, USA

Be fearless. Your opinion and your happiness are the keys. Get out and draw. You will learn more by drawing it yourself.

I admire all birds for their ability to fly, but I enjoy chickens because I am able to get close to them. Plus, there is such a wide variety of chickens.

I went into the poultry barn at the county fair. An extremely upset rooster with wild feathers caught my eye immediately. The first picture I took of him inspired this quilt.

Fowl Mood | 27 × 35 inches; 2020 | Cotton | Loose-edge appliquéd

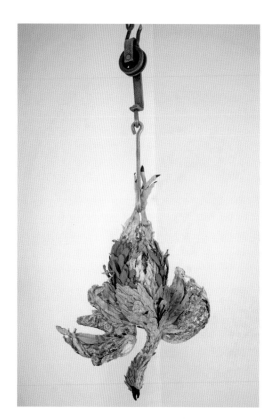
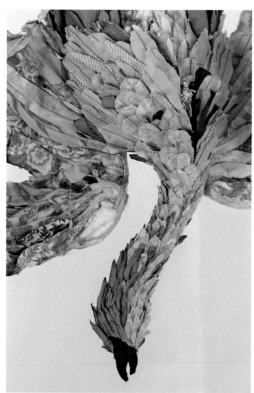

TAMARA KOSTIANOVSKY

Brooklyn, New York, USA

Keep at it. Persistence is the key to the game.

In 2015, I started toying with the idea of making birds with discarded textiles. I went online to purchase feathers sold for taxidermy that I could use for reference. A few days later, to my surprise, I received a box in the mail containing a real dead pheasant.

This bird was mesmerizing, horrible, and beautiful—all at the same time. I had all these meat hooks in my studio from my previous work with fiber cow carcasses, so I hung it from one of them.

There was also something related to Christian iconography in the Crucifixion-like pose of the hanging dead bird. I became smitten with the image for years. There is a striking contrast between the tragic nature of the image and the beauty of the fabric.

Recently, I have become interested in depicting birds that are native to the Americas. In my Fowl Decorations series, I overlay them onto antique European wallpaper designs, juxtaposing the story told by the colonizers of a Paradise ready for human exploitation, against vivid and fierce imagery of these native birds.

Immanence | 18 × 24 × 15 inches; 2017 | Upholstery fabric, discarded clothing, metal hook, chain | Assemblage | *Photo by Sol Aramendi*

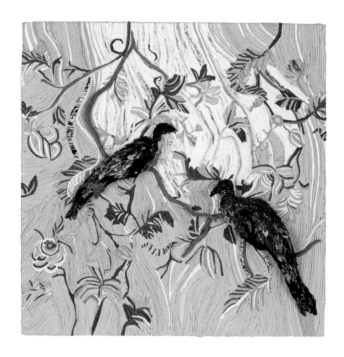

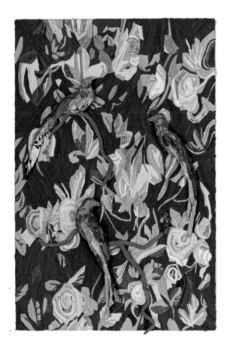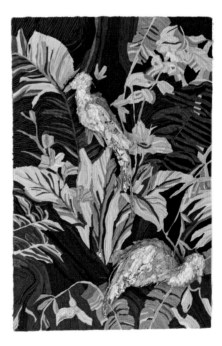

Fowl Decorations | Triptych: Top: 48 × 48 × 9 inches; Bottom left: 48 × 32 × 9 inches; Bottom right: 48 × 32 × 9 inches; 2020 | Discarded clothing, wood, acrylic nails | Assemblage | *Photo by J. C. Cancedda*

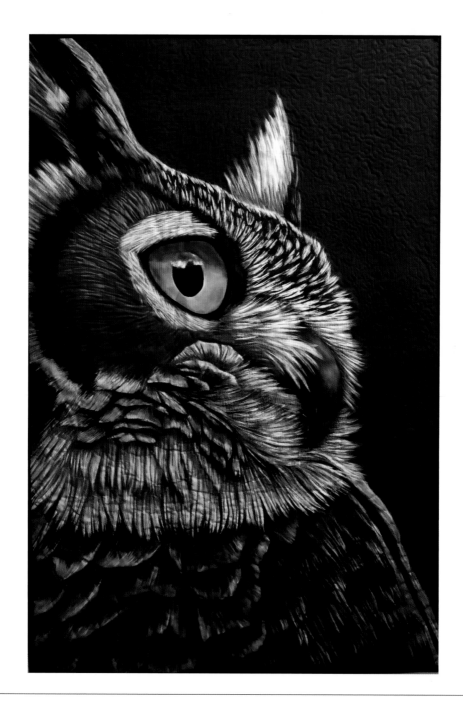

Melanie Marr | *The Great One* | 44 × 30 inches; 2020 | Fabric, paint, thread | Drawn, painted, quilted

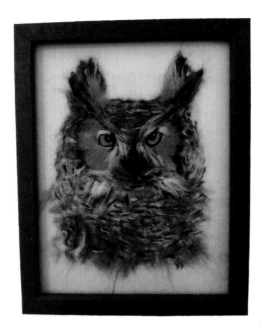

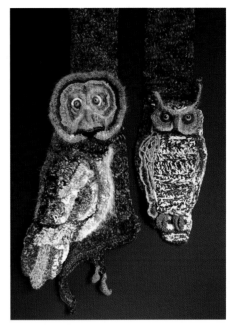

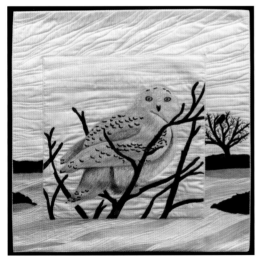

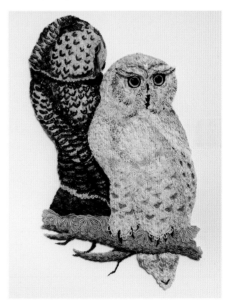

Top left: Donna Schyff | *Great Horned Owl* | 12 × 9 inches; 2018 | Wool roving, felt | Needle felted | *Inspired by photograph taken by Stephen L. Tabone*

Top right: Sandra Klink | *Owl Scarf* | 72 × 12 inches; 2021 | Yarn | Crocheted

Bottom left: Sarah Ann Smith | *Snowy Owl* | 24 × 24 inches; 2014 | Artist-dyed and painted cottons, thread, yarn | Fused collage, thread colored, dyed, painted

Bottom right: Louise Saxton | *Bubo & Snow (after Edward Lear, 1832)* | 29 × 20.5 inches; 2014 | Reclaimed vintage and antique needlework, lace pins, nylon tulle, silk, beading pins on museum board | Assemblage | *Photo by Gavin Hansford, Australia*

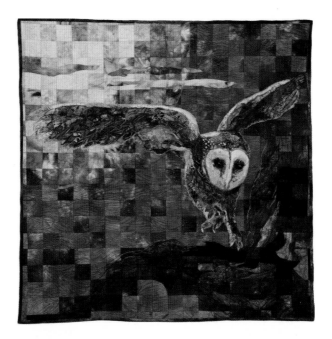

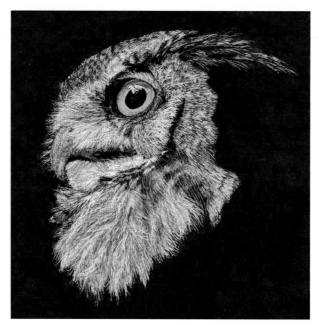

Top: Sue de Vanny | *Night Moves* | 36 × 36 inches; 2016 | Commercial and hand-dyed cottons, beads | Collaged, pieced, beaded, free-motion quilted

Bottom: Janine Heschl | *Great Horned Owl* | 12 × 12 inches; 2020 | Batik fabric, calico | Free-motion embroidered

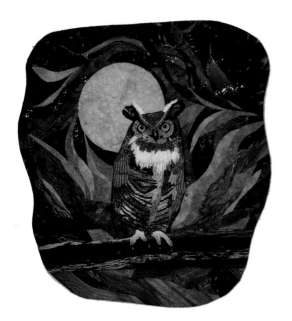
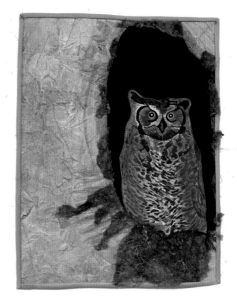

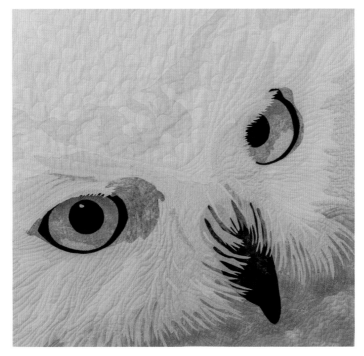

Top left: Gretchen Brooks | *Darkness Becomes Her* | 38 × 35 inches; 2018 | Commercial cottons, sheer novelty fabric, texture magic, lutradur, rayon and silk threads | Raw-edge appliquéd, free-motion quilted, painted, heat distressed, 3-D appliquéd, trapuntoed

Top right: Joanne Adams Roth | *Hootie* | 20 × 15.5 × 0.75 inches; 2021 | Fabric, paints, yarn, goat hair, thread | Painted, paper fabric formed, appliquéd, stuffed, fabric collaged, felted

Bottom: Marian Eason | *Eyes into the Soul* | 27 × 28 inches; 2017 | Cotton | Fused raw-edged appliqué, machine quilted | *Photo by Nick Eason*

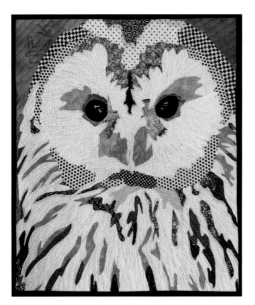

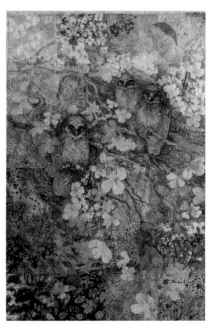

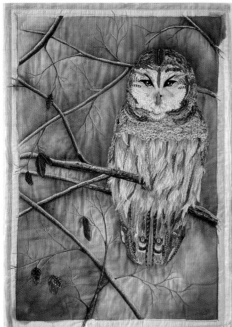

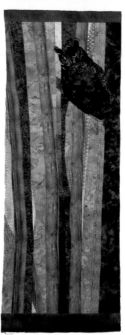

Top left: Sandra Kaiser | *Ural Owl* | 19 × 16 inches; 2021 | Printed and hand-dyed cottons | Fused appliqué, painted, machine quilted

Top right: Olena K. Nebuchadnezzar | *Daydreamers* | 42 × 28 inches; 2014 | Cotton, paint, rayon thread | Appliquéd, painted, embroidered

Bottom left: Michele O'Neil | *Winter Musings* | 37 × 27 inches; 2019 | Cotton, ink, paint, thread, silk sari, fur | Collaged, drawn, painted, thread painted, quilted

Bottom right: Ricki Smith Selva | *Great Horned Owl* | 72 × 24 inches; 2020 | Cotton, nylon tulle, salvaged and recycled fabric | Collaged, raw-edge appliquéd, machine pieced, machine quilted | *Photo by: Barbara Hollinger*

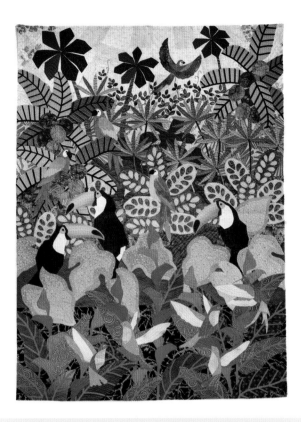

YOSHIKO KURIHARA

Chiba, Chiba Prefecture, Japan

The world is full of interesting things such as painting, theater, music, travel, novels, nature, etc. Let's use them as inspiration for our work.

This work, *Birdland*, was inspired by a visit to a bird park about two years ago, where I encountered a variety of birds.

Birds have such beautiful colors and characteristic shapes. I find them fascinating. I was especially interested in toucans because of their large, yellow beaks and the strongly contrasting colors of their bodies with black feathers and a white chest.

Bird Land | 67 × 49 inches; 2020 | Cotton | Machine pieced, hand appliquéd, free-motion quilted | *Photo by Tsuyoshi Kurihara*

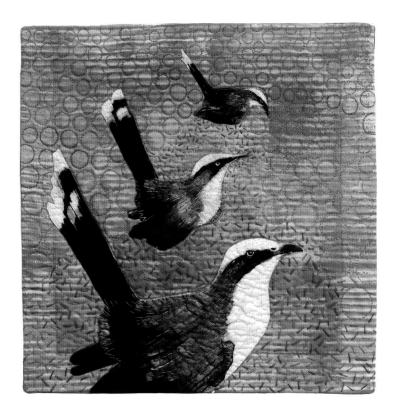

LINDEN LANCASTER

Picola, Victoria, Australia

Make lots of work. Do something every day, no matter how small. Use those smaller works to try out ideas. Don't overthink it: find what you like in each piece and carry it on to the next.

You have to be patient when studying birds. They do not make themselves easily available for us to observe or photograph. This search-and-find aspect becomes part of the excitement in depicting them. They all are so different in their calls, movements, habits, colors, and plumage.

I like all types of birds, but having said that, I'm not as fond of raptors. Magpies are ubiquitous yet have wonderful characters. We once had a pet magpie that would mimic our daughters singing *Madam Butterfly*! A lot of people don't like them because they are vicious swoopers when protecting their babies. I would do the same.

In recent years, I have become more aware of my local native birds and their habitats (shown in the Plains Birds gallery). The bush stone-curlew is a shy, ground-dwelling bird unique to Australia. It is a curious-looking bird with large eyes and long, gangly legs. In some parts of Australia, this bird is becoming endangered due to the loss of habitat and attacks by introduced predators, such as foxes. The bush stone-curlew is most happy in areas that have lots of fallen branches and litter on the ground for foraging, shelter, and camouflage. They are active on moonlit nights, where they emit an eerie "weer-lo" call.

Three Magpies | 16 × 16 inches; 2018 | Cotton, cotton threads | Monoprinted, screen printed, raw-edge appliquéd, kantha stitched | *Photo by Cameron Lancaster*

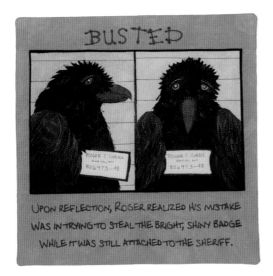

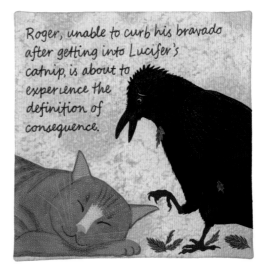

CAT LARREA

Anchorage, Alaska, USA

Keep doing art! Start with the idea of what your piece can be, and don't be disappointed if it doesn't end up how you wanted or expected. Having gone through the mechanics of making it once, it will be easier to modify the next time. And the next, and the next!

While the diversity of birds in Alaska is amazing, my favorite is the raven. They are intelligent, brazen, and social and can be quite playful. The ravens that live in Anchorage often commute to "work" from their roost in the Chugach Mountains. After foraging in town during the day, they head back uphill in the late afternoon. I envy their view of the mountains at sunset and fantasize about where they go at night. Imagining what a bird in flight sees leads one to become the bird for that moment.

In my more realistic work, I try to honor the form and function of a bird in detail. However, I enjoy the whimsical spirit of my cartoon raven, Roger, as he grapples with his conflicted nature of being a wild animal in a human world.

Birds inspire art in so many ways, from the movement and shifting shape of an entire flock, through the graceful lines of an open wing, down to the symmetry and pattern of a single feather. As an art subject, a raven provides stunning contrast to almost any background. The study of birds demonstrates all the art elements and can elicit delightful paths of creativity.

Left: *Busted* | 12 × 12 inches; 2014 | Hand-dyed and commercial cotton, hand-painted linen and silk organza | Fused appliqué

Right: *Raven Consequence* | 12 × 12 inches; 2015 | Hand-dyed and commercial cotton, hand-painted linen and silk organza | Fused appliqué, overstitched hand lettering

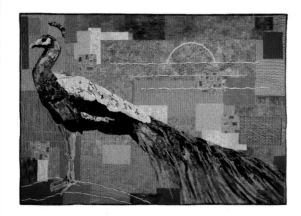

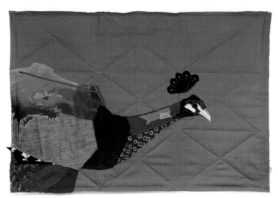

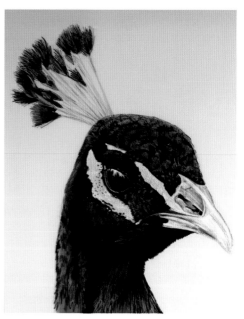

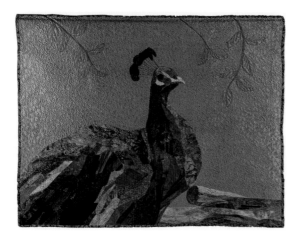

Top left: Eileen T. Wintemute | *The Royal Treatment* | 39 × 57 inches; 2018 | Cotton, silk, specialty fabrics, thread, yarn, trim | Collaged, raw-edge machine pieced and appliquéd, machine quilted, couched | *Photo by Luke Bisagna*

Center left: Tracey Cameron | *Peacock 02* | 32 × 48 inches; 2020 | Recycled fabrics, thread, leather, ribbon, paint | Raw-edge appliquéd, collaged, quilted, painted

Bottom left: Rod Daniel | *Sitting Pretty* | 37 × 48 inches; 2012 | Cotton batiks, silk, thread | Turned-edge fabric appliqué, thread painted | *Based on a photograph by Jim Carnevale; used with permission; photo by Jim Carnevale*

Right: Gillian Bates | *Peacock* | 24 × 20 × 1.5 inches; 2016 | Paint, hand and machine embroidery, threads | Painted, hand and machine embroidered

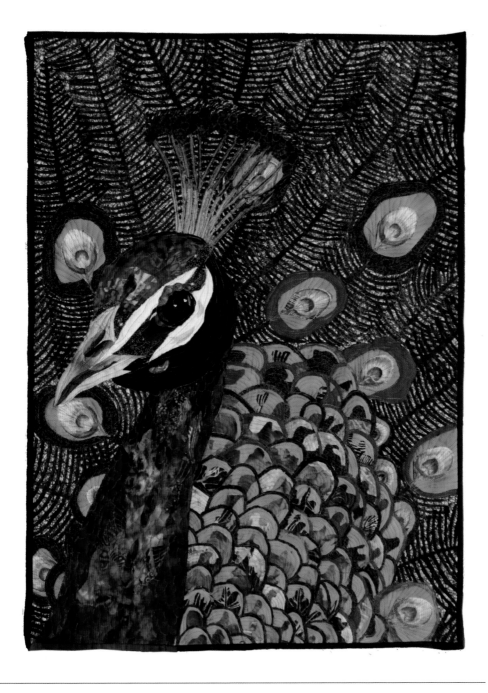

Margaret Jessop | *His Majesty* | 33 × 24 inches; 2014 | Cotton, polyester thread | Collaged

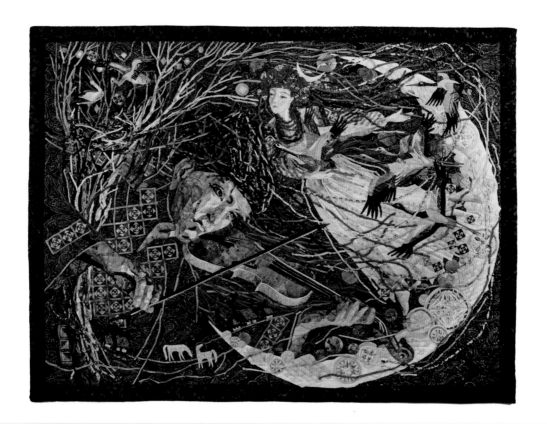

NATALIA LASHKO

Khmelnytskyi Oblast, Ukraine

I was born in Russia. My grandmother was a needlewoman—weaving, knitting, embroidering, and sewing clothes for fellow villagers. From the remaining small pieces of multicolored fabric, she made wonderful quilts. I was fond of painting and loved to paint from early childhood, so I became an artist. I got a good art education at college and an industrial art institute. When I was a student, I fell in love with a Ukrainian man and got married. That was the moment I fell in love with Ukrainian culture and folklore.

My husband and I were attending the same institute in 1984, when I found a small illustration with embroidered straw in an old book about goldwork embroidery. I realized that the craftsmen had used straw to imitate gold embroidery. Sadly, the techniques of straw embroidery have been lost. So I began embroidering paintings with strips of fabric.

I am often inspired by Ukrainian songs. The famous song "I Walked toward Him Like a Moon Princess," about a girl's unrequited love for a fiddle player, is the inspiration for my piece.

I Walked toward Him Like a Moon Princess | 40 × 52.5 inches; 2016 | Cotton | Hand appliquéd

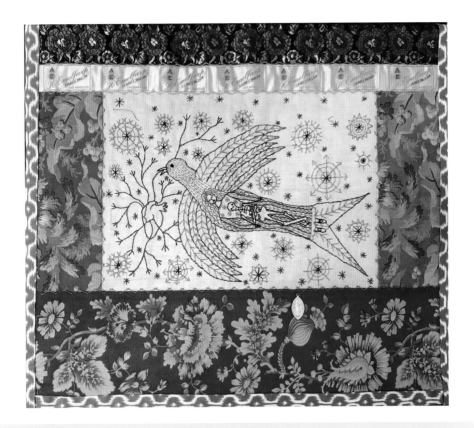

MAVIS LEAHY

Silverton, Oregon, USA

Follow your passion. Create what makes you happy.

Every morning, my day starts out with a trip to the barn, then a hike with the dogs. My connection with Nature and its creatures is my muse. The ever-changing ingenuity of flora and fauna is truly a gift to us mere mortals. One sees Nature's grace and beauty, but also her violence and savagery. The fragile beauty of a hummingbird in the garden is prey to the deadly aim of the falcon.

I try to weave the tales of Nature I am a witness to every day into my art. I recently moved to the Pacific Northwest, and I am still learning about Oregon's birds. I am fortunate to live in a rural setting, and I am able to follow the everyday lives of countless species, many of which are new to me.

Where the Path May Lead Us | 21 × 18.5 inches; 2020 | Antique linen, antique English floral red chintz ca. 1870, French green floral linen ca. 1880, vintage satin clothing labels ca. 1940–1950, vintage religious medal | Hand pieced, embroidered

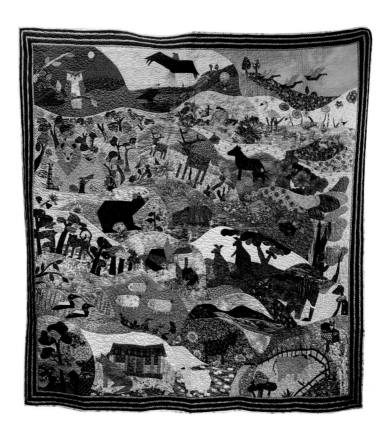

HSIN-CHEN LIN

Tainan City, Taiwan, China

Practice makes perfect! Believe in yourself, be willing to take challenges, and accept failure.

Before designing my quilts, I write down the story first. When I confirm my creative inspiration and get ready to convert it into a physical picture, I usually listen to classical music, because these activities require a lot of cranial stimulation and emotion. Symphonic music creates an atmosphere that leads me into an imaginary world, helping me to search for lines or color.

The rich natural environment where I live attracts a variety of birds. Its location on the migration route of birds in East Asia and Australia brings tens of thousands of birds to the island every spring and autumn. This rich bird ecology includes 674 wild bird species, including twenty-nine species that are endemic.

The relationship between birds and humans is very close. Birds have provided humans with many living materials since ancient times. They prey on insects to maintain the balance of agricultural ecology. They feed on nectar and fruits, assist in pollination, expel seeds and pits, and promote the regeneration of plants. Human beings are similar to birds in their choices of habitat and environmental resources, and they are very similar in their ways of using the earth's resources. Nowadays, bird habitats are rapidly shrinking and becoming polluted. We may be seeing our future as well.

Zoo | 78 × 75 inches | 2004 | Hand-dyed and commercial cottons, embroidery floss, wool yarn, metallic thread, beads, sequins, ribbons | Hand stitched, appliquéd, pieced, quilted, embroidered

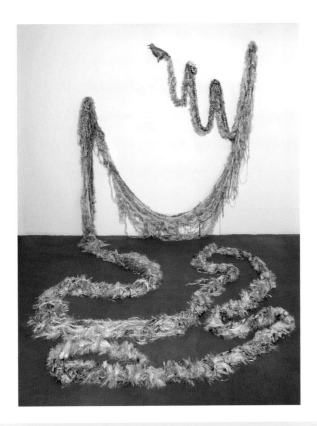

LUZ ÁNGELA LIZARAZO

Bogotá, Colombia

Don't give up: this is a long journey, and every obstacle is an opportunity. Be disciplined. Working every day in my studio is my greatest inspiration. One image always leads to the other.

Birds are a symbol that represents our soul and its journey on the earth. I live in a place where birds are very plentiful, and, with climate change, new species from other places have arrived. I'm interested in all birds, even the ones that no longer exist or were imaginary. I search out and collect images of ancient birds, because I'm interested in observing birds from other places and other times.

Years ago, the "pájaro real de cola trenzada" (royal braided-tail woodpecker) suddenly appeared in my work. When I met him, he spoke with strength and poetry. This bird is a traveler bird, a free bird that is born in the high mountains. Its long and braided tail is not an obstacle to it arriving in the most-remote and most-sophisticated places, making it unique.

Since then, I have been working as a collector navigating through many different places looking for images of this bird, creating a catalog that gets bigger with time. My collection now includes more than one hundred pieces featuring the "pájaro real de cola trenzada," from representations in ancient engravings, drawings, paintings, Chinese lacquer, embroideries and other fabrics, and images in porcelain plates and sculptures.

Ornitografías, aves que no vemos | 27 × 13 × 13 inches; 2016 | Antique plates, metal, wood, pencil | Collaged, mixed media, painted, carved, drawn, embroidered | *Photo by Oscar Monsalve*

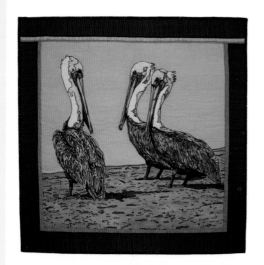

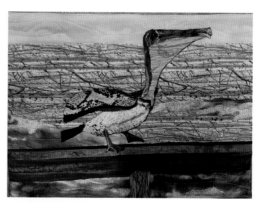

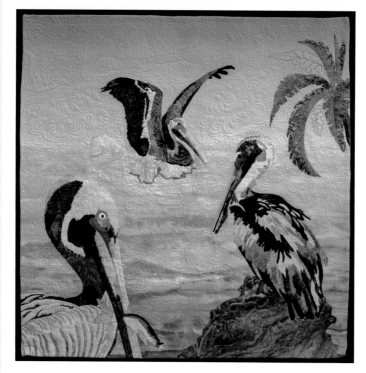

Top left: Sherry Davis Kleinman | *Birds of a Feather Flock Together* | 40 × 40 inches; 2015 | Cotton, paint | Digitally drawn photo, printed, painted, hand embroidered, machine quilted | *Photo by Steven Kleinman*

Top right: Ruthie Snell | *Pelican* | 13.5 × 19 inches; 2021 | Cotton, silver netting | Appliquéd, thread painted

Bottom: Jackie Berry | *I'm Not Just an Ugly Brown Bird* | 34 × 34 inches; 2019 | Commercial fabrics, tulle, ribbon | Pieced, stitched, raw-edge appliquéd, free-motion embroidered

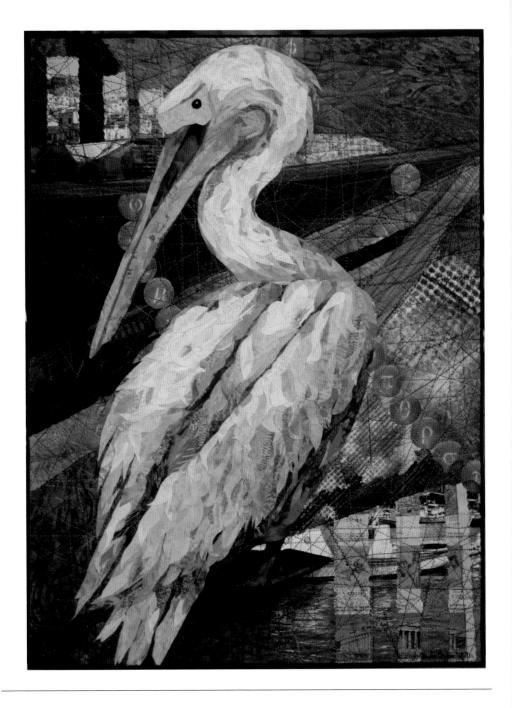

Denise Oyama Miller | *Petros* | 26 × 19.5 × 1.5 inches; 2013 | Fabric, paper (tickets, photos), threads | Collaged, machine quilted, stamped, painted

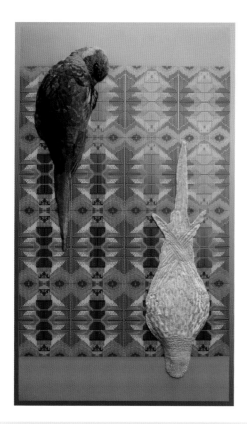

IRENE MANION

Dora Creek, New South Wales, Australia

Believe in yourself. Don't follow trends; just listen to your soul. Learn about art: Go to as many art galleries and exhibitions as possible. Read books and magazines about art and artists.

It is during quiet moments, when thoughts follow random paths, that my lightbulb moments occur. Issues in my work that are preoccupying me randomly connect to create a new perspective, and the next step in the journey is clarified. A notebook to jot down ideas as they appear is essential, because these thoughts can be so transient. The interplay between medium and concept is what allows an exploratory work to emerge.

Birds have become a lens through which I experience the natural world. I have always admired their amazing variety and marvel at a species that has evolved the ability to fly.

Our recent Australian experiences of extreme drought, fire, and then floods gave us the opportunity to watch how our local birds endured these events. The iconic Australian magpie has become the main subject of my current work. We had a pet magpie when we were children. Their remarkable birdsong is created by two sets of vocal cords through which they create a rich, distinctive warbling song. Their high intelligence, their beautiful black-and-white coloring, and their ability to live alongside humans make them favorites to all who encounter them.

Death and Transfiguration | 36 × 20 × 0.5 inches; 2017 | Digitally dye-sublimation printed polyester fabric | Machine and hand embroidered

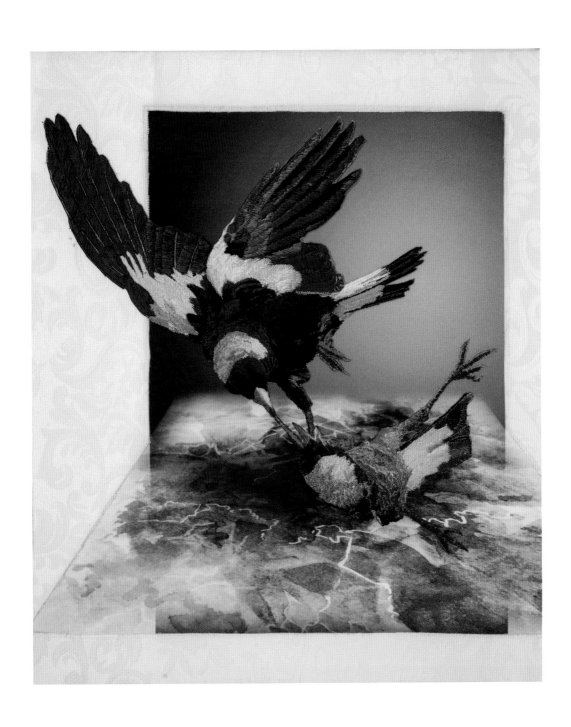

Preparing for Adulthood | 21 × 18 × 0.5 inches; 2020 | Polyester, various machine embroidery threads | Machine and hand embroidered

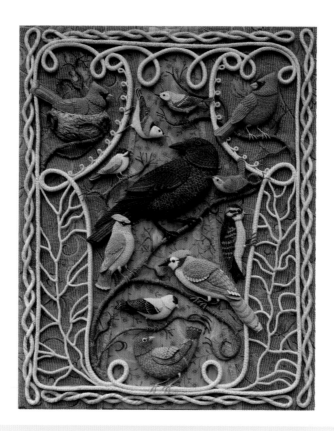

SALLEY MAVOR

Falmouth, Massachusetts, USA

If you want to make art a part of your life, set up a place to draw, paint, or stitch on a daily basis. And then practice, practice, practice, with the goal not only of mastering a technique, but expressing yourself.

When I feel stuck, which happens with just about everything I make, I remind myself that it's not a setback, but an opportunity to try something completely new.

I love how each species of bird has its own distinct shape, color, and markings that invite exploration with pattern and abstraction. This piece was made to celebrate Beebe Woods, the beloved forest in my hometown of Falmouth, Massachusetts.

Birds of Beebe Woods | 30 × 24 × 1 inches; 2012 | Wool felt, thread, wire, beads | Hand stitched, stump-work embroidered, wrapped | *Photo by Rob Goldsborough*

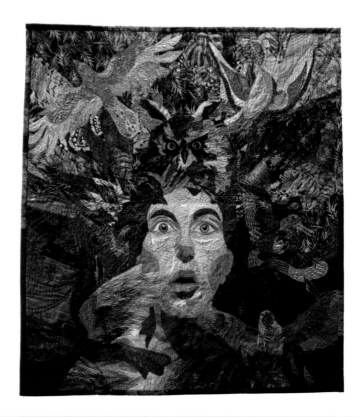

LESLEY MAYFIELD

Winlaw, British Columbia, Canada

Just make something by using whatever you have at hand. The process of making will show what you need to learn. I like to go outside to observe the marvelous forms of the natural world and the ways that energy moves through it: wind, sun, water, time.

Birds are like stitches in life's miraculous fabric, perfectly connecting what needs to be joined: insects, plants, animals, fish, entire ecosystems, including us. They are both the messengers and the message.

When they appear in my work, it's for beauty, for strength, and for frightening fragility. The inspiration of birds is to be everything that we are not: to be HERE, then, on winged intent, THERE. To travel 1,000 miles on the strength of mere ounces and feathers. To know how to go, navigating by stars and magnetic fields. To see the world from a higher perspective. To live seemingly free of the bonds that so constrain us.

But of course, they are neither "free" nor immune to harm. And the harm is us: our rampant destruction of nature's livable places, our insidious poisons, our walls of false skies, our noise, our predation, and our abysmal ignorance. If hope is the thing with feathers, then we are destroying it wholesale.

Wild Birds of My Soul Are Disturbed from Their Roost | 50 × 44 inches; 2011 | Upcycled fabrics | Pieced, appliquéd, embroidered, machine and hand quilted

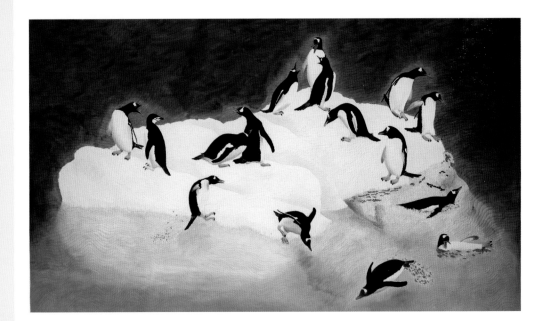

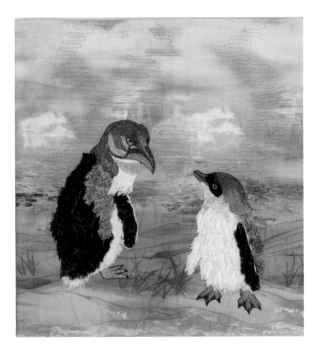

Top: Sue Sherman | *Penguin Playground* | 50 × 85 inches; 2020 | Cotton, dye, threads | Dye painted, thread painted, quilted

Bottom: Lynn Gilles | *Blue Penguin Memories, Phillip Island, Australia* | 20 × 19 inches; 2020 | Unraveled denim and canvas, commercial cotton fabric, rayon and cotton threads | Stitched, thread painted, machine embroidered and quilted

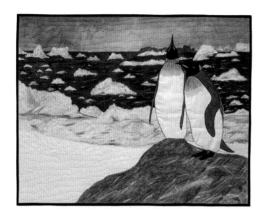

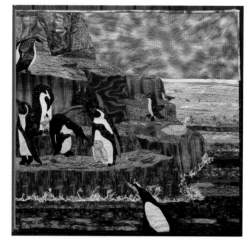

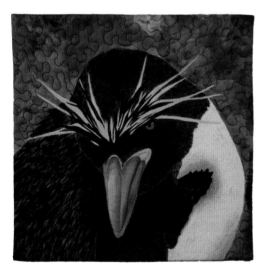

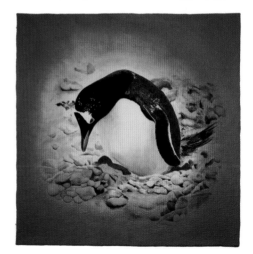

Top left: Patricia Gould | *A Pair of Kings* | 34 × 43 inches; 2009 | Silk, paints, oil sticks, threads | Painted, free-motion stitched

Top right: Phyllis Cullen | *Really Deep Southern Sunshine* | 52 × 54 inches; 2009 | Cotton, organza, cheesecloth, fake fur, upholstery fabrics, novelty poly fabrics, foil | Raw-edge appliquéd, strip pieced, foiled, free-motion quilted

Bottom left: Sue Sherman | *Macaroni Penguin* | 12 × 12 inches; 2021 | Cotton, dye, threads | Dye painted, thread painted, quilted

Bottom right: Sue Sherman | *Antarctica 18.3C* | 41 × 41 inches; 2021 | Cotton, dye, threads | Dye painted, thread painted, quilted

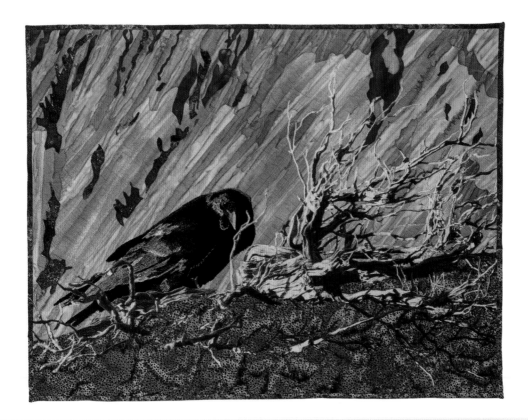

KATHLEEN MCCABE

Coronado, California, USA

If art is in your soul, listen to it. Give that voice a chance to express itself. Experiment; try different things. It doesn't need to be a masterpiece, but make art. Don't keep it to yourself.

When I feel stuck, I sort my fabric, I organize my supplies, and I look at photos I've taken that inspired me. Before long, all my ideas come flooding back.

Birds have lots of character, and their coloring is very distinct. Real birds' feathers reflect the light in different ways. Birds are always present, but they take flight easily. They come near and yet keep their distance. Their behavior is predictable, yet surprising. I can capture a bird with art in a way I cannot do in life. I love to collect bird sculptures, usually in pairs: cloth birds, wooden or ceramic birds, papier mâché.

I was hiking in Death Valley one January and took lots of pictures of this lone crow (I was told later by a bird lover that it is a raven). Its presence against the vast desert backdrop of the dry crater intrigued me, so I created *Crow at the Crater* (a.k.a. *Raven at the Rim*).

Crow at the Crater | 27 × 34 inches; 2015 | Hand-dyed and commercial fabrics | Photo transferred, fused, raw-edge machine appliquéd, thread painted, machine quilted | *Collection: Thomas Contemporary Art Collection*

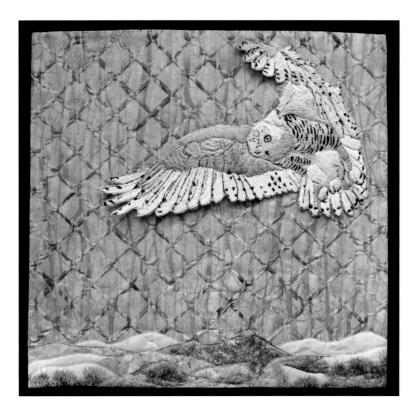

GINNY MCVICKAR

Pleasant Hill, Oregon, USA

Art requires courage. We are fearful of making mistakes and of the work not turning out how we imagined it to be. I have found that you must have the courage to let go a little and allow the piece to change as you go. You will find that something you might have thought was a mistake will turn into something better than you had originally planned.

I have a huge library of bird photos I keep from my trips, and I use those as a reference for various profiles, proportions, feather patterns, and color. I can then apply my artistic license and go to my stash and pull fabrics and embellishments to choose from. Often my final work doesn't look much like the original photo at all.

I have always been fascinated with the behavior of birds in their migration patterns, their breeding behaviors, and their physical adaptations to climate. I find their beautiful plumage coloration and feather arrangements so alluring to translate into fabric. As a career park ranger, I was able to view birds and their behaviors on a daily basis, which gave me insight to how intricately connected they are to their environment.

Snowy Owl | 16 × 16 inches; 2021 | Batiks, cottons, tulle, polyester trilobal thread | Appliquéd, thread painted, free-motion quilted

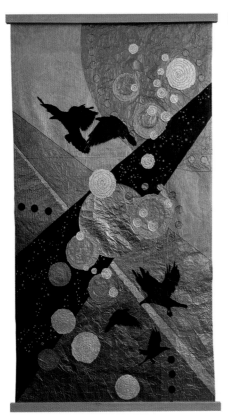
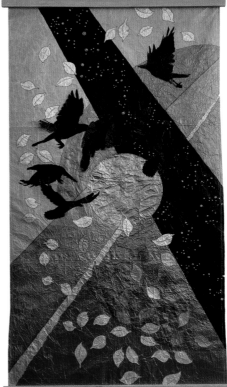
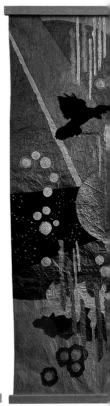

KRISTIN MEUSER

Las Vegas, Nevada, USA

Open yourself to your intuition. Let the person you are flow through your art. Think of each piece as a path to the next and the next and on and on as your style, skill, and content emerge.

As I contemplate a new project, I try to listen deeply to my intuition and heart. Soon, the elements begin a dialogue and new life emerges from the piece itself. I try to allow for mistakes and adjust to the new paths they present. It is a living thing!

What interests me about birds is the questions they inspire: How did each bird's song evolve? What do the variations truly mean? How do they know when to leave, where to go, where to stop along the way, when to return? What determines the material used by each species, who builds the nest—one parent or the other, or both? Who raises the fledglings, and are they as vulnerable as they seem? And who leads the murmurations?

This series represents the Classical Five Elements and their corresponding climate events. Crows are curious, ominous, intelligent witnesses to the escalating impact of climate change represented by Ether/Consciousness of our endangered planet, Wind/Tornados, Water/Hurricanes, Fire/Fire Storms, and Earth / Combining All.

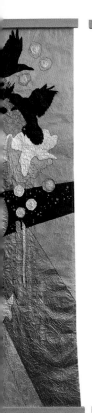
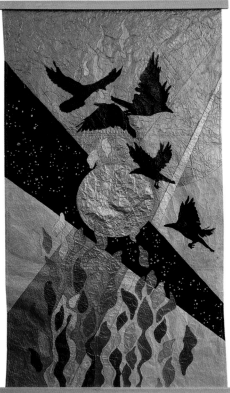
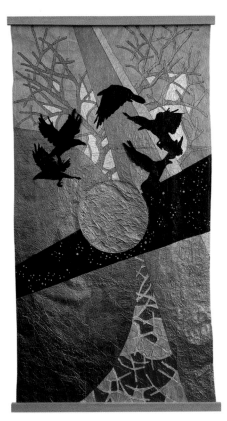
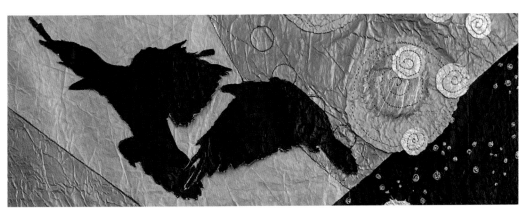

Top, left to right: *The Five Elements and Climate Change: Ether (Consciousness)* | 50 × 28 inches; 2021 | Lokta paper, thread, watercolor, acrylic, paper detritus | Painted, machine sewn

The Five Elements and Climate Change: Air (Wind Stories) | 50 × 28 inches; 2021 | Lokta paper, thread, watercolor, acrylic, paper detritus | Painted, machine sewn

The Five Elements and Climate Change: Water (Hurricanes) | 50 × 28 inches; 2021 | Lokta paper, thread, watercolor, acrylic, paper detritus | Painted, machine sewn

The Five Elements and Climate Change: Fire (Fire Storms) | 50 × 28 inches; 2021 | Lokta paper, thread, watercolor, acrylic, paper detritus | Painted, machine sewn

The Five Elements and Climate Change: Earth (Holding All of It) | 50 × 28 inches; 2021 | Lokta paper, thread, watercolor, acrylic, paper detritus | Painted, machine sewn

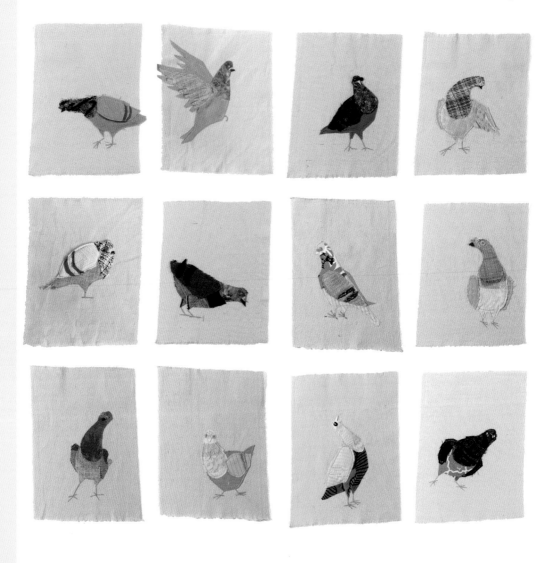

Tracey Cameron | *Pigeons* | 30 × 60 inches; 2016 | Recycled fabrics, thread, leather, ribbon, paint | Raw-edge appliquéd, collaged, quilted, painted

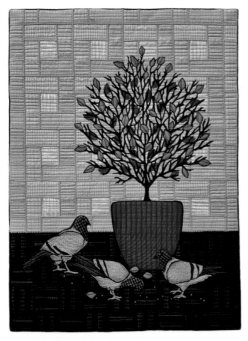

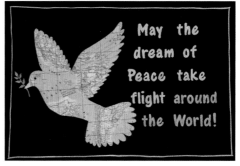

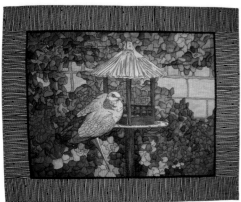

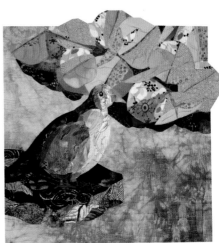

Top left: Terry Howard Grant | *Pigeons* | 24 × 18 inches; 2021 | Commercial fabrics, overdyed, recycled shirt fabrics, cotton cording | Machine appliquéd and quilted

Top right: Christine Rohn Hartman | *Dove of Peace* | 20 × 30 inches; 2016 | Cotton, beads, rubber stamp / fabric ink, fabric pens | Fused appliqué, beaded, stamped, inked, machine quilted | This was inspired after the bombing in Paris in 2015.

Bottom left: Sherry Davis Kleinman | *Balancing Act* | 40 × 40 inches; 2015 | Cotton twill | Digitally drawn photo, printed, painted, machine and hand stitched | *Photo by Steven Kleinman*

Bottom right: Marya Lowe | *Morning Mourning Dove* | 20 × 19.5 inches; 2019 | Cotton | Fused collage, machine quilted

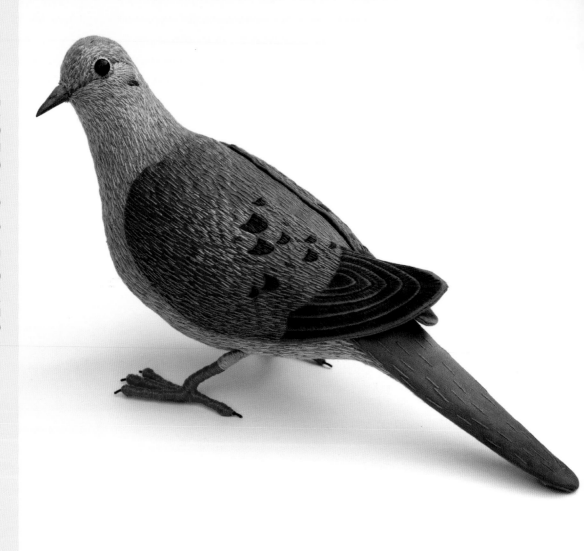

Laura Schlipf | *Mourning Dove* | 6 × 4 × 9 inches; 2019 | Cotton, wool stuffing, embroidery thread, wire, wood, glass |
Embroidered, sewn, whittled

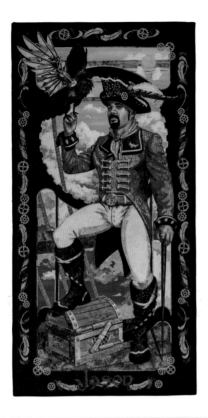

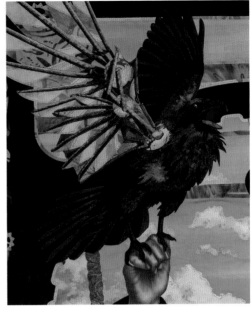

Detail

KESTREL MICHAUD

West Melbourne, Florida, USA

Make art you like, whatever subject or medium that may be. Don't force yourself to make art on someone else's terms. If you aren't having fun, it's just not worth it. Be passionate and excited about your project. Nothing gets the creative juices flowing like excitement about the piece.

I was probably predestined to have an affinity for birds because of my name. My parents were avid birdwatchers, which is how I ended up with the name "Kestrel." My first word was "duck." My second word was "bird." One of my favorite vacations as a kid was our yearly visit to Crane Creek State Park (Ohio) to see the birds in migration. We'd camp in nearby Maumee State Park, and I remember chasing the wild pheasants through the tall grasses. In the morning we'd head over to Crane Creek, which is where I saw my first eastern whip-poor-will — although

not until it yawned. Its camouflage was so perfect, I couldn't see it until it opened its bright-pink mouth.

One of my favorite memories is of going to the National Aviary in Pittsburgh with my mom to draw and paint for a day when I was around eight years old. There was this great curassow whom we dubbed "Curly" because of the curly feathers on top of his head. He kept stealing my pencils and running off with them! I'd have to chase after him to get them back. It was awesome and infuriating.

Jason | 52 × 26 inches; 2019 | Cotton | Raw-edge fused appliqué, commercially printed

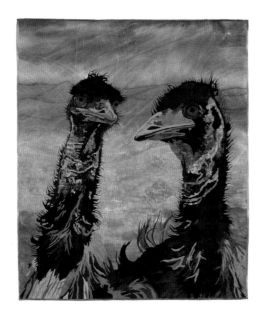

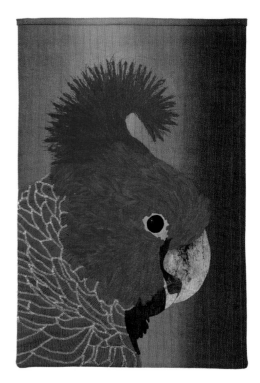

BETH MILLER

Kambah, Australian Capital Territory, Australia

Don't be afraid to have a go. Take lots of photographs and use your own images if possible. If you would like to use another person's image, ask for written permission before you start your artwork.

I regularly take photographs, which I download onto my computer. Every now and again, I will go through the collection to select photographs that fit into a theme or ones I would really like to make into art. I examine each photo to determine if it needs to be cropped to make it a more powerful or balanced image. I print out each image, then pin the selection onto the design wall so that the final selection can be made.

I love having birds in the garden, since they bring a sense of peace and joy with their chorusing and their comical behavior and antics. Their grace when flying, the colors of their feathers, their nesting habits, and the way they look after their babies all inspire me to make quilts that showcase birds.

Gang Gang Cockatoo—Callocephalon fimbriatum is the Australian Capital Territory Faunal Emblem. This piece is based on a photograph supplied by Peter Fullagar, used with permission.

Left: *Bush Larrikins* | 79 × 62.5 inches; 2003 | Commercial, hand painted, and hand dyed fabric | Fusible appliquéd, machine quilted | *Photo by: David Paterson*

Right: *Gang Gang Cockatoo—Callocephalon fimbriatum* | 19 × 17 inches; 2013 | Commercial cotton | Fused appliqué, machine embroidered, machine quilted | *Photo by David Paterson*

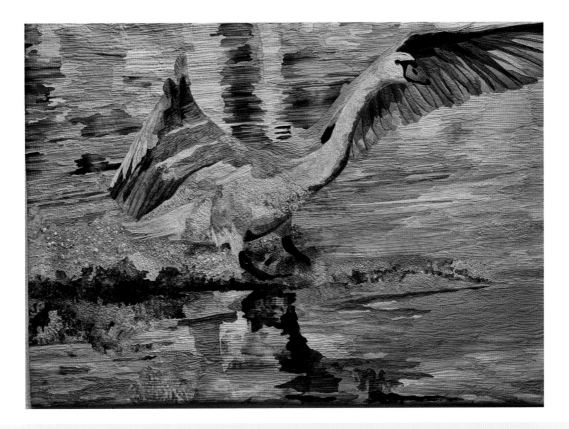

SANDRA MOLLON

Valley Springs, California, USA

The best advice I can give is to keep working! It takes lots of practice in any art or sport to develop the skills you need. I consider that I am still learning. But I enjoy it; it's the thing that gets me out of bed in the morning, and often the last thing I do each evening is to evaluate my work.

I started with a photo by Ken Miracle. I love reflections; that is one of the things that drew me in, plus the graceful movement and energy of the splashdown.

The Mute Swan | 35 × 46 inches; 2019 | Hand-dyed and commercial cottons | Raw-edge fused appliqué, machine quilted | *Derived from a photo by Ken Miracle; used with permission*

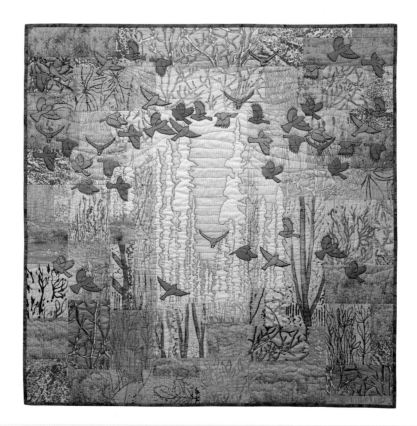

REE NANCARROW

Fairbanks, Alaska, USA

Do not be afraid to try something new. My work changes each time I learn a new technique or gain some new information about the natural world. It is what energizes me and keeps me enthusiastically tackling new ways of expressing myself.

I think carefully about the story I want to tell and then gather images of all aspects of that story. I select colors and hand-dyed fabrics that imply the season of the year or time of day. Then I gather images of the vegetation the birds live in and images of the birds themselves.

My goal is not to achieve an exact representation of a specific place, but to capture its feeling and energy. As a piece is developed, elevation, ground cover, season of year, and species of plants and animals are often considered. Accurate representation and interpretation of that particular place are achieved using both printed and quilted images.

There are very few species of birds that overwinter in Fairbanks, Alaska. One of the first signs of spring is the return of migrating nesting birds, which arrive before our snow has melted, and bring thoughts of the coming summer season. *Gathering to Migrate* depicts songbirds as they flock together to fly south for the winter. I am inspired by all birds, but particularly those that are being impacted by climate change.

Gathering to Migrate | 40 × 40.5 inches; 2014 | Cotton, dye, paint | Silk screened, deconstructed silk screened, stenciled, stamped, painted | *Photo by: Eric Nancarrow*

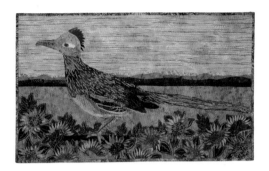

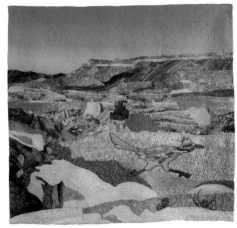

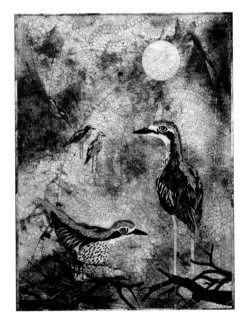

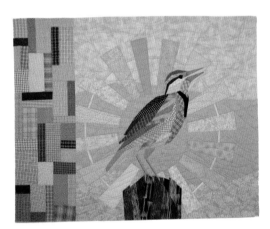

Top left: Lynn B. Welsch | *Roadrunner* | 19.5 × 32 inches; 2019 | Commercial and dyed cottons, beads | Fused, free-motion machine quilted, hand beaded

Top right: Robyn Gold | *Beep, Beep!* | 33 × 36 inches; 2018 | Cottons, button, pearl cotton thread, watercolor pencils | Hand appliquéd, machine quilted, embellished, colored | *Photo by Carl Valle*

Bottom left: Linden Lancaster | *Bush Stone-Curlew* | 40 × 30 inches; 2018 | Cottons, paint | Whole cloth monoprinted background, collaged, thread sketched, quilted | *Photo by Cameron Lancaster*

Bottom right: Shelly Burge | *Prairie Serenade* | 39 × 48 inches; 2013 | Cottons | Machine pieced and quilted

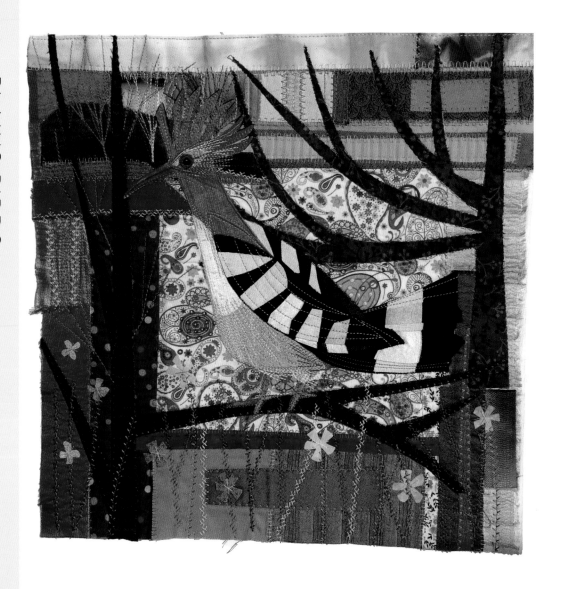

Rachel Sumner | *Spring Hoopoe* | 12 × 12 inches; 2018 | Fabric, thread | Pieced, appliquéd, machine embroidered

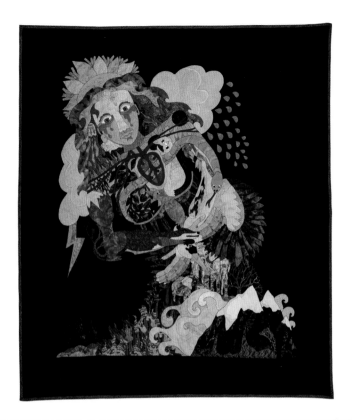

KATHY NIDA

El Cajon, California, USA

Make lots of practice pieces that you don't feel you need to finish. Take lots of classes from a variety of teachers, because you don't know what will stick. Give it time . . . most of the artists you see have been doing it for a long time. Don't give up on yourself. Honestly, if you enjoy what you're doing, it doesn't really matter if anyone else does. Just keep making.

I start by drawing. Once I start drawing, something will eventually come out of it. I love that I can use the basic bird parts (head, beak, wings, body, tail) and make up whatever kind or color or design of bird that I want, because the real ones have so much variety that you can't really argue with whatever I design.

I love the symbolism of birds: some for peace and love, some for wisdom, some harbingers of death, some protectors, some not. And of course, I love the idea of flight, of being able to take off from the earth and just roam, playing in the wind, diving down for prey. I often use ravens and a bird that seems to look a bit like our hawks. I also draw lot of owls; they stand for wisdom and knowledge.

Earth Mother for Ventura | 64 × 55 inches; 2015 | Commercial and hand-dyed cottons | Fused appliqué, machine stitched, machine quilted | *Photo by Gary Conaughton*

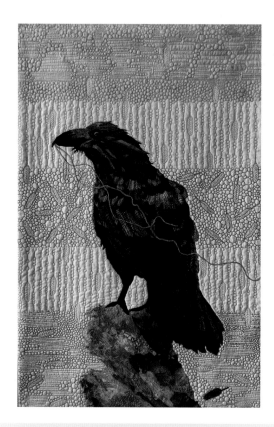

MARGARET A. NOAH

Montrose, Colorado, USA

I like this quote from Sheryl Sandberg: "Done is better than perfect." You need to finish your art; don't put it away. You will learn so much by finishing!

The life around my bird feeders is better than any TV show. I keep binoculars close by so I can watch the birds. They are good for my soul.

I love crows! They adapt to their surroundings, whether it is sitting on a fence post out in the desert or having a scavenger hunt in a parking lot with friends. They are clearly very intelligent birds.

Maybelle | 56.5 × 37.5 inches; 2020 | Cotton, paint, colored pencils | Raw-edge fused appliqué, free-motion quilted

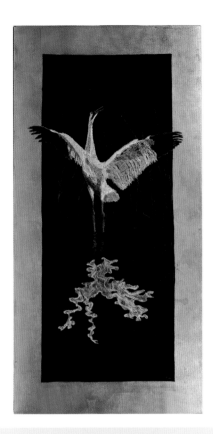

MARY PAL

Toronto, Ontario, Canada

My advice to beginning textile artists is just to sit down in your studio and start creating with textiles and stitch. You will find that new ideas are constantly generated and your skills honed while you work. As the artist Sol Lewitt said, "Just do!"

Because my work is representational, a photo of a possible subject is often a great starting point for creating a new work. It raises tantalizing challenges: how best to depict that subject, how to tackle the environment the subject will be situated in, and how to design an artwork that is worthy of viewers' time and contemplation.

Birds are inspiring not only because of the beauty of their movement and their embodiment of freedom as they soar in the sky, but also their stunning plumage and the almost human expressions they are capable of. I am especially intrigued by the intelligence and personality of crows and ravens. But in *Upon Reflection*, my goal was to depict the elegance and majesty of the crane.

Upon Reflection | 48 × 24 × 1.5 inches; 2013 | Hand-dyed cheesecloth, dupioni silk, gold leaf | Sculpted cheesecloth stitched to dupioni silk | *Photo by Ray Pilon*

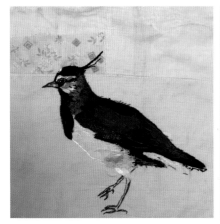
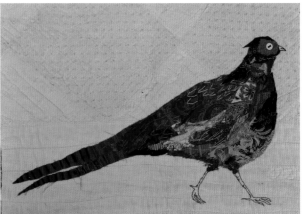

MANDY PATTULLO

Newcastle, UK

Always research thoroughly: look at both photographs and drawings of the type of bird you want to represent, so you know the bird intimately. Develop your own style.

Finding a palette of fabrics is always the starting point. Because I work in a collage style and use very small fragments, there is no limit as to what I can use, so I will often mix cottons with sheers and with finds from charity shops, such as scarves. This thinking and gathering part of a project is always really exciting and motivating.

I am attracted to the plumage of the birds and to their silhouette. I am particularly fascinated by the ways artists and illustrators have depicted them in art, such as Audubon, and in bird identification guides. I like reading the descriptions of the colors and plumage, but what really captures my imagination is the character of the bird, and this is what I am always trying to portray.

I am interested only in depicting birds that I have seen, or that are from the north of England, where I live. I am lucky to live a short drive from a coastal nature reserve and in the other direction can quickly get out to hills and heath, so we have a wide diversity to observe. I am particularly inspired by the exotic nature of some of our common local birds, such as the lapwing and the pheasant.

Left: *Lapwing* | 10 × 12 inches; 2019 | Antique quilt, variety of fabrics | Collaged
Right: *Pheasant* | 11 × 16 inches; 2018 | Antique quilt, variety of fabrics | Collaged

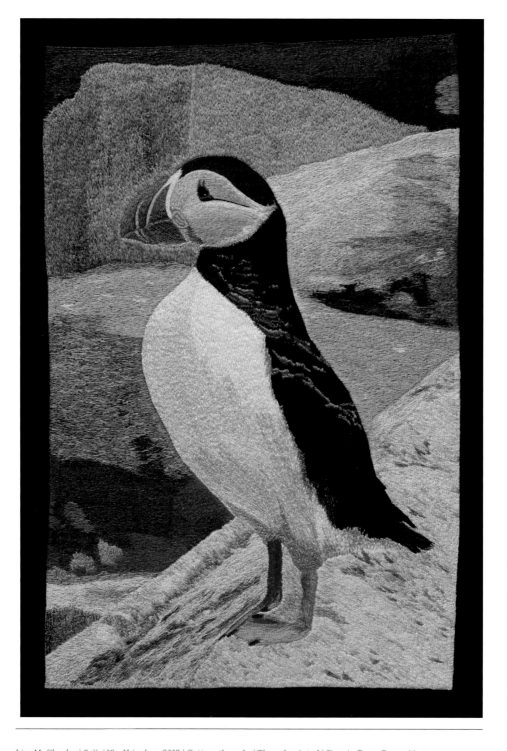

Lisa M. Charles | *Puffy* | 18 × 11 inches; 2012 | Cotton, threads | Thread painted | *Photo by Teresa Garrett-Martin*

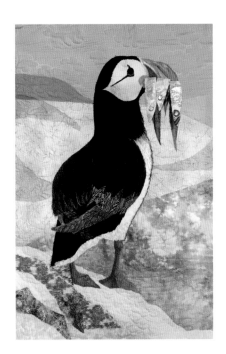

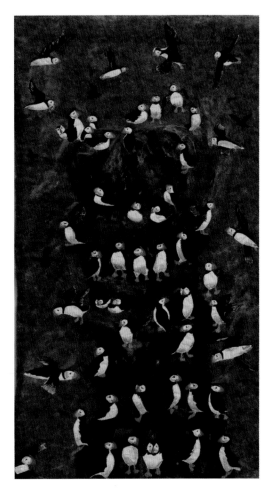

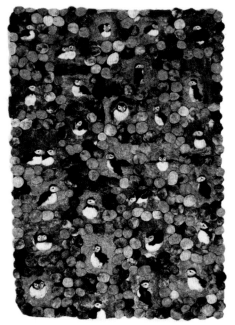

Top left: Tamar Drucker | *Puffin* | 36 × 24 inches; 2005 | Cotton, yarns | Collaged | *Photo by Bruce Rosebaum*

Bottom left: Heidi Strand | *The Habitat of Puffins* | 70 × 50 inches; 2015 | Wool, fleece, cotton | Needle and wet felted, hand sewn

Right: Heidi Strand | *On the Ledge* | 52 × 31 inches; 2007 | Wool, fleece, cotton | Needle and wet felted, hand sewn

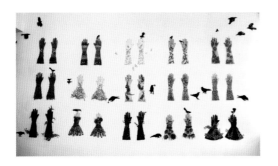

Detail

SHARON MARGARET PEOPLES

O'Connor, Australian Capital Territory, Australia

Turn up each day in your studio / making space and work on something. For me, stitch meditation for ten to twenty minutes is perfect, since it means that I'm already stitching. Then I write in my journal, which gives my day a form.

I first began working with imagery of birds after the death of three close family members. Birds are often seen as intermediaries between the natural / physical and spiritual realms. Perhaps this is because they are as comfortable in the air as on the water and land. I was particularly drawn to black-colored birds: crows, currawongs, choughs, Australian magpies, and European blackbirds. I machine-embroidered with black thread on soluble fabric. Once washed, black "lace" remained. I used this like black Spanish lace—a signifier of mourning in many cultures.

More recently, songbirds have become inspirational. I often feel as though the birds are trying to communicate with me. The song of the Australian magpie is beautiful. They seem as though they are caroling along to ensure they get some food from humans. During Australia's COVID-19 lockdown last year, I worked in the garden and was accompanied by a willie wagtail, who followed me as I turned the soil—hoping to find grubs to eat. This inspired a whole new series of work called Gardening Gloves.

Left: *Wall of Namadgi Gloves* | 108 × 144 × 1 inches; 2021 | Cotton, linen, polyester, threads | Machine embroidered on soluble fabric
Right: *Blue Gardener* | 63 × 33 inches; 2021 | Nylon, threads | Machine embroidered on soluble fabric

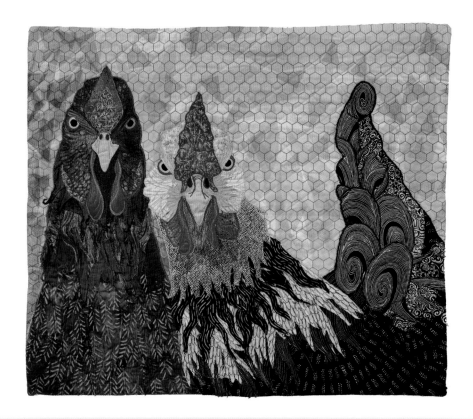

PAMELA PILCHER

Portland, Oregon, USA

Be flexible. Everyone has their own style of creating, just as we each have our own learning style. Some artists plan a piece out in every detail before they start working. I tend to be more intuitive. The result may be quite different from my original sketch. I keep experimenting until I am happy with the result. Some pieces come together easily, and others are exhausting. Don't be afraid to walk away from it for a while and return to it with fresh eyes.

I started feeding and watching birds in my twenties and have added to my "life list" sporadically through the years. Cataracts are making it difficult to see the details of birds in the wild these days. The colors get lost in the glare against the sky. But listening to the song sparrow that hangs out in my backyard makes up for the drab browns it displays.

Given my enjoyment of flight and voice described above, why would I choose chickens? My daughter's family raised backyard chickens for a couple of years. They were much more colorful than those I knew as a farm girl decades ago. They had an attitude about them that I found fascinating.

Mad as a Wet Hen | 22.5 × 26.5 inches; 2018 | Cotton, garment fabrics, tulle | Collaged, raw-edge appliquéd | *Photo by Rebecca Pilcher-Cleland*

174

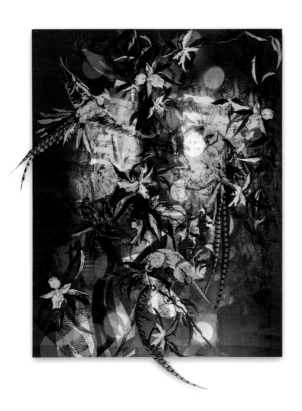

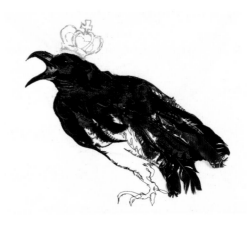

JACKY PUZEY

Bristol, UK

Push yourself and your creativity. Try new things, take advice, look at how more-established artists have progressed. Work for an arts organization; you will learn invaluable skills. Exhibit as much as possible.

For me, the key is always drawing! And research, both visual and contextual. I love to visit the V&A in London for exhibitions of historical and contemporary fashion and textiles. I go for long city walks, getting immersed in a city's culture and looking for wildlife, from the expected urban pigeons to the peregrine falcons that thrive on New York's skyscrapers.

I find birds fascinating—I love the texture of the feathers, the freedom of their flight, and how they are used as symbols across cultures, from the Raven of the Norse gods to the Phoenix rising from the ashes.

My raven embroidery was inspired by meeting the farmer who breeds the ravens for the Tower of London. Parakeets are now a highly visual part of London's open spaces: displaced bright, chattering, lime-green birds, making London their home. Peacocks are also migrant birds, brought over during the British colonial period to decorate country estates, and now are iconic garden residents of many UK stately homes.

Left: *The Dandy Parakeet's Screen* | 55 × 47 × 2 inches; 2016 | Duchesse satin, custom-dyed feathers, embroidery | Digitally embroidered, painted, drawn, appliquéd, digitally printed | *Photo by Becca Luger*

Right: *The Raven* | 39 × 39 × 1 inches; 2017 | Cotton organdy, laser-cut paper silk, silk organza, custom-dyed black feathers | Digitally embroidered, painted, drawn, appliquéd, digitally printed | *Photo by Jo Hounsome*

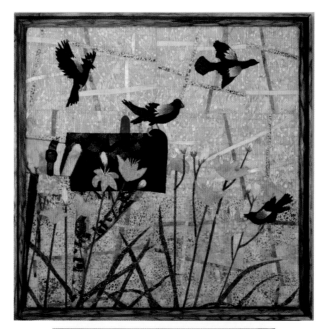

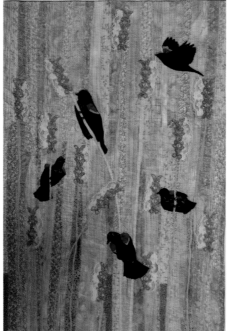

Top: Kathie Briggs | *Mail Call* | 21.5 × 21.5 × 2 inches; 2020 | Commercial cotton | Machine pieced, raw-edge fused appliqué, machine quilted

Bottom: Molly Eckes Flowers | *Redwings and Winter Cattails* | 28 × 19 inches; 2016 | Cotton, cotton and rayon lace, raffia, beads, embroidery floss | Raw-edge appliquéd, beaded, couched, hand embroidered, hand quilted, painted

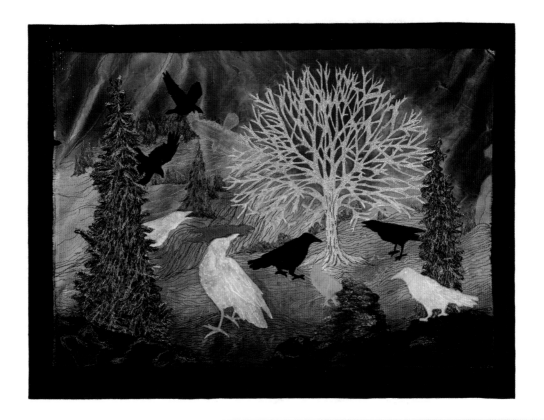

DOROTHY RAYMOND

Loveland, Colorado, USA

Make things for the fun of it. Don't seek perfection; let things flow. Explore many different styles and techniques. Join an arts organization like Studio Art Quilt Associates.

To get inspired, all I need to do is look through my fabric stash and the ideas come jumping out at me. My problem is lack of focus, not lack of creativity.

The ability to fly has always intrigued me. I live on a small lake and get to observe many birds. When I see them soaring above the water, I wonder if they are doing it for joy or if there's other social behavior going on. Maybe they are soaring with their imaginary companions.

Crow Mountain began with a piece of hand-painted fabric that suggested a cold, frosty night. Crows are very intelligent, but what if they also had imagination? In the mountains among the trees seems like the perfect place for reality to fade and imaginary companions to emerge.

Crow Mountain | 18 × 24 inches; 2019 | Silk, cotton, fabric markers, nonwovens, thread | Hand-painted and sun-printed silk; appliquéd, thread painted | *Photo by Allan Snell*

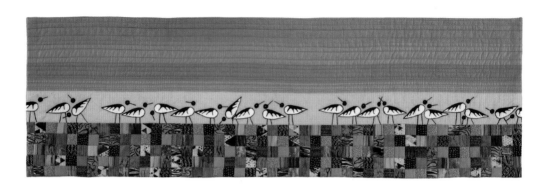

BETH AND TREVOR REID

Gowrie, Australian Capital Territory, Australia

Try to find your own voice, and never give up. Take part in the art community: join groups, ask lots of questions. There isn't a right or wrong way of doing things; it is your way.

We love the diversity among bird species: the colors and the different calls they make. We have a large population living in our garden in Canberra that give us pleasure every day, from noisy white sulphur-crested cockatoos that wake us in the morning flying over the house, king parrots with their scarlet breasts, and satin bower birds that are always on the lookout for anything blue. It's amazing that the native magpies that live in our garden can identify us as friends and won't swoop during nesting season. But let a person they don't know come down the street, and all hell breaks loose.

With the oystercatcher, a wading bird, we were fascinated by the way they feed along the shoreline, probing the sand or mud with their long beaks, but always on alert for danger.

Oyster Catchers—the Shoreline | 14.5 × 50 inches; 2015 | Cotton, paint | Machine pieced and quilted, individually drawn and painted birds | *Photo by David Paterson*

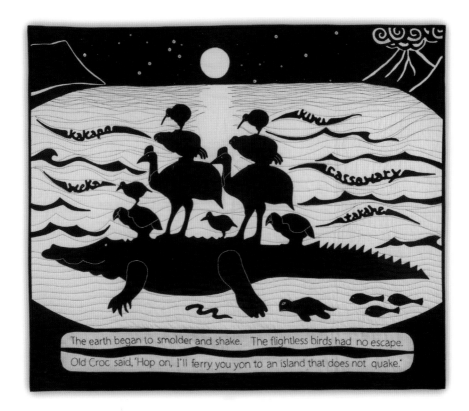

The earth began to smolder and shake. The flightless birds had no escape.
Old Croc said, "Hop on, I'll ferry you yon to an island that does not quake."

DEBORAH ROCHA

Newton, Massachusetts, USA

Color, composition, and line are the artist's tools, and we improve our use of them with each work we make. Creating art is a process, and we all make mistakes, but if we learn from our mistakes, we transform them into lessons. The sense of play, the excitement of curiosity, the joy of creating, and the trust in our muses lead us in a direction we need to go. These are the treasures of the artist's life.

Birds capture my imagination with their flight, song, beauty, and color. In a class of their own are the flightless birds, who are perhaps closest of all to their dinosaur antecedents. Would they trust a croc to ferry them to safety? They are, after all, distant cousins . . .

Plight of the Flightless | 36 × 43 inches; 2020 | Cotton, thread, embroidery floss, sequins, glass beads | Reverse hand appliquéd, embroidered, beaded | *Photo by Joe Ofria*

VALERIE RODELLI

Inverness, Illinois, USA

Do what you feel in your art; don't let the self-doubt roll in. Have trusted people or organizations who understand what making art is really about. They will feed your creativity.

I find that just getting into the studio motivates me to work on a project. It is my happy place. While calming music is playing and my essential-oils diffuser is running, my thoughts usually turn to some form of creativity. I switch mediums often to keep myself involved in making something. Clarity often comes when one takes a break and returns to it with fresh eyes and thoughts.

Birds are fascinating. There are many species around my neighborhood, from small finches to large egrets. I watch them in my yard with interest and delight. Each species has distinct songs and nest-building activities. In researching birds, I found that the same species of bird can have several songs. The cardinal can have a mating call and a territorial song. Their ingenuity in building a nest is amazing, scavenging around for just the right twig or scrap, then building a nest in a very short time. Nests can be in trees, on rainspouts, in bushes, or on the ground. The birds are protective of their nest and chase any invader in their territory or near that nest. It is wonderful to see the chicks hatch, grow, and fly away!

Birdsongs | 20 × 8 × 10.5 inches; 2016 | Old music books, paper, cloth, clay, paint, dowel | Folded, molded, painted, collaged | *Photo by Patrick Fraser*

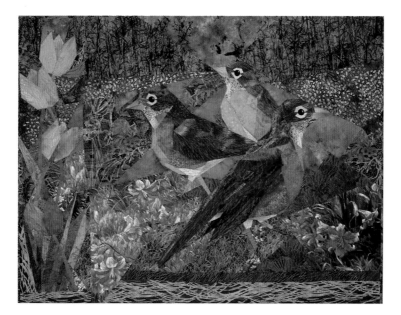

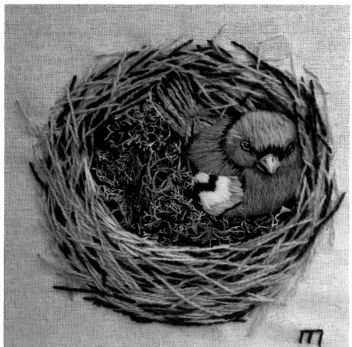

Top: Ruth Powers | *Early Birds* | 38 × 49 inches; 2005 | Hand dyed and commercial cottons. | Machine pieced, free motion machine quilted

Bottom: Tina Nelson | *Nest with Moss and Robin* | 8.5 × 8.5 × 1 inches; 2021 | Linen, wools, moss | Hand stitched

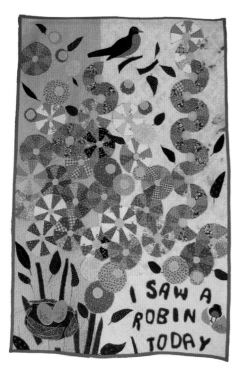

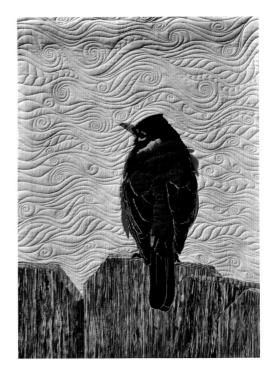

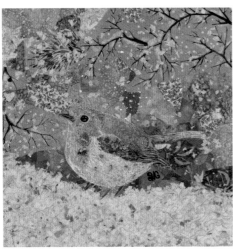

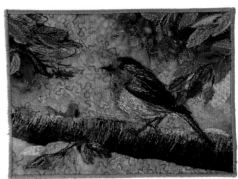

Top left: Sylvia M. Weir | *I Saw a Robin Today* | 60 × 45 inches; 2017 | Cotton | Machine pieced and appliquéd | *Photo by William Lemke*

Top right: Kim Frisk | *Waiting on Spring* | 48 × 36 inches; 2020 | Cotton, silk, threads, paint | Fusible appliquéd, free-motion quilted

Bottom left: Holly Anne Gardner | *Patience for Spring* | 12 × 12 inches; 2020 | Cotton, tulle | Collaged, thread painted

Bottom right: Ludmila Gancova | *Robin* | 5 × 7 inches; 2020 | Fabric, threads | Raw-edge appliquéd, free-motion quilted, thread painted | *Photo by Doug Conley*

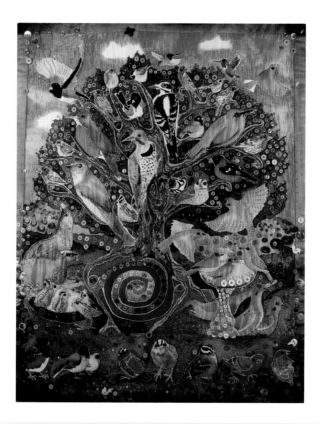

JUDITH RODERICK

Placitas, New Mexico, USA

Follow your heart! Do what excites you, what inspires you, what brings you joy and delight. Birds bring life, beauty, movement, and song to my world, to my landscape. Anywhere in the world that I have traveled or lived, birds are there. They bring hope, a smile, an uplifting, a delight to life on planet Earth.

I appreciate the myriad of species at my feeders each day throughout the seasons, and I welcome the arrival of the thousands of sandhill cranes that winter in the Rio Grande valley near my home. These human-sized, graceful, ancient birds have been around since the age of the dinosaurs, and their return always makes the heart glad!

The birds that I am the most like are the bowerbirds, the arrangers. They carefully construct a complex bower and then collect and display thousands of colored objects in a pleasing manner. I delight in depicting them and helping them decorate their bowers.

I generally embellish my art, after machine quilting, with my large, rich, and varied button collection. I am often gifted with these family treasures, and I find the hand sewing of carefully chosen buttons to be a very satisfying and meditative experience.

Tree of Life | 42 × 34 inches; 2010 | Hand-painted silk | Painted, hand quilted and embellished

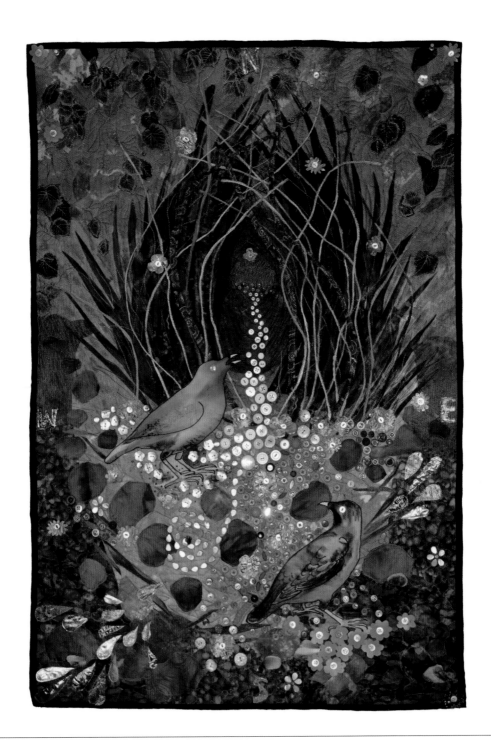

Myself as a Bowerbird | 48 × 32 inches; 2013 | Silk | Painted, machine quilted

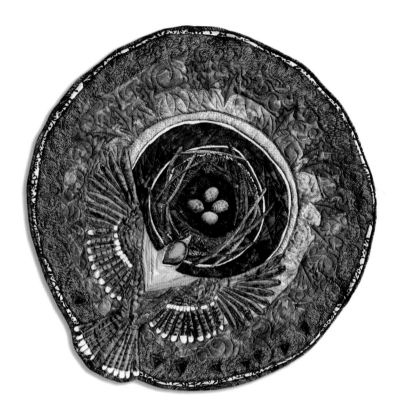

LORRAINE ROY

Dundas, Ontario, Canada

Focus. This might sound strange, but one of the hardest things to do at the start is to cut a path apart from the multitude of shiny subjects and techniques available. Choose just one or two and study them until you know them as intimately as your own hand. The more you learn, the more inspiration comes.

What I love most about birds is their ability to appear and then disappear again as if by magic, perfectly blended in their respective environments. They also appear and disappear from one season to the next. This mirrors how well connected they are to the local climate and with other living forms.

I choose to portray the birds that live on my own property, especially those that are indigenous. I love watching how the numbers change from year to year, with new species making themselves at home while others move on to other places.

This Avian Heart #2 | 35 × 35 × 1 inches; 2019 | Cotton and synthetic fabrics, threads | Raw-edge appliquéd, machine embroidered, quilted

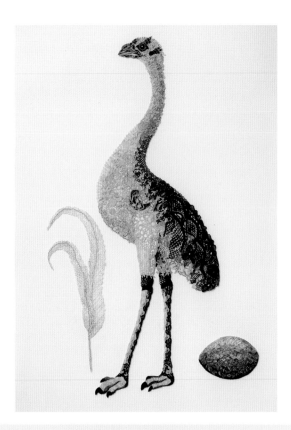

LOUISE SAXTON

Kew, Victoria, Australia

Experiment, have fun, work hard, and be true to yourself and what you love, rather than following what seems fashionable at the time. My past sixteen years working with discarded domestic needlework came to me after decades of drawing and painting. It has sustained my practice because of the materials' strong connection to my family lineage of women needleworkers.

I have a lifelong love of birds, especially Australian native birds, having spent time surrounded by natural bushland growing up in the Blue Mountains in New South Wales.

In 2010, a series of books published by our National Library on natural-history illustration inspired my Sanctuary Collection. I chose to hugely increase the scale of the original paintings and to reinterpret each bird in reclaimed needlework, pinned with delicate lace pins to nylon tulle. I was drawn to the idea of relating everyday embroidery

and lace, once commonplace and now quickly vanishing in our consumer-driven world, to the vulnerability of disappearing species within the natural world.

In some of my Sanctuary Collection pieces, the original painting led the way. In others, it was my collection of found, foraged, and collected materials, which inspired the choice of a particular bird.

Going to Jackson (after George Raper, 1791) | 62.5 × 4 inches; 2012 | Reclaimed needlework (vintage and antique embroidery, lace), lace pins, nylon tulle, beading pins on museum foam core | Assemblage | *Photo by Gavin Hansford, Australia*

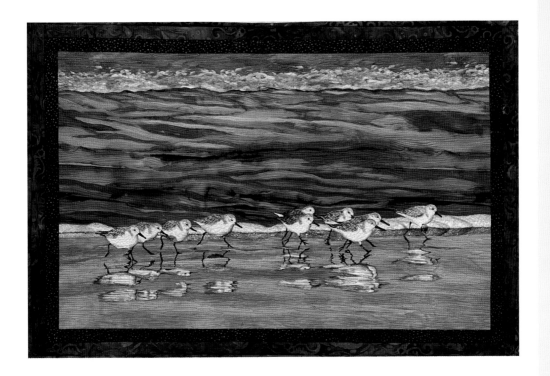

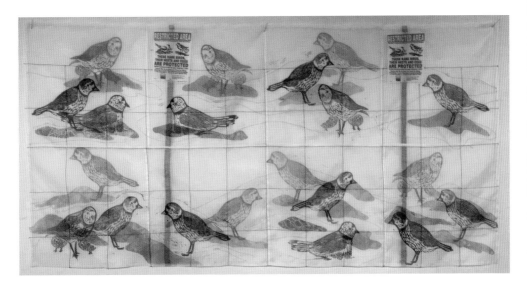

Top: Lenore Crawford | *Sanderlings* | 22 × 32 inches; 2021 | Fabric, paint, thread | Raw-edge fused, painted, top stitched

Bottom: Nancy Crasco | *Plovers' Plight* | 24 × 48 inches; 2017 | Silk organza | Linoleum and gelatin plate prints, bojagi construction, machine quilted

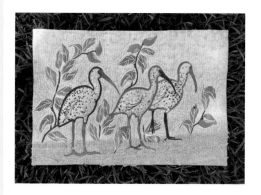
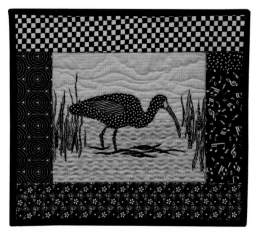

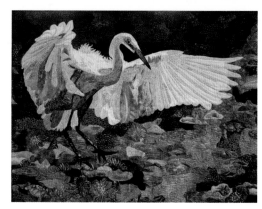

Top left: Erlinda Rejino | *The Three Amigos* | 19 × 28.5 inches; 2020 | Cotton, thread | Raw-edge appliquéd, machine quilted, hand embroidered and stitched

Top right: Heidi Beltz Sandkuhle | *White Faced Ibis* | 14 × 15.5 inches; 2013 | Cotton, bridal tulle netting | Appliquéd, quilted

Bottom left: Brenda Wood | *Curlew* | 24 × 24 × 2 inches; 2020 | Cotton, acrylic pens, paint, ink | Embedded fibers, drawn, stitched, painted

Bottom right: Jerri A. Stroud | *Soft Landing* | 31 × 40.5 inches; 2018 | Cotton, batik, tulle | Collaged, free-motion quilted

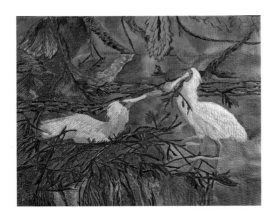

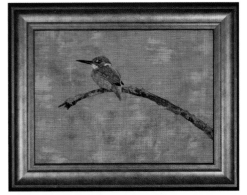

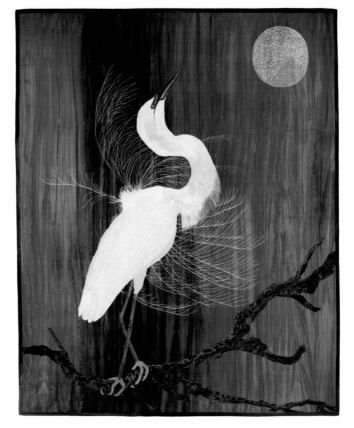

Top left: Janet Herman | *Spoonbills Nesting* | 16 × 20 inches; 2017 | Cotton, paint | Painted, free-motion embroidered

Top right: Angela Knapp | *Patience* | 20.5 × 26.5 inches; 2020 | Fabric, paint, threads | Layered, painted, free-motion embroidered

Bottom: Chris E. Eichner | *Daisagi* | 41 × 33 inches; 2015 | Batik | Fused appliqué, thread painted | *Photo by Jeff Norman*

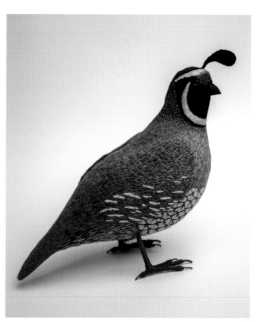

LAURA SCHLIPF

Los Angeles, California, USA

Just make something, then keep making things. Making mistakes—even failing—is necessary and desirable in the process of improving and progressing, so don't ever be discouraged when things don't turn out how you'd hoped.

I try to look at the world around me with fresh eyes. I pretend I'm seeing it all for the first time, and I allow myself to be amazed by all the things I normally take for granted.

I'm interested in the way that people's personal connections with birds tie into the story of their lives. For so many people, a certain type of bird represents a place that they've lived, a person they've loved, or a significant moment in their life. Because you can find birds everywhere on Earth, all people have some type of connection to them.

I'm inspired by the ordinary, "mundane" birds that surround me. If I take a minute to look closely at a bird that's so common and normal in my daily life that I barely notice it, such as a house finch or a mourning dove, and really consider it as an individual living thing, I'm always surprised to realize how beautiful and amazing they are. Their colors, patterns, and songs, the way their bodies are adapted to their environments and fill their ecological niches—it all feels miraculous.

Left: *Bee-Eater* | 9 × 4 × 7 inches; 2020 | Cotton, wool, wood, wire, glass | Embroidered, sewn, carved
Right: *Quail* | 9 × 5 × 9 inches; 2021 | Cloth, wool stuffing, embroidery thread, wire, wood, glass | Embroidered, sewn, whittled

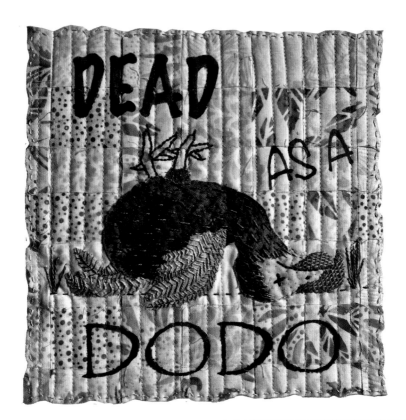

JANET SCRUGGS

Kamloops, British Columbia, Canada

Try everything and anything. Don't limit yourself to one style of working. Research all types of art, from graffiti to crochet. It is amazing to see how some artists take a traditional craft or art form and push its limits to new heights.

My go-to method for jump-starting my creativity is to look at other artists' work, whether in person, in books, or on the internet. This might be famous painters or modern textile artists. Jan Beaney and Jean Littlejohn videos and books never fail to inspire me and get me thinking creatively.

As a young girl, I had fantasies about flying. I even had a recurrent dream about being able to fly around the house by kicking my legs. As an adult, I find the endless variety of birds to be fascinating, yet there are so many that I will probably never encounter. Each one is unique, in form, color, lifestyle, and nesting. I grew up on the prairies but have lived and visited coastal areas as well. This has led to a fascination with bird species found near water and the ocean: herons, sandpipers, osprey, and loons. Such endless variety and beauty is inspiration enough to fuel any imagination.

Dead as a Dodo | 8 × 8 inches; 2021 | Cotton, embroidery thread, watercolor pencil blocks | Raw-edge collaged, hand stitched, stencilled

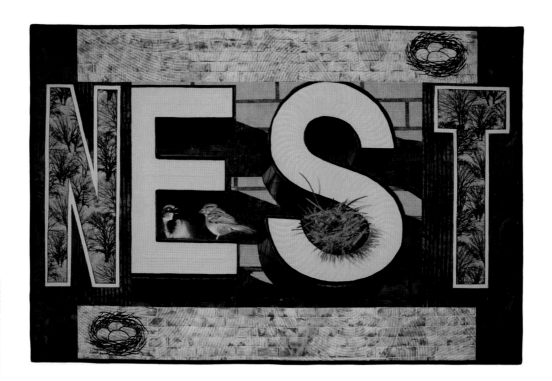

SARA SHARP

Austin, Texas, USA

An artist must always be learning. If you need practice drawing, stitching, or painting, put in the hours to improve your skills. Keep your mind open to new ideas and techniques to help your work remain fresh. Be willing to submit your work to competitions, so you can learn from rejection and occasionally enjoy success and appreciation from your peers. If you are able to teach and pass along your knowledge to others, do so with gratitude for those who have encouraged you.

I have been a birdwatcher all my life. In recent years, I have loved trips to observe shorebirds along the Texas Gulf coast. My favorite hometown bird is the painted bunting, one of the most colorful birds on the US mainland. The royal-blue, chartreuse, green, and scarlet-red colors on this bird appear almost neon in intensity. It can be a challenge to catch sight of this rare bird, since it is quite shy of humans.

My bird quilts are based on my own photographs, taken with a long lens on my digital SLR camera. My favorite way to show the shading and texture of bird feathers is by using hand-guided, free-motion machine thread painting. This technique requires scores of different shades of thread, intensely stitched and layered to create the appearance of feathers.

Suburban Nest | 32 × 48 inches; 2015 | Hand-printed and commercial cottons, paint, ink, cotton and monofilament threads | Machine pieced and appliquéd, free-motion quilted, machine thread painted, hand painted, monoprinted, screen printed, machine embellished

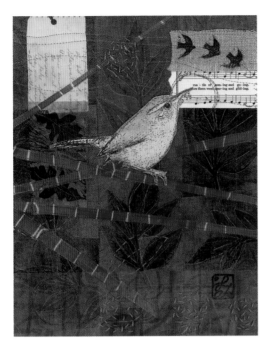

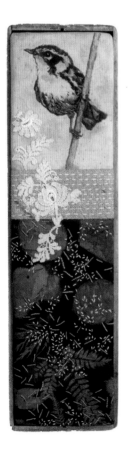

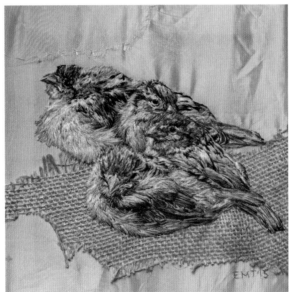

Top: Lisa Thorpe | *Wren Song* | 14 × 11 inches; 2020 | Fabric, paper, thread | Hand dyed, digital manipulation of photo, hand-carved stamp printed, collaged, free-motion and hand stitched

Bottom left: Sharon McCartney | *Lookout* | 20.5 × 6 × 3 inches; 2017 | Cotton, linen, antique lace, thread, antique box | Drawn transfer, embroidered, hand stitched, rusted, sun printed

Bottom right: Emily Sian Tull | *Sparrow Fledglings* | 8 × 8 inches; 2015 | Cotton, hessian, polyester | Thread painted, hand stitched

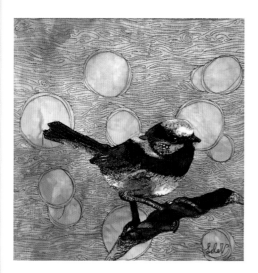

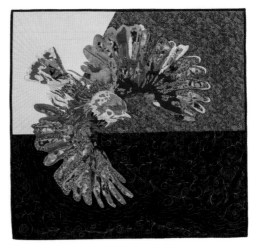

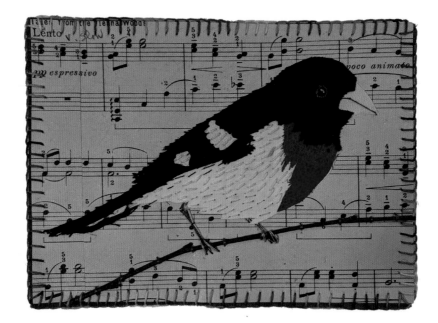

Top left: Sue de Vanny | *Little Wren* | 12 × 12 inches; 2017 | Commercial and hand-dyed cottons, threads | Collaged, pieced, free-motion embroidered and quilted

Top right: Judy Makinson | *Green's the Thing* | 40 × 40 inches; 2014 | Cotton | Machine pieced, raw-edge fused machine appliqué, machine quilted

Bottom: Martha E. Ressler | *Rose-Breasted Grosbeak* | 5 × 7 inches; 2021 | Cotton, paper sheet music, wool felt, embroidery thread | Raw-edge appliquéd, hand embroidered

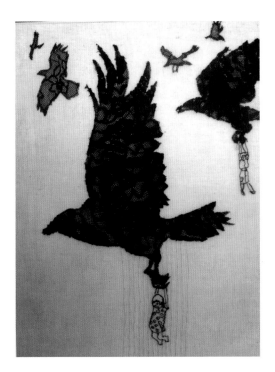

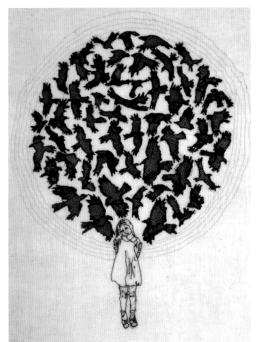

JO SMITH

Cleethorpes, North East Lincolnshire, UK

Always be true to yourself and believe in what you are creating, breathe life into your thoughts and feelings, let them sing. I have always preferred to use found materials, old clothes, and household linens, since the fabric has already had a life and holds onto these memories in its folds, creases, and degraded areas.

Birds can symbolize a whole gambit of emotions. They can convey pain and sorrow with the same intensity as beauty and joy. They have freedom we do not, to see all and soar above, to ride the winds. Hearing their song at dawn is an incredible gift for the soul.

My work is very emotive and is often triggered by a particular event, a memory, something happening in the world, or something simple and close to home, such as the death of a mouse. It builds up within and needs to be released. I have a therapy cloth of a crow with streams and streams of red straight stitch emitting from its open beak. It helps to feel the flow of stitch through cloth against my fingers to clear my mind of clutter.

When my sister and I left the hospital after losing my mother, we saw magpies everywhere. One more or less sat with us the whole time while relatives were contacted and the sad news relayed. Since that time, I always think of my mother when I see a magpie.

Left: *Crows—the Taken* | 17 × 13 inches; 2013 | Found vintage lace, cotton muslin, thread | Free machine embroidered, hand stitched, appliquéd

Right: *Crows—the Gathering* | 17 × 13 inches; 2013 | Found vintage lace, cotton muslin, thread | Free machine embroidered, hand stitched, appliquéd

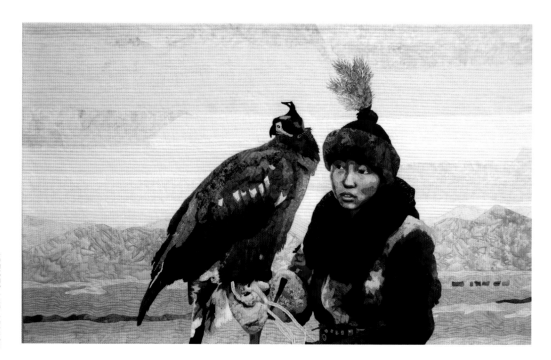

MARY JANE SNEYD

Dunedin, New Zealand

Just do it. Start small. Put in the time. You will get better with practice. And look at lots of art.

I often trawl through thousands of family photos searching for inspiration. I love to spot and photograph the many different types of birds on my travels overseas. I also will wander quietly in the garden to catch birds unaware.

There are no native land mammals in New Zealand except for two types of bats, but there are lots of fascinating native birds. I live on 8 acres on the edge of town, and I see and hear many types of native birds every day. I love the New Zealand native birds, but they tend not to be very brightly colored.

I was inspired to make *Lord of Birds: Hunting in Mongolia* by the close relationship I saw between the young girl and her bird, and their relationship with the very harsh environment. The fierce pride of the bird is mirrored by the pride in the young woman's face as she displays their close bond. I have always enjoyed creating portraits of strong women: the eagle and the girl in this picture each highlight and amplify the strength of the other.

The Lord of Birds: Hunting in Mongolia | 34.5 × 56 inches; 2020 | Commercial fabrics, recycled clothing, corduroy, string | Fused raw-edge collage, glued appliqué, free-motion and walking-foot quilted, embellished with plaited string | *Inspired by a photo by Leo Thomas; used with permission*

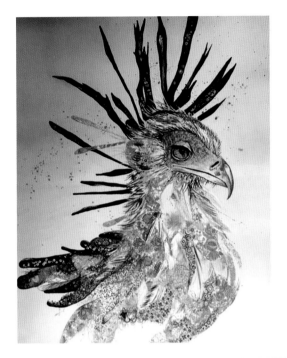

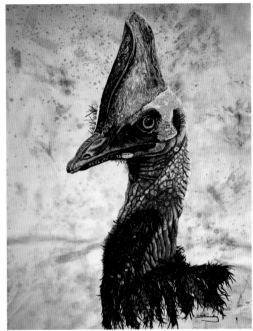

SOPHIE JANE STANDING

Nanyuki, Laikipia, Kenya

Don't get too caught up with the idea that a piece of art should be perfect. Your first pieces are experiments, almost samplers. It is something you don't need to hang up in pride of place over the mantelpiece or in your lounge. It should be something you do and keep for yourself in your studio as a reference point for future works. Be yourself and enjoy your own style and mark-making techniques.

I am constantly inspired by animals and birds. Birds have such an incredible diversity of colors and reflective sheen. I get lost in my work sometimes, locked into the bird's eyes and feather patterns.

My textile embroidered art is a process of trial and error and experimenting. I start with a photo of the bird, which I develop into a full-scale drawing, and then I gather a wide variety of fabrics from my stash. I like to be very expressionistic with the combination of fabrics, placing very bold flowers next to stripes and clashing abstract patterns. The machine stitching adds details and also makes all the patterns merge together into a coherent composition. I always start with the eye and slowly stitch all the details, changing color continuously to bring the bird to life. This process combines my love of so many things . . . flora and fauna, threads, sewing, and art.

Left: *Secretary Bird* | 59 × 35 inches; 2016 | Liberty tana lawn fabrics, paint | Appliquéd, painted

Right: *Cassowary* | 37 × 29.5 inches; 2021 | Liberty tana lawn fabrics, paint | Appliquéd

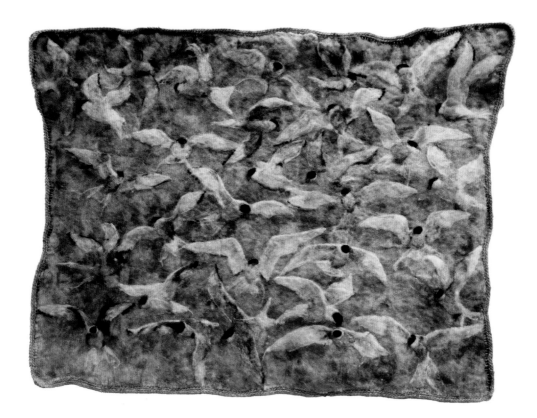

HEIDI STRAND

Reykjavik, Iceland

Follow your heart and keep an open mind. Stay free and create to fulfill your own ambitions. Do not fear mistakes, but backtrack and start anew. Look at criticism and adversity as a challenge. Use the chances you are offered; one thing leads to another.

I work mostly with wool. I prefer to make big pieces with hot-water felting, composing them freely and using many colors; I see this work as a meditation. The finished felts then inspire me to create different motifs, often incorporating needle felting.

Birds bring me joy and connect me with nature. They are so beautiful, both in shape and color. They have so much character and such a strong will to live, as well as stamina, loyalty, meticulousness, and temperament.

I am particularly inspired by puffins, Arctic terns, and pink-footed geese. Iceland has large colonies of these birds. You can get quite close to the puffins (see Puffins gallery), and it is a wonderful experience to lie at the top of nesting cliffs and watch the hubbub. The puffin is calm and composed, while the terns are always on the move and awfully hard to approach. The pink-footed geese have lost a lot of ground in the Icelandic highlands due to the construction of large hydroelectric power plants. They lay their eggs in spring and then molt in late summer, a powerful symbol of vulnerability.

Wings of Love | 28 × 37 inches; 2021 | Wool, cotton | Needle and wet felted

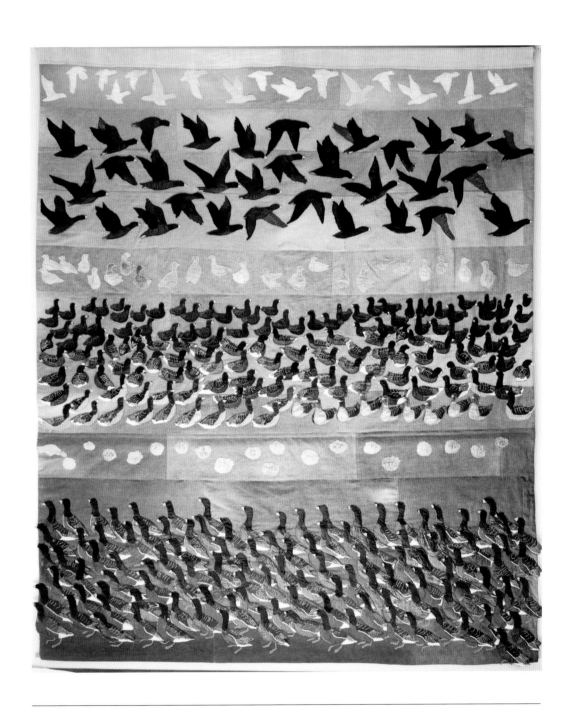

Seasons | 99 × 79 inches; 2019 | Reused jeans, polyester, organza, cotton, linen yarn | Freehand appliquéd, machine embroidered, crocheted, stitched

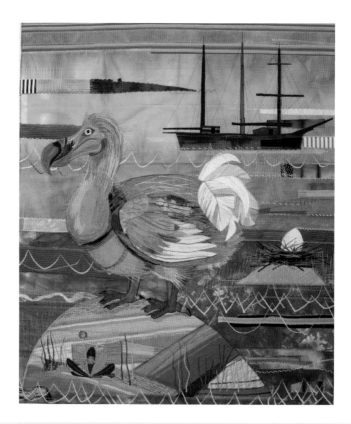

RACHEL SUMNER

Devon, UK

The important thing is to just have a go, to see it as an adventure without a specific end in sight. Making mistakes is very much part of the creative process and may ultimately spark a new and exciting direction.

Inspiration comes from many sources, but if I don't have a specific idea in mind, I will often reach for my stash of fabric odds and ends and see what catches my eye. I like to quickly piece together little groupings of fabric and secure them into place, using some of the lesser-known stitches on my machine. It's a very relaxed process with no pressure to produce a finished article. These "mini samplers" can be purely abstract or might suggest a landscape or some other scenario to be developed into a finished piece.

For me, the presence of birds always enlivens and animates my surroundings. These engaging creatures have a great capacity both to move and amuse. Their plumage, posture, display, and interaction make it easy to invent little characters and scenarios. I try to capture these moments and translate them into stitch. It is in the tilt of a head or the detail of an eye that a character can seem to be gained or lost, and it is these finishing touches that I always look forward to making.

Discovering the Dodo | 43 × 35.5 inches; 2015 | Fabric, thread | Pieced, dyed, appliquéd, machine embroidered

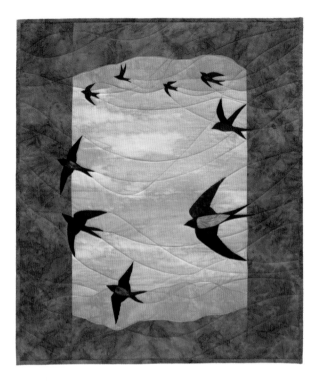

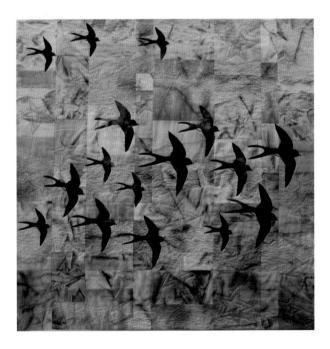

Top: Jennifer Danly | *Swallows* | 34 × 28 inches; 2019 | Fabric, thread | Machine appliquéd and quilted | *Photo by Mark Gulezian*

Bottom: Chantal Guillermet | *My Corner of the World* | 40 × 40 inches; 2019 | Hand-painted and hand-dyed cottons, paint sticks, watercolor pencils, paint, rayon thread | Hand painted, fused, free-motion appliquéd and quilted

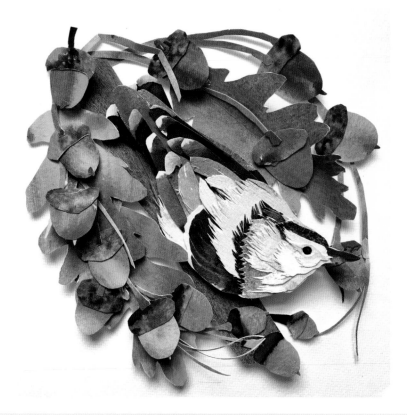

SARAH SUPLINA

Stamford, Connecticut, USA

In art, always be original and follow your heart. My heart follows the ever-changing beauty of the seasons. And as the seasons change, so does my bird inspiration. Winter lends itself to creating the birds at my feeder, and summer inspires me to create tropical birds in all their bright colors.

I love working with birds because of their variety and beauty. Each bird is unique, with a different facial expression, coloring, and habitat. I am inspired both by the ones I observe in my own backyard, and by the birds I may never see in person.

I always start a new piece with great excitement. I research, sketch, and then paint my papers. I paint all my own watercolor papers, using both hot- and cold-press paper. I love the varied shades of color and the surprise imperfections from watercolors.

After painting, I start the drawing-cutting-assembly process. This step is the most time consuming, but it is essential to create the layers and textures I love so much. I could not live without my Fiskars scissors, my Xacto knife, Elmer's glue, and my tweezers. The last step is painting in any necessary details to complete my beloved birds.

Acorn Nuthatch | 8 × 8 × 1.25 inches; 2021 | Painted watercolor paper | Painted, cut, assembled

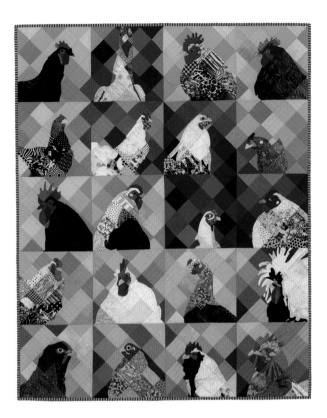

TIMNA TARR

South Hadley, Massachusetts, USA

Just keep making. You can find your creative voice only by trying out the styles that do not work for you. While you are experimenting, what you are really doing is honing your craft.

Visiting an antique shop or a tag sale always gets my mental juices flowing. I think I need to see something that is new to me, but that has already had a bit of a life.

I would not say that I am a "bird person." Birds in general are fine, but chickens have my heart. Their coloring and feather patterns draw me in, but what I really love is watching them strut across the grass. They have so much swagger and yet can be so anxious, just like some humans that I know.

Zooming Chickens | 41 × 33 inches; 2020 | Commercial cottons | Prepared-edge machine appliquéd, machine quilted | *Photo by Stephen Petegorsky*

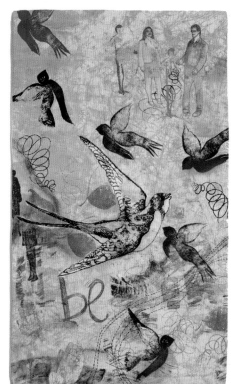

DANIELA TIGER

Toronto, Ontario, Canada

My best advice to emerging artists is to be brave and just get going. Keep the criticism (both from within and from afar) at bay. Sometimes the destination feels unclear, but the joy is about the journey.

I am inspired by the natural world around me, seeing what colleagues are up to, an intriguing call for entry, experimentation with stitch or print, or even by creating new dye pots and seeing what emerges. I take lots of pictures to give energy to my creative spirit.

I admire birds for their freedom. When I watch a bird in flight, gracefully dancing through the breeze, it seems to me that it has the ultimate privilege to follow any path. I have always felt weighted, awkward, quite unskilled at the mastery of gravity. Oh, to be so graceful and weightless while riding the currents in the sky!

Be Your Best Self | Left panel: 41 × 24.5; right panel: 41 × 22 inches; 2017 | Cotton, dye, paint, thread, silk organza | Digitally altered photos, thermofax printed, flour paste resist, painted, drawn, free-motion stitched, hand stitched and quilted

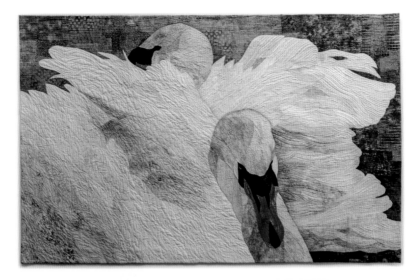

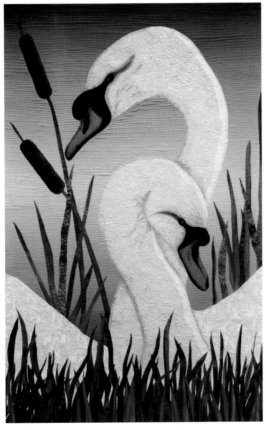

Top: Judy Crotts | *Swan Lake* | 34 × 54 inches; 2019 | Cottons | Raw-edge appliquéd, free-motion quilted | *Photo by Johanna Wissler*

Bottom: Sally Gould Wright | *Swan Song* | 46 × 30 inches; 2015 | Cotton, cotton velvet, paint, silk and polyester threads | Raw-edge fused appliqué, painted, free motion quilted

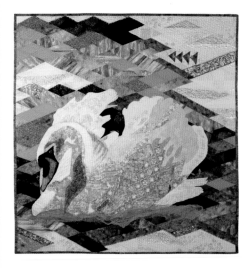

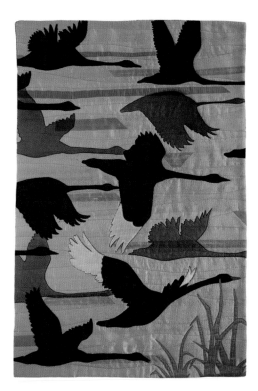

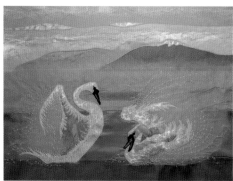

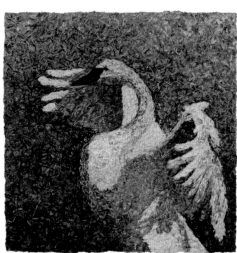

Top left: Eileen Wintemute | *The Winter Swan* | 38 × 40 inches; 2020 | Cotton, specialty fabrics, beads, cheesecloth, ink, paints, lace | Raw-edge appliquéd, machine pieced, decoratively stitched, fabric painted, machine quilted, beaded | *Photo by Luke Bisagna*

Top right: Stella King | *Black Swans* | 23.5 × 16 inches; 2018 | Dupioni silk, cotton fabric, organza | Machine-stitched raw-edged appliqué, machine pieced

Bottom left: Izabella Baykova | *Swans* | 20 × 26 inches; 2021 | Silks, synthetics, tulle | Appliquéd, hand and machine embroidered

Bottom right: Mita Giacomini | *Rise* | 12 × 12 inches; 2020 | Wool, silk, cotton and other natural and synthetic fibers | Surface woven

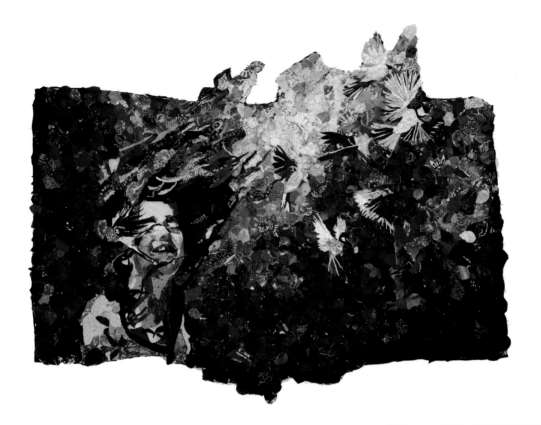

BLAIR TREUER

Bemidji, Minnesota, USA

Live your truth. Be honest in your work. Trust your instincts and inspiration and resist the urge to ask yourself what others will think of what you're creating and how you're creating it.

My children's participation in an important Ojibwe ceremony required me to make blankets as a part of their offering. The process of making them was very spiritual for me. It was the only way I could contribute as a non-Native woman, so I poured everything I had into those offerings.

Birds help me tell my story. Because I create portraits representing my thoughts and feelings instead of literal illustrations, the birds I use help write the narrative of the piece. Their beauty and their whimsy add energy and vibrancy to my work. What they represent within my work offers a greater depth and meaning to the story I am trying to tell.

The goldfinch is a constant in my work. It is the language bird in the Native American Ojibwe culture. Ojibwe culture and spirituality consist of layers upon layers of meanings: how to connect to the earth, to the spirits that dwell here, to each other, and to oneself. The birds represent that depth of knowledge and understanding that my family and other Ojibwe people who follow a traditional path possess about who they are, where they come from, and what their purpose is while they are here.

Luella | 42 × 62 × 4 inches; 2019 | Fabric and thread, mounted to wire | Painted, thread painted, raw-edge appliquéd | *Photo by Monika Lawrence*

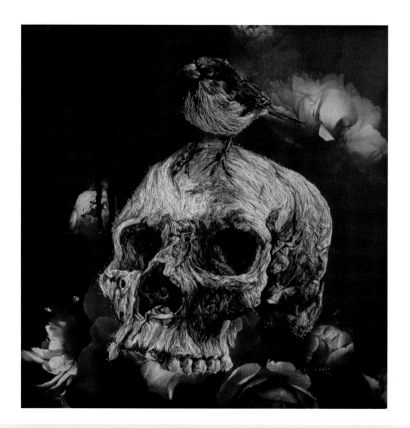

EMILY TULL

Ramsgate, Kent, UK

Don't put pressure on yourself or judge what you are making against others. This is your own journey. Don't see mistakes or things not going to plan as a bad thing; we can learn so much from our mistakes.

My sketchbooks are the key to my work, whether notes from watching a wildlife documentary or phrases, quotes, or lyrics that have caught my attention. I like to look back over the old ones. An image or something written may spark a new idea, or I will find an idea never realized that may be ready to happen.

I have a strange relationship with birds. On the one hand, they are these incredibly beautiful flying machines, but alongside this I also have a fear of them, especially when flying near me. I hope through my artwork that I can gain a better understanding and that this will lessen my fear.

Being based in the UK, my work predominantly features British birds—native birds with the occasional winter visitor. I am always drawn to the underdog, to species that are endangered and rarely seen. I want to promote their plight and beauty. Birds I see in my daily life, the humble garden birds, have appeared in my work many times. They can be often overlooked for the larger birds of prey, but they are full of character, and I spend many hours watching their antics.

Sparrow and the Skull | 10 × 10 × 2 inches; 2018 | Wallpaper, threads | Hand stitched on wallpaper

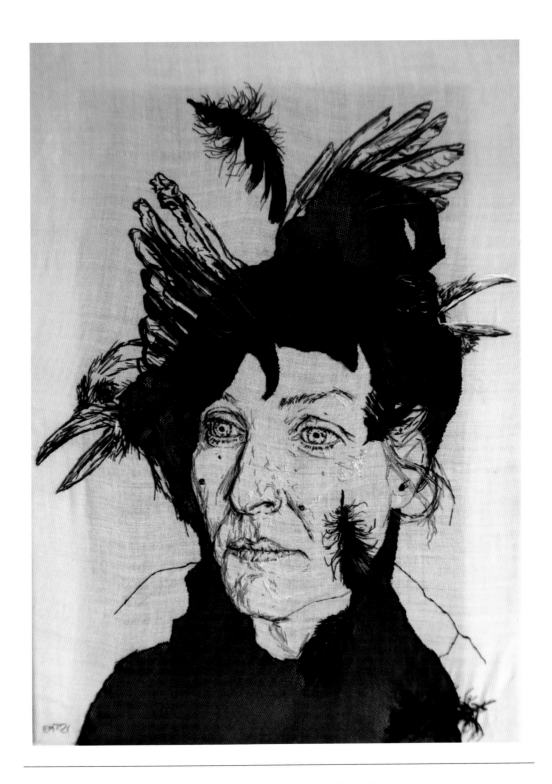

Covid 19—Bird Brain 2 | 15 × 11 inches; 2021 | Mesh, cotton, threads | Thread drawn, hand stitched

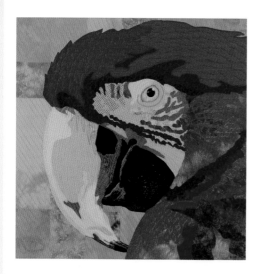

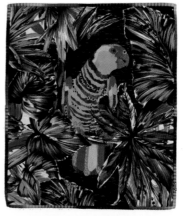

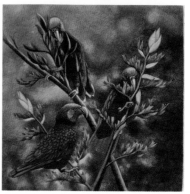

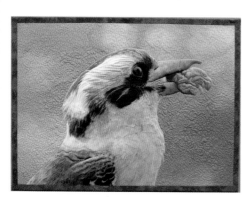

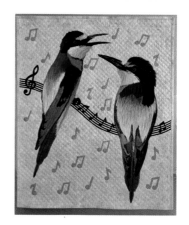

Top left: Barbara Yates Beasley | *Anna* | 12 × 12 inches; 2014 | Commercial and hand-dyed cotton fabric, silk, acrylic paint, art markers | Raw-edge fused appliqué, free-motion stitched

Top right: Kim J. Brownell | *Amazon* | 20 × 18 inches; 2018 | Cotton and upholstery fabrics | Appliquéd, collaged

Center left: Sania Samad | *When the Parrots Talk* | 45 × 70 inches; 2018 | Velvet, beads, silk thread | Beaded, hand embroidered

Center right: Sonya Prchal | *North Island Kaka* | 18 × 18 inches; 2018 | Cotton, paint, embroidery threads | Painted, thread sketched, free-motion quilted

Bottom left: Barbara McKie | *Kookaburra* | 26 × 36 inches; 2012 | Digitally manipulated artist photo, hand-dyed cotton, thread | Printed, free-motion quilted

Bottom right: Esther Tronchoni | *The Song of the Bee-eaters* | 58 × 47 inches; 2020 | Cotton | Appliquéd, thread painted

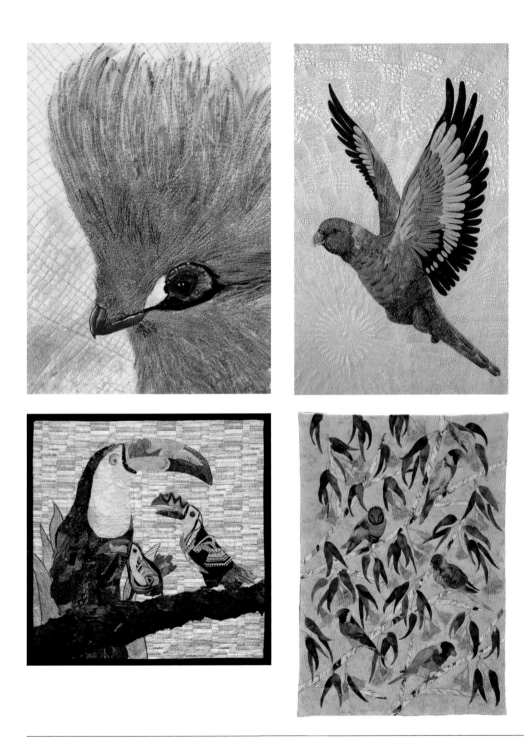

Top left: Wilma Fletcher Scott | *Little Green Turaco Bird* | 12 × 8 inches; 2017 | Cotton, paint, pencil, thread | Painted, thread painted

Top right: Helen Godden | *Rainbow Lorikeet* | 76 × 42 inches; 2012 | Silk sateen, paint | Hand painted, free-motion quilted

Bottom left: Sandra Lauterbach | *3 "Cans"* | 40 × 40 inches; 2015 | Textiles | Fused, manipulated, machine quilted

Bottom right: Kim Frisk | *Flower Hopping* | 24 × 18 inches; 2020 | Batik, rayon and cotton threads | Fused appliqué, free-motion quilted

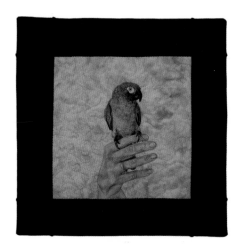
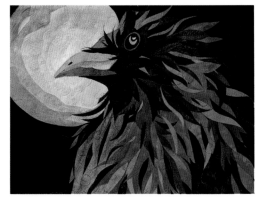
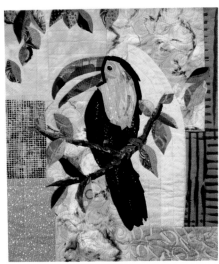
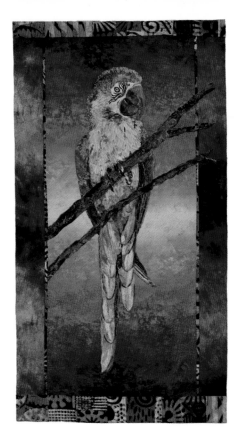

Top left: Sherry Davis Kleinman | *Daphne* | 19 × 19 inches; 2016 | Cotton, paint, ink, rayon and cotton threads | Painted, machine and hand stitched | *Photo by Steven Kleinman*

Top right: Linda Diak | *Edgar* | 35.5 × 45 inches; 2020 | Cotton | Raw-edge appliquéd, free-motion quilted

Bottom left: Marya Lowe | *Plaid-Billed Toucan* | 25.5 × 23 inches; 2019 | Cotton, paint | Fused collage, machine-quilted, painted

Bottom right: Joan H. McCreary | *Mr. Macaw* | 46 × 25 inches; 2021 | Hand-dyed and commercial fabrics, tulle, thread | Raw-edged fabric collage, free-motion thread, painted

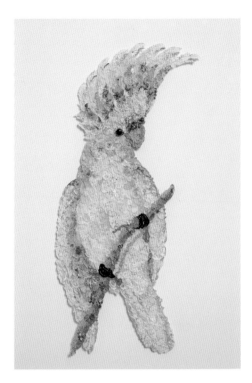

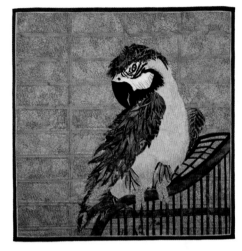

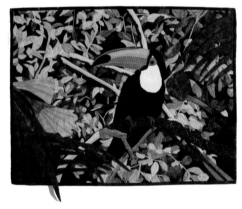

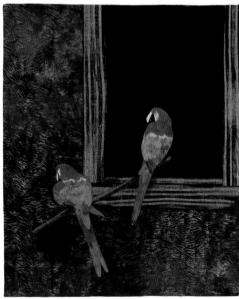

Top left: Louise Saxton | *Major Tom (after John & Elizabeth Gould, c. 1848)* | 40.5 × 19.5 inches; 2010 | Reclaimed needlework (vintage and antique embroidery, lace), lace pins, nylon tulle | Assemblage | *Photo by Gavin Hansford, Australia*

Top right: Cindy Richard | *Talkative Parrot* | 20 × 19.5 inches; 2017 | Cotton | Fused appliqué collage, free-motion quilted

Bottom left: Valerie Wilson | *Tropical Colour* | 27.5 × 23 inches; 2007 | Cotton, ink, watercolor pencil | Raw-edge appliquéd, inked, colored, machine quilted

Bottom right: Carla White | *Toco Toucan* | 19.5 × 25.5 inches; 2018 | Batiks, cotton, felt | Raw-edge appliquéd, thread painted

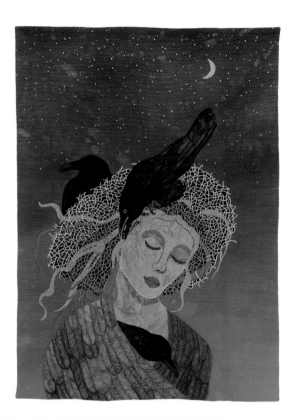

NANCY TURBITT

Smithfield, Rhode Island, USA

Just do the work. The more you take time to work, the stronger your creativity becomes and the more in tune your artistic decisions become. I am a bit of a storyteller, and my work often blends reality and fantasy. Writing my stories can be a way for me to jump-start artwork by giving my creativity another way to begin.

My mother was a birdwatcher, and I grew up always looking toward the sky. Birds are such wonderful creatures with the incredible luck to fly above the world. One of my favorite things in this world happens in spring, when the songbirds come back. I love hearing them sing in the early hours of the morning. It is such a strong trigger for me, which lifts my spirits and brightens my days.

I have always been inspired by the birds that live in my area. Nuthatches are cunning little creatures. They are the only bird that walks down the trunk of a tree as well as up. Owls have also been a lure for me. They are mysterious with their nocturnal habits. I love hearing them call to each other in the wee hours of the night. I had a wonderful experience with a great horned owl by calling back to him. His curiosity urged him to fly 3 feet over my head, bringing me an amazing view of his massive wingspan.

Lady Feather | 42 × 43 inches; 2016 | Hand-dyed and commercial cottons, silk, leather, feathers, thread | Discharged, drawn, embellished, fused raw-edge appliqué, machine and hand stitched

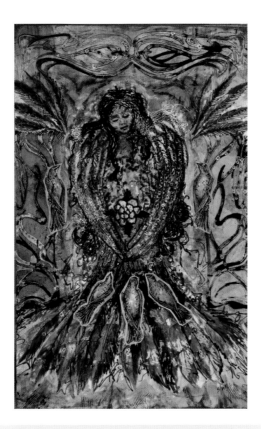

SHARON WALL

Altoona, Pennsylvania, USA

Figure out what subject matter you like most, and research all types of artists who also work with that theme. Study the work of whichever ones you respond to. Then translate what you like into your own style and technique. My piece was inspired by medieval and art nouveau styles.

I like to take a pad of newsprint and a large black marker outside to sketch nature. Since I work with a lot of stencils, I like to capture shapes. By using a marker, it makes it impossible for me to linger on tiny details or to be able to erase.

I love to observe the variety of ways that birds interact with each other and with people. There is nothing more intriguing than seeing a hummingbird hover in front of your face. Bird communities often seem to mimic that of humans: sometimes congenial, sometimes confrontational.

Robin Spirit Guide | 48 × 30 × 2 inches; 2014 | Cotton, dye, paints | Deconstructed silkscreen, stenciled, fused

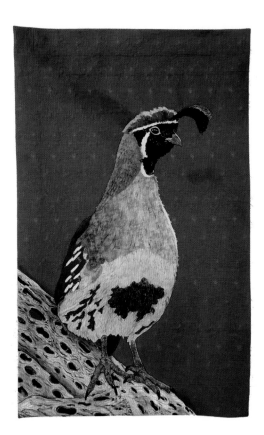

DEBBIE WATKINS

Montrose, Colorado, USA

Don't worry about rules. Mistakes or problems often lead to discoveries that enhance the finished product. My creativity usually is jump-started by trying a technique that is new to me. The challenge is then to incorporate the technique into a successful finished piece.

I enjoy spending time in nature, and birds are one of the essential inhabitants. Their songs, flight patterns, interactions, and color add to any outdoor experience. Shorebirds are particularly special to me because of many wonderful childhood experiences on the shores of Lake Superior.

A photo taken by my friend Dee inspired *Dee's Gambel*. The new technique I tried was using Evolon, a microfilament textile. I colored the Evolon by using Prismacolor pencils and burned holes through it to create the cholla the Gambel's quail is perched on.

Dee's Gambel | 37 × 23 inches; 2018 | Nonwoven material, cotton, pencils, paint | Colored, stitched

JOAN WEBSTER-VORE

Hudson, Iowa, USA

Don't hesitate or be afraid to take a visual risk. Just start making stuff and keep working at it even when you are unsure of where it will take you. Play with materials, turn them upside down and inside out, and keep considering and pushing all the possibilities for as long as it takes.

When birds take flight, the sky is filled with movement, color, line, and changing shapes as they dance above. I love how light and dark shifts occur in moments of flight as they change direction, and have been fascinated with observing birds for as long as I can remember. In my college years, many hours were spent in the bird museum on campus making small watercolors of specimens.

Since 2015, I have been working on a body of work relating to the extinction of the Passenger Pigeon. *Target Practice* was inspired by the story of their extinction.

There once were three to five billion passenger pigeons in North America, and they vanished from the sky over a hundred years ago, a loss of a quarter of the bird population on this continent. When I first learned about the enormity of what happened and how so few people knew about it, I felt compelled to respond. We need to pay attention to the consequences of our actions, the changes happening around us, and care for the life of and on our planet.

Target Practice | 60 × 144 × 2 inches; 2015 | Paper, binder clips, wood, brads | Digitally altered paintings of male and female passenger pigeons from the collection of the University of Northern Iowa Museum, Cedar Falls, Iowa | *Photo by Ronald Tigges*

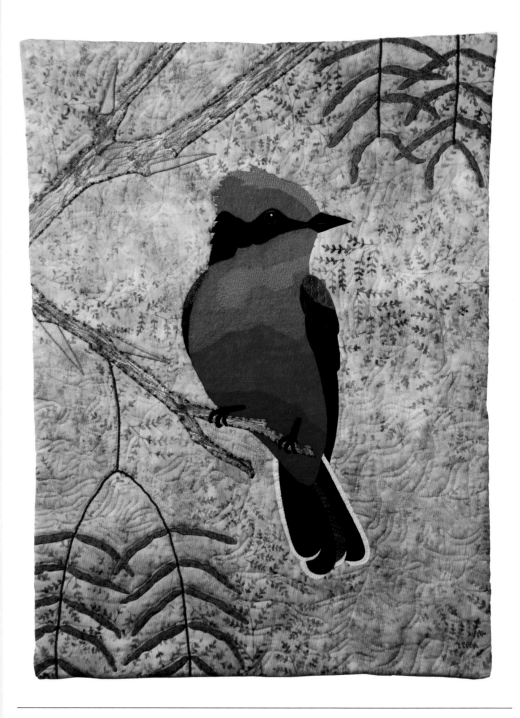

Nancy Fisher | *Vermilion Vision* | 24 × 18 inches; 2018 | Hand-dyed and commercial cottons, cotton thread | Raw-edge machine appliquéd, satin-stitched machine appliquéd, machine satin stitch embroidered, machine quilted | *Photo by Travis Fisher*

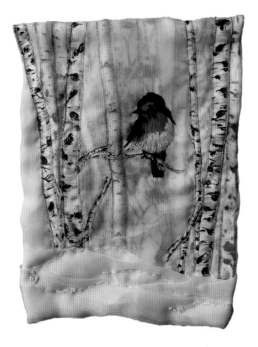

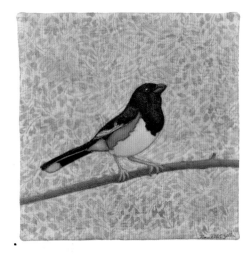

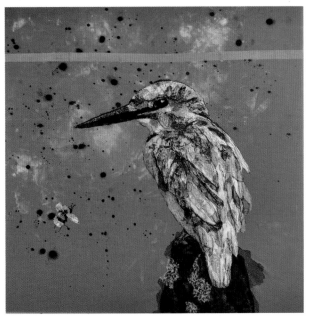

Top left: Susan Ronchka | *In the Birch Forest* | 12 × 8 inches; 2020 | Commercial print, cotton floss, organza | Appliquéd, thread painted, hand stitched

Top right: Nanette Zeller | *Eastern Towhee* | 12 × 12 inches; 2018 | Cotton, watercolor pencils | Fused appliqué, colored

Bottom: Charlotte Bergstrøm | *Flying Wonder* | 23.5 × 23.5 inches; 2020 | Fabric, tull, lace, yarn, thread | Raw-edge appliquéd, free machine embroidered

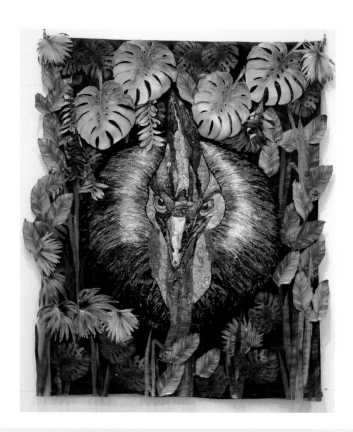

PRUE WHEAL

Nairne, South Australia, Australia

Have a go! Don't be afraid to try an idea. There will be mistakes, but that is a good way to learn. Relax and have fun.

I start with an idea in my mind of the quilt I want to create. Photographs are helpful to depict proportions, shapes, etc. Then it is time to sketch onto the background fabric. My pictorial quilts are created as a collage, so they often evolve and change as I go along. Sometimes an unfinished quilt will languish on the pinup wall until a fresh fabric that is "just right" turns up and I can complete the picture.

Cassowaries are large, colorful, flightless birds, believed to be closely related to an ancient lineage descended from dinosaurs. Although named the southern cassowary, they are endemic to the rainforests of northern Australia. They generally live a solitary life until mating season and are vital to sustain rainforests as they wander and consume fruits and plants, thereby spreading stones and seeds throughout the forest. After mating, the male bird incubates the eggs and cares for the chicks for about nine months. Mum goes off to find another partner!

"Don't Mess with Me" | 45 × 40 inches; 2019 | Cotton, polyester netting, fake leather, synthetic curtain fabric, threads | Raw-edge appliquéd, thread painted

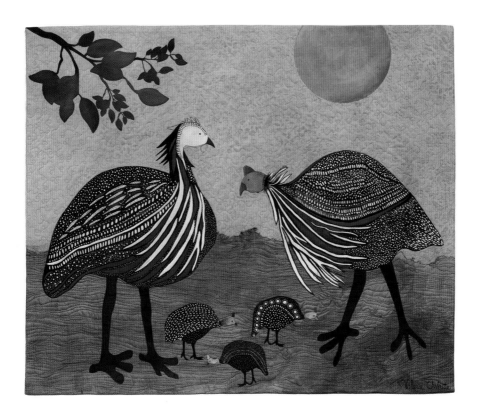

VALERIE C. WHITE

Denver, Colorado, USA

Working in a series is one of the best ways to demonstrate a cohesive, unified body of work. A series offers opportunities to investigate techniques and ideas you want to express. Find a subject that you are passionate about that is open to variations of your selected theme. Gather information about the subject by doing a little research. The more you know about a topic, the more you can express.

Early in my work, I was easily distracted by the newest techniques and materials. I soon learned it was better to become skilled in a few techniques rather than being mediocre in many. If finding your authentic voice is important to you, working in a series offers structure and a means to stretch.

Family Affair was the first piece I created in the guineafowl miniseries. The Royal East Africa vulturine guineafowl is unique, the largest species of guineafowl. For me these stately birds hold an allure that is both magnificent and complex. I'm drawn to and amazed by their coat and color. The long, lance-shaped feather stripes of brilliant blue, white, and black are truly exquisite! I believe this kind of beauty comes only from a power greater than myself.

Family Affair | 39 × 39 inches; 2021 | Cotton, paint, textile markers, stencils | Painted, overdyed, thread painted | *Photo by Wes Magyar*

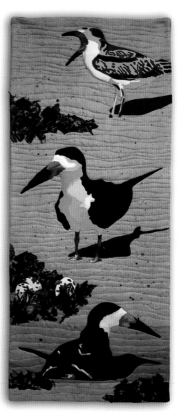

MARTHA WOLFE

Davis, California, USA

Move out of your comfort zone and explore. When something is not working as you'd like or doesn't look as you'd hoped, don't abandon it or pretend that you can ignore it. Consider how you can fix it, even if it means backpedaling for a while. Take it apart. Do it again a different way until it is right.

If the opportunity arises, join a challenge group. You'll learn so much about yourself as an artist and about your work style. It will push you when you are uninspired, it will teach you time management and organization, it will help you understand your abilities and limitations, it will provide opportunities to explore and experiment, and it will offer you great companionship on your creative journey.

I think birds are a lot like any number of pleasures of the unknown: you don't know until the moment you see them what treasure has fallen into your path. Nature is especially exciting because you never know what or when it is going to reveal to you.

I live near a wetland, so I love to see the migrating birds and the wonderful murmurations of blackbirds. I really like the beach with its rugged shorelines. I walked on the beach most days when I lived in Florida. There were loads of pelicans, ibis, herons, and cranes and a variety of terns, which were a constant source of entertainment. Their postures and behavior range from fascinating to unintentionally very funny.

Left: *Dusk in Yolo County* | 15 × 27 inches; 2017 | Silk sari strips, silk organza, perle cotton | Stitched, quilted, embroidered
Right: *Wild Life: Nesting Skimmers* | 42 × 18 inches; 2017 | Hand-painted linen and silk organza, hand-dyed silk charmeuse | Painted, raw-edge appliquéd, machine quilted

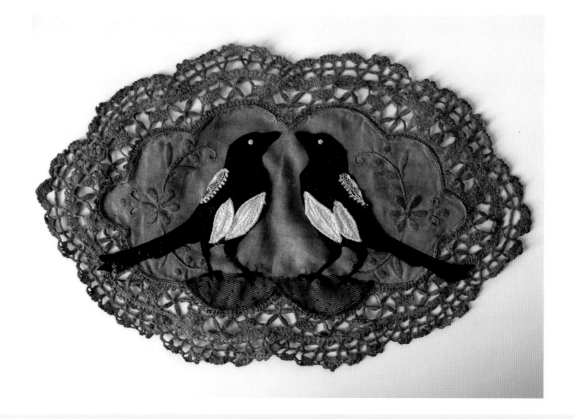

LESLEY WOOD

Durham, County Durham, UK

Like a magpie, gather together a "stash" and create a mixed-media fabric collage. It is a very flexible technique that can involve a spot of recycling (good for the planet!) and is easily achieved using fabric glue or a few simple stitches. Collage is a very forgiving technique. If a piece appears not to be "working," it can be altered, amended, or concealed by the addition of more materials. If all fails, the piece can be cut up and reused in future pieces. How good is that!

The majority of my work is hand-stitched, mixed-media, fabric collages. I gather together materials, ephemera, and a substrate, which is often a reclaimed piece of cloth. Vintage table linens have featured a lot in my work as grounds. I then audition the various elements I have gathered together until I am happy with the overall composition. This process allows for many changes as the piece of work develops from my initial ideas.

My interest in birds as a subject for my artwork was sparked by a couple of nesting magpies outside my home. These large, territorial, easily identifiable birds have been a joy to watch with their attitude and dramatic plumage. Magpies are easily recognized and associated with a number of myths, including their attraction to and theft of shiny objects. This makes them an interesting subject for my creative work, which generally has a strong narrative.

Two for Joy | 12 × 16 inches; 2019 | Vintage table linen, fabrics, thread | Hand-stitched fabric collage

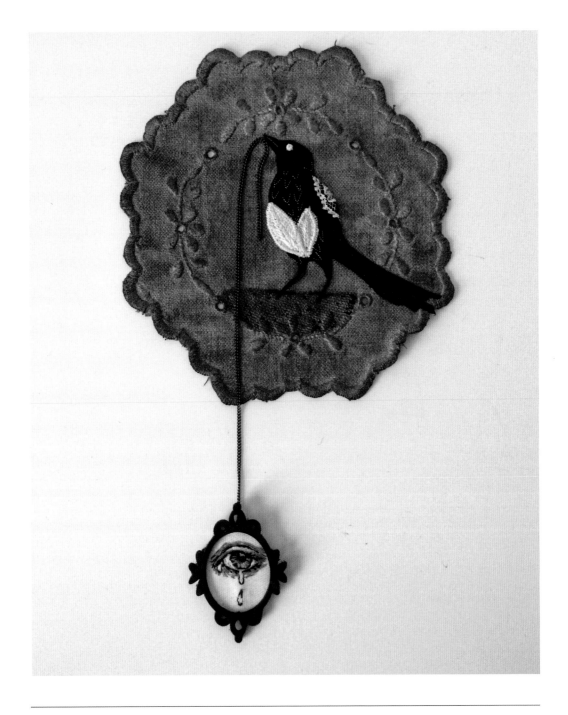

This page: *One for Sorrow* | 16 × 12 inches; 2019 | Vintage table linen, fabrics, thread | Hand-stitched fabric collage

Next page, top right: *Seven for a Secret Never to Be Told* | 16 × 12 inches; 2019 | Vintage table linen, fabrics, thread | Hand-stitched fabric collage

Next page, center left: *Three for a Girl* | 16 × 12 inches; 2019 | Vintage table linen, thread | Hand-stitched fabric collage

Next page, center right: *Four for a Boy* | 16 × 12 inches; 2019 | Vintage table linen, fabrics, thread | Hand-stitched fabric collage

Next page, bottom left: *Five for Silver* | 16 × 12 inches; 2019 | Vintage table linen, fabrics, thread, beads | Hand-stitched fabric collage

Next page, bottom right: *Six for Gold* | 16 × 12 inches; 2019 | Vintage table linen, fabrics, thread, beads | Hand-stitched fabric collage

The traditional rhyme "One for Sorrow" was my starting point for one of my first series of work. I followed this by featuring more of these characterful birds in my hand-stitched pieces. My aim was to capture the magpies, their flash of iridescent blue when in flight, and their defiant territorial poses.

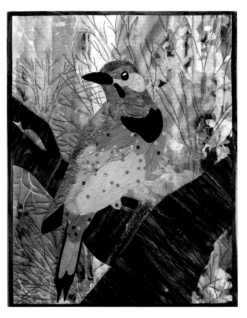

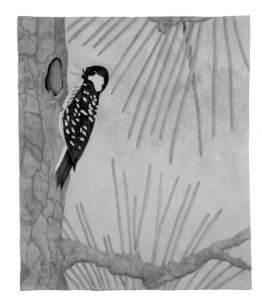

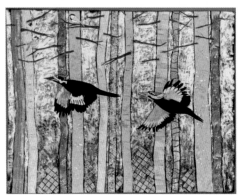

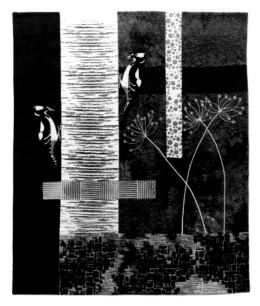

Top left: Ruth McCormick | *Northern Flicker* | 18 × 14 inches; 2020 | Cotton, sound-recording device | Fused raw-edge appliqué, free-motion quilted, recording of flicker sounds

Top right: Nancy G. Cook | *Ground Fire Brings Light and Life: Long Leaf Pine and Red Cockaded Woodpecker* | 42 × 36 × 2 inches; 2013 | Hand-dyed cotton; colorfast inks; cotton, polyester, and silk threads; cotton embroidery floss | Inked, machine quilted, hand embroidered | *Photo by Gerald Bloch*

Bottom left: Sharon Buck | *Lords of the Forest* | 40.5 × 53 inches; 2021 | Paint, fabric, thread | Painted, tiled, appliquéd, threadwork, free-motion stitched | *Photo by Tiffany Danielle*

Bottom right: Duffy (Marie) Indeherberg | *Woody and Pecker* | 35.5 × 30 inches; 2019 | Cotton, paint | Hand dyed, stamped, stenciled, machine quilted

Carla Osterby | *Mr. Woolrich* | 11 × 4 × 1.5 inches; 2021 | Wool, upcycled Woolrich sweater, natural elements, pipe cleaners, tape, paint | Needle felted

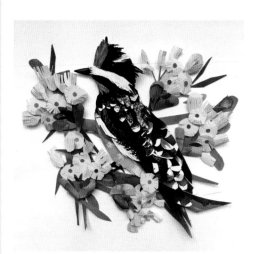

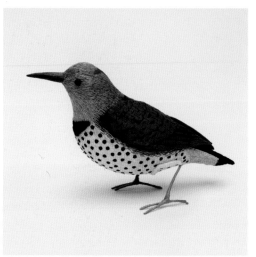

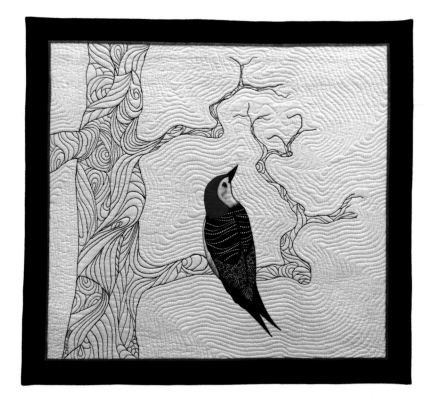

Top left: Sarah Suplina | *Sweetheart Woodpecker* | 8 × 8 × 1.25 inches; 2020 | Painted watercolor paper | Painted, cut, assembled

Top right: Laura Schlipf | *Yellowhammer* | 6 × 4 × 12 inches; 2019 | Cloth, wool stuffing, embroidery thread, wire, wood, glass | Embroidery, sewing, whittling

Bottom: Cheri Ucci | *Backyard Woodpecker* | 28 × 31 inches; 2017 | Cotton, ink, paint, cotton thread | Raw-edge appliquéd, free motion quilted, painted

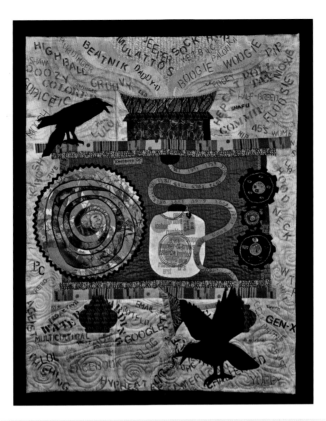

DIANE WRIGHT

Guildford, Connecticut, USA

Give yourself the opportunity to play without expectations. The word "no" need not apply.

I first became enchanted with birds when we were living in Australia: a whole continent of new-to-me, very colorful, unique birds. I was so excited about my opportunity that I traveled the whole country seeking out birds, some very rare. Subsequently, I have used birds as themes, motifs, and characters in my creations.

I am particularly drawn to corvids, especially crows, because they are intelligent problem solvers. The particular problem I was portraying with this piece was the changes in language over time. I created a "word time machine" in operation with old words floating around the top. Those words were sucked into the machine, operated by my intelligent problem solvers, and were then spat out as updated words. One can't help but notice that the "new" words are currently arcane.

Evermore | 46 × 36 inches; 2010 | Satin, felt, hand-dyed and commercial cottons | Pieced, appliquéd, stenciled, stamped | *Photo by David R. Wright*

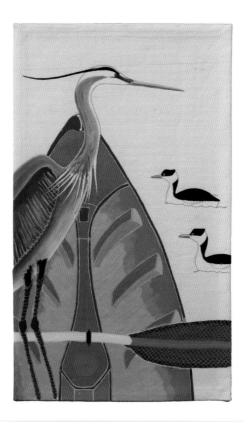

KATHY YORK

Austin, Texas, USA

Make a lot, be prolific. The more you make, the more you will learn. Piecing always helps organize my brain, and then other types of ideas for projects come forward.

Birds defy gravity. They seem to float. They can go wherever they want and are not limited to roadways, like the expression "As the crow flies." I like how easy it is to see them, because they are always around if you look and listen, and how I feel connected to the natural world when I see them.

I love songbirds because they are so tiny and chirp so cheerfully. I also love waterbirds—herons, gulls, pelicans, ducks, terns, oystercatchers—because they remind me of my childhood.

The Heron, the Kayak, and the Grebes | 50 × 30 inches; 2018 | Cotton, dye, thread | Whole-cloth batik dyed, machine quilted

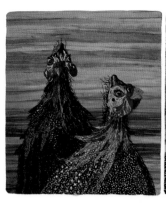
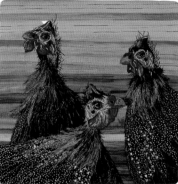
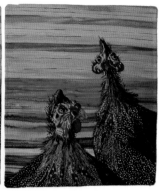
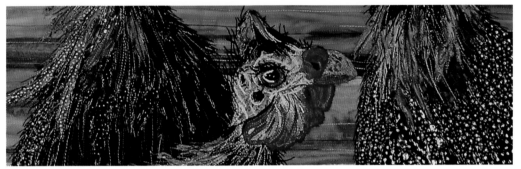

Detail

ZARA ZANNETTINO

Highbury, South Australia, Australia

One approach I recommend to artists wishing to explore their creativity is to immerse themselves in their favorite environment and hone their observation skills by taking many photos, with a diverse range of viewpoints. This will help them identify what type of subject matter excites them the most. It might be a preference for color, reflection, a macroscopic view, shadows, texture, or even patterns. I personally find that by applying my favorite construction and surface-design techniques to my artistic preferences, I am more likely to complete my art projects.

My fascination with birds began as a child. I loved patiently hiding in trees and bushes to observe their activities. Even at this young age, I noticed that neutral or monochrome birds revealed extraordinary beauty if studied closely. Consequently, these days it is usually a bird preening its ruffled feathers that will inspire my art, especially if they have iridescent colors that morph with movement. Wetland and coastal birds are a recent interest. Despite their ability to camouflage, they have subtle splendor in their form and intricate feather designs. Of course, the intoxicating gaudiness of parrots with their vibrant, saturated colors is also highly addictive for my creativity.

Absurd Birds | 21 × 60 inches; 2021 | Cotton, paint, cotton and polyester threads | Screen printed, raw-edge collaged, free-motion machine stitched and quilted

231

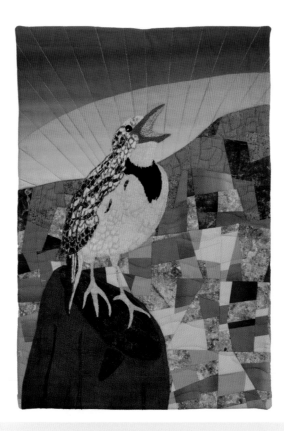

DEBRA ZELENAK

Lander, Wyoming, USA

Learn techniques. When you take a class, don't take one with the goal of having a finished project at the end. Take classes for the techniques taught. Then use and adapt them to your own work.

I have always liked birds. They're colorful, they sing sweetly, their graceful flight elicits wonder, and their funny antics cause me to smile and laugh. During difficult times they have conveyed messages of hope. If you asked me ten years ago what my favorite type of bird was, I would have answered ducks. My art foundation is based on the long tradition of carved duck decoys. An intense passion for these exquisitely sculpted birds was my catalyst for becoming an artist.

I love watching songbirds and listening to their songs. After living in large cities for most of my Air Force career, I got used to all the background noise. Having retired to a rural area in Wyoming, I am now aware of all of nature's sounds, especially the songs of birds.

Greeting the Dawn | 21.5 × 14.5 inches; 2020 | Fabric, thread | Improvisationally pieced, appliquéd, free-motion quilted

Russian Quilters Association

Special Project—Quilted Field of the World

Organized by Rimma Bybina, Leader of the Russian Quilters Association (www.QuiltShow.ru)

In 2019, the Russian Quilters Association's Quilted Field of the World brought together one hundred artists from different Russian cities, as well as other countries. The artists sewed blocks measuring 39 inches square (1 meter by 1 meter), and each work was a piece in the overall picture and at the same time an independent work of art. Each block featured sky, earth, or sky with a bird. The blocks were combined into one glorious quilt and shown at many different events. This is a sampling of some of the amazing bird pieces.

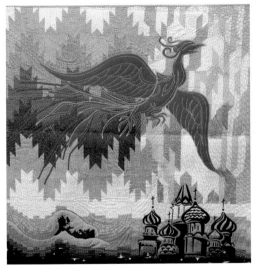

Galina Rassokina, Novosibirsk

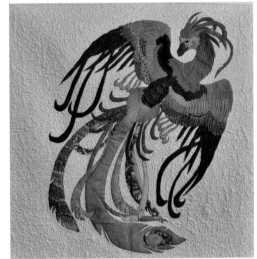

Olga Ushenkova, Orel

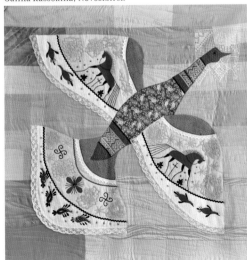

Taisia Zotova, St. Petersburg

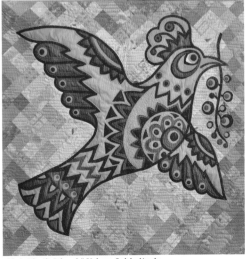

Club "Quilt Island," Uzhno-Sahkalinsk

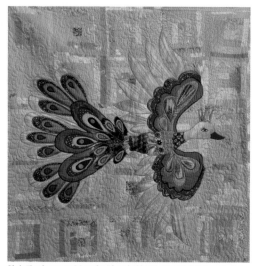

Club "Loskutnaya Mozaika," headed by Marina Tulupova, Ivanovo

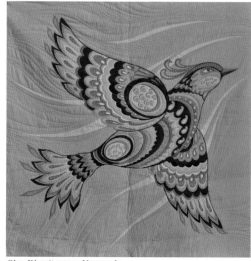

Olga Kharitonova, Voronezh

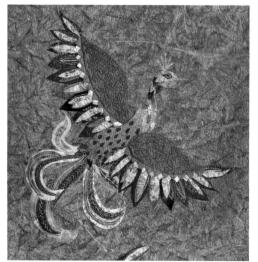

Emma Grigorovskaia, Moscow

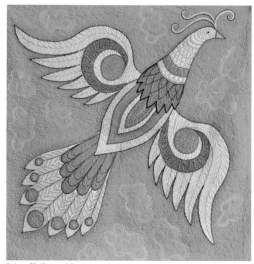

Irina Shikova, Moscow

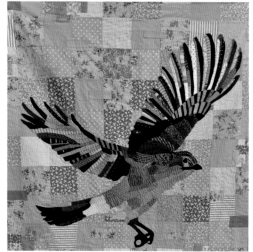

Ruslana Tsibulskaia, Moscow

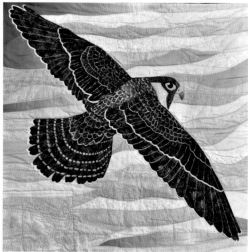

Tatiana Krasilnikova, Lipetsk

Tentmakers of Cairo

Cairo, Egypt

The Tentmakers of Cairo are part of a centuries-old tradition of creating art to decorate the tents used by wealthy and powerful Egyptians. The Khayamiya panels are created by a large network of artists and stitchers, most of whom start learning how to create the panels while working after school at the family business, when still in their early teens. The artisans work in a series of interrelated shops along the Street of the Tentmakers (Shari'a al-Khayamiyya, or Suq al-Khayamiyya), centered in the Qasaba of Radwan Bey, a historic covered market built in the seventeenth century.

Both the hand-stitched and hand-drawn designs are passed down within a shop lineage. While traditionally the designs were abstract, starting in the early twentieth century the Tentmakers also started to make works featuring birds, camels, and folktale characters. The earliest bird pieces were inspired by tomb paintings. "Orange Hoopoe" is based on a tomb painting from the Tomb of Khnumhotep II, Beni Hasan, Egypt (circa 1900 BCE; collection of the British Museum). The orange hoopoe faces to the left, because in ancient Egypt death belonged on the west side of the Nile—the side where the sun set. Life belonged to the eastern side, where the sun rose. All cemeteries, tombs, and funerary temples were on the west of the Nile—such as the Valley of the Kings, the Valley of the Queens, the Valley of the Nobles, and so on. Ancient Egyptian tomb paintings often show birds looking to the right, but the orange hoopoe (or "hud-hud" in Arabic) always looks to the left. Because of this, the hoopoe is still sometimes seen as a bad omen—a symbol of death—which is a pity because they are beautiful birds. Similarly, "Fabulous and Ancient Ducks" is based on ancient paintings depicting high-ranking Egyptians hunting birds on the Nile River with decoys and throwing sticks, such as one in the Tomb of Menna (circa 1400–1352 BCE; copy in the collection of the Metropolitan Museum).

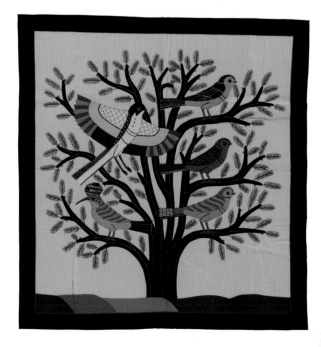

In recent years, especially since 2007, when Jenny Bowker from Australia met the Tentmakers and started helping them find an international audience, the Tentmakers have developed more-complex designs featuring birds, adding details through hand embroidery. Many of the designs feature a Tree of Life, such as "Tree of Life" and "Christmas Tree of Life." The "Christmas Tree of Life" design was first created by Sameah Farougah. Now that Sameah Farougah is an elder craftsman, the design is being stitched by his brother and his son under his supervision.

The Tentmakers are very proud of their traditions and that their art can share those traditions with the world. The Khayamiya are completely hand-appliquéd and hand-embroidered onto a canvas backing. While each shop is separately owned, the designers and stitchers may work for more than one shop, and many of them work together to market their art through Etsy. I would like to thank Ahmed Kamal for his assistance in answering questions about these amazing pieces.

Trees of Life: the Orange Hoopoe | 35 × 35 inches; 2021 | Cotton, canvas | Hand appliqué stitched by Sameah Farougah | From Gamal Kolthoma | *Photo by: International Quilt Museum*

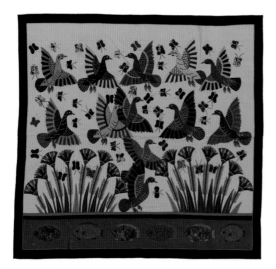

Fabulous and Ancient Ducks | 39 × 59 inches; 2021 | Cotton, canvas | Hand appliquéd | From Tarek al Safty | *Photo by: International Quilt Museum*

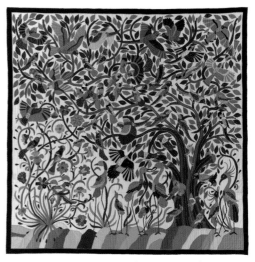

Tree of Life | 98 × 98 inches; c. 2018 | Cotton, canvas | Hand appliquéd | *Photo by: International Quilt Museum*

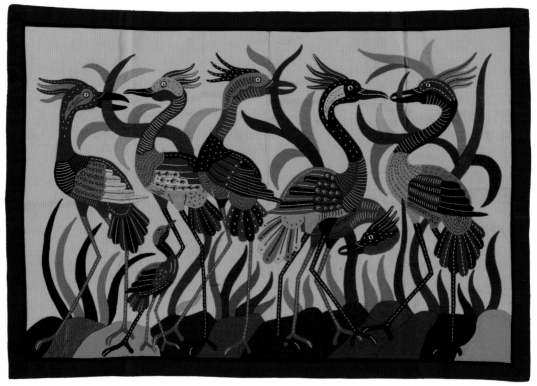

Unique Cranes | 35 × 53 inches; 2021 | Cotton, canvas | Hand appliquéd | From Tarek al Safty | *Photo by: International Quilt Museum*

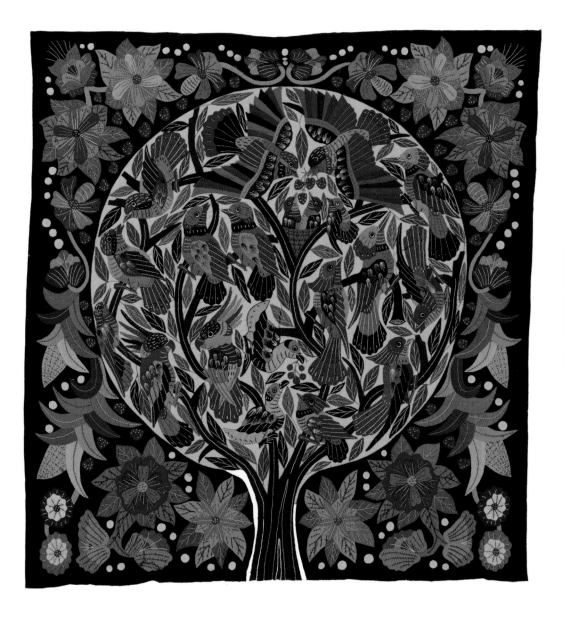

Christmas Tree of Life | 51 × 51 inches; c. 2018 | Cotton, canvas | Hand appliqué stitched by Sameah Farougah | From Tarek al Safty |
Photo by: International Quilt Museum

INDEX OF ARTISTS